Joyce Wieland

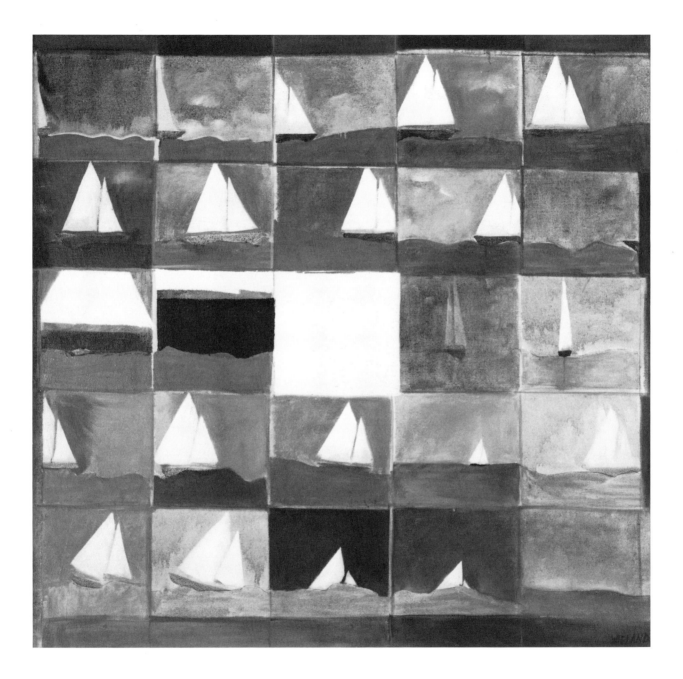

Joyce Wieland

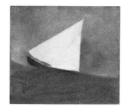

Art Gallery of Ontario
Musée des beaux-arts de l'Ontario

Key Porter Books
Toronto

Copyright © 1987 Art Gallery of Ontario.
All rights reserved
ISBN: 0-55013-018-8

CANADIAN CATALOGUING IN PUBLICATION DATA
Fleming, Marie
 Joyce Wieland

Catalogue issued to coincide with the
exhibition held at the Art Gallery of Ontario,
Apr. 17-June 28, 1987.
Co-published by the Art Gallery of Ontario.
Bibliography: p.
ISBN 1-55013-018-8

1. Wieland, Joyce, 1931- – Exhibitions.
2. Wieland, Joyce, 1931- – Criticism and
interpretation. I. Lippard, Lucy R. II. Rabinovitz,
Lauren. III. Wieland, Joyce, 1931- . IV. Art
Gallery of Ontario. V. Title.

N6549.W53A4 1987 709'.2'4 C87-093123-7

ITINERARY OF THE EXHIBITION

Art Gallery of Ontario, Toronto
April 16-June 28, 1987

Confederation Centre Art Gallery and Museum, Charlottetown
October 16-November 15, 1987

Beaverbrook Art Gallery, Fredericton
December 4, 1987-January 30, 1988

Mackenzie Art Gallery, Regina
February 19-March 31, 1988

Organized and circulated by the Art Gallery of Ontario with the assistance of the Canada
Council.

The Art Gallery of Ontario is funded by the Province of Ontario, the Ministry of
Citizenship and Culture, the Municipality of Metropolitan Toronto, and the Government
of Canada through the National Museums Corporation and the Canada Council.

DESIGN: Brant Cowie/Artplus

TYPESETTING: Computer Composition of Canada, Inc.

Printed in Canada
by D.W. Friesen and Sons, Ltd.

COVER ILLUSTRATION
Early One Morning *1986*
Oil on canvas
99.0 × 134.5 cm
Collection of Faye and Jules Loeb,
Toronto

PLATE 1
Sailboat Tragedy and Spare Part *1963*
Oil on canvas
129.4 × 134.8 cm and
21.3 × 34.5 cm
Vancouver Art Gallery, Vancouver

CONTENTS

ACKNOWLEDGEMENTS

If an exhibition can be seen to be a collaborative event, revealing the potential of group effort that Joyce Wieland's own quilts represent, nowhere is this more evident than in this exhibition and publication. I am grateful to Joyce Wieland for her enthusiastic participation and to those writers who added their talents and their own enthusiasm for Joyce's work to the catalogue: Lucy Lippard, Lauren Rabinovitz, and Marie Fleming, who conceived the exhibition while still Associate Curator of Contemporary Art at the Art Gallery of Ontario.

I would also like to thank Avrom Isaacs and Martha Black at the Isaacs Gallery and the many private and public lenders that made the exhibition possible. Deeply involved at the Art Gallery of Ontario, for which I owe my appreciation, were Barbara Fischer, Assistant Curator of Contemporary Art, and my secretary, Cheryl Izen; Maia Sutnik, Head of Photographic Services, and her staff Faye Van Horne, Carlo Catenazzi and Brenda Dereniuk; Registrar Barry Simpson and Traffic Coordinator Cynthia Ross; Conservators Barry Briggs and John O'Neill; Bernie Oldcorn, Manager of Technical Services, and John Rusekas, Chief Preparator, and their staff; Glenda Milrod, Head of Extension Services, and her staff. At Key Porter Books, I would like to thank editor Margaret Woollard and designer Brant Cowie.

PHILIP MONK
Curator of Contemporary Canadian Art

PREFACE

Joyce Wieland's retrospective is her first major exhibition since that outpouring of creativity called *True Patriot Love/Véritable amour patriotique* at the National Gallery of Canada in 1971. These intervening years have added different strains to an already diverse career in film and a full range of media—paintings, drawings, prints, assemblages and quilts. While her National Gallery exhibition marked the significant contribution of her infusion of feminist, nationalist and ecological issues into Canadian art, the exhibition at the Art Gallery of Ontario diffuses those themes into the different clusters of work that compose her career. This strategy of diffusion parallels Joyce Wieland's own development from the late 1970s on in her rich series of colour pencil drawings and oil paintings, which are presented with her earlier work here for the first time, making a full circle with the figurative work that opens the exhibition.

WILLIAM J. WITHROW
Director, Art Gallery of Ontario

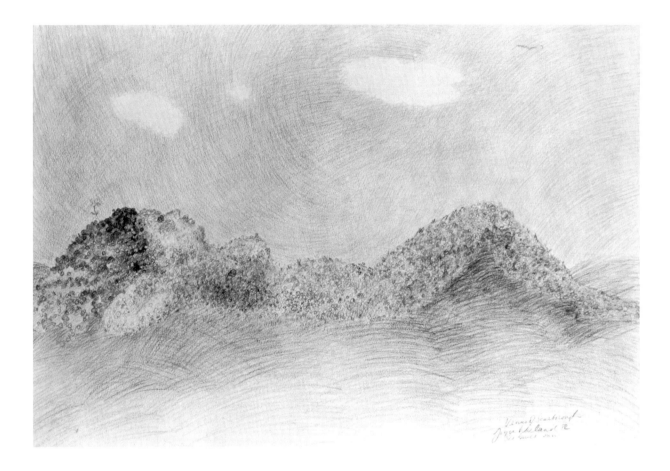

FIGURE 1
Study for "Venus of Scarborough"
1982
Coloured pencil on paper
38.4 × 56.8 cm
The Artist

Lucy Lippard

Watershed

CONTRADICTION, COMMUNICATION AND CANADA IN JOYCE WIELAND'S WORK

"To believe in nature was to rebel."
HENRY DAVID THOREAU

Joyce Wieland is one of those wild cards that saves the contemporary art world from its straight-and-narrow conformity to an institutionalized "wildness." The simple fact that she has been able to move comfortably back and forth among painting and drawing and sculpture and collage and experimental film and feature film and quilting and public art questions the constrictive specialization that characterizes most "successful" art. Her expansive approach to mediums is parallelled by the breadth of her content. Wieland's art has occasionally been criticized for being awkward, sentimental and, above all, "naive." But without these elements it would not have been able to stretch and flex to accommodate so many different ideas and subjects.

At the same time, Wieland has always had a centre—unifying a personal, sexual and domestic landscape that over the years has grown to encompass a transcontinental landscape. She began her mature paintings around 1956, and by 1960 the basic components of her art were already in place. In an interview that year, she noted her interest in the Dadas: "It's not just painting, not just art. . . . They're artistic in a *general* way. . . . They see things whole. Their jokes are

about life."[1] Her own development has been marked by a desire for that same wholeness.

In 1970, Wieland reinforced her centre by adding "woman" and "Canadian" to her identity as "artist." In 1976, a midlife summing up appeared in the form of *The Far Shore,* a feature film conceived in 1969 and originally titled *True Patriot Love: A Canadian Love, Technology, Leadership and Art Story. True Patriot Love* then became the title of her retrospective extravaganza at the National Gallery of Canada in 1971, the year she turned forty. Its subtitle might have been "Reason over Passion"—a quotation from then Prime Minister Pierre Trudeau that became the ironic title of her cross-Canada film of 1967-69, echoed in a quilt given to Trudeau, with its French counterpart, *La raison avant la passion.*

Wieland's born-again Canadianism (reminiscent of the *Mexicanismo* of Kahlo, Rivera and the 1920s muralists) came after she had lived in New York for several years, and it coincided with the upsurge of the new feminism. This double validation of her identity may have emerged from the quasi-objectivity that distance can offer. "I think of Canada as female," said Wieland in 1971, when she was still living in New York. "All the art I've been doing or will be doing is about Canada. I may tend to overly identify with Canada."[2]

Few modern artists have taken on the state as a persona. Wieland's identification with Canada goes beyond the feminist/feminine empathy between earth and body, though that too is prominent in her later work and is epitomized by the flowering earth sculpture, *The Venus of Scarborough,* of 1982. Like Laura Secord, the early nineteenth-century heroine who led her cow through enemy lines and helped save Upper Canada from an invading U.S. army (an event Wieland re-enacted for her 1971 show), she may aspire to be a kind

of Canadian Joan of Arc within the cultural sphere. When she made the film *Reason over Passion* (a cross-continental voyage that is all landscape except for a speech by Trudeau, who stands in for the entire Canadian people and also urbanely replaces Toronto), she said she "felt like Leni Riefenstahl . . . a government propagandist." In some ways she is, though it was the reign of the charismatic Trudeau that inspired this high pitch of nationalism; it would be more difficult to be a "cultural activist" for Brian Mulroney.[3]

Most "political art" today comes from the Left and is either directly or indirectly critical of the state. The apparent paucity of right-wing political art is explained by the ubiquity of art that claims to be neutral and thereby supports the status quo—everything that does *not* take a critical position. Wieland's work is an exception—liberal *and* nationalistic. She is perhaps fortunate not to be characterized as a "political artist," although several of her short films are among the best political art of the 1960s. In the best known of these—*Rat Life and Diet in North America*—Canada is a (temporary) haven for the endearing gerbil draft resisters who escape from the Fascist cats and the Vietnam War. In Canada, the gerbils take up an idyllic life of organic gardening, but at the end they are under attack again. I thought the message was pretty straightforward, but the avant-garde, ill at ease with political emotion, was able to interpret it with typical ambiguity. P. Adams Sitney observed that "the viewer cannot be sure if she is mocking a political situation or films about such political situations."[4]

It may be that Wieland is not categorized as a political artist because she is not an ideologue, or because her content is such a seamless part of her art, or because she is Canadian. I, for one, was struck by retrospective guilt when researching this essay; I realized

that, like most garden-variety cultural imperialists, I knew little *about* the work of this major woman artist, although I had known *of* it and even written *on* it in the mid-sixties, and have travelled often in Canada, written for Canadian publications, and so forth. Undoubtedly, one reason for this situation is the curious distance between the United States and Canada—a distance initiated by a patronizing colonialism that aroused Canadian self-awareness and justified forcible rejection of American influence in the early seventies.

In any case, Wieland's "nationalization" resembled the simultaneous politicization of many women artists, which also emerged organically but gained from the distance provided by "living among the enemy." Wieland had deeply ambivalent feelings about the art of her husband, Michael Snow, and about that of close male colleagues, as well as about the U.S./Canadian relationship. Around 1970, she was drawn back toward her mother-land, rediscovering the ties that bind after weaning herself by a long absence.

The feminist revelation may have come as less of a shock than the Canadianism, since Wieland already had a long history of close friendships and collaborations with women during the sixties. Unlike many women artists, she did not have to turn one hundred and eighty degrees to become a feminist (a term she sometimes adopts and sometimes doesn't). Although she was the only woman in the Isaacs Gallery, and did "a lot of paintbrush washing and coffee getting," she "never lost sight of what I was trying to accomplish myself."[5]

When the new feminist art movement emerged internationally in the early seventies, Wieland was already practising what others had just begun to preach. Her paintings had emphasized sexual imagery from the female viewpoint as early as 1959, though "Toronto's

infamous prudery'' prompted her at the time to be somewhat reticent about the content of these abstract, stained canvases, the not-very-veiled female and male genitalia that she said years later were ''sex poetry,'' describing wombs and cycles as ''an imprint of my state: my infertility.''[6] These works often appreciated (without heroizing) the phallus, which in *Nature Mixes* (1963),is metamorphosed in storyboard form from hand and flower.

Wieland not only used female motifs but recognized them. In 1965, she told Leone Kirkwood, ''It's very female to put things in other things, like boxes. . . . In a way you could say it's female to limit things.''[7] She liked films because ''there's a lot of repetition in a small space.''[8] By 1971, many components of a ''woman's art'' and what Miriam Schapiro has called ''femmage'' were visible in Wieland's work, including collaboration and the rehabilitation of women's traditional arts in the form of quilting, knitting and embroidery. When Judy Chicago's *Dinner Party* was shown in Canada in 1982, Canadian reviewers were justifiably irate that American critics (myself included) had been so ignorant of Wieland's earlier work in this area.[9]

By 1970, Wieland had also undergone the obligatory realization of sexism in her professional life, that shock of rage when she found herself ''put in her place'' by the male-dominated underground film establishment. Her short films, especially *Rat Life,* had been accepted and praised by her male colleagues, among them Jonas Mekas, who called *Rat Life* ''one of the most original films made recently.''[10] However, with the advent of the longer *Reason over Passion,* Wieland was denied a place in the Anthology Film Archives' pantheon: ''I was made to feel in no uncertain terms by a few male filmmakers,'' she recalled, ''that I had overstepped my place,

that in New York my place was making little films.''[11] It was a set-back that, ultimately, she was able to profit from; this experience became one of the sources of *The Far Shore*—a *really* long and large film, and far more ambitious than anything undertaken by her ''underground'' comrades.

In retrospect, Wieland has also analysed the influence of Michael Snow during their twenty-five-year marriage: it was ''. . . not so much in style as in having my own well-developed outlook, philosophy, and so on. I was on my way in a sense to becoming an artist's-wife-type artist until I got into looking around in history for female lines of influence. I read the lives and works of many, many women, salonists, diarists, revolutionaries, etc. I started to invent myself as an artist. I saw only gradually that my husband's artistic concerns were not mine. . . . I had to look into the lives of women who had made independent statements in their lives. In a sense my husband's great individuality and talents were a catalyst to my development. Eventually women's concerns and my own femininity became my artist's territory.''[12] Sitney has noted that while Michael Snow found his own language in structuralism, Wieland did not.[13] She found her tongue in another kind of silence, a gentle but fragmented and disjunctive serialism with a narrative line above or below the surface. Yet her exposure to and work within the structuralist discipline undoubtedly had a benign effect on her art, rather like Eva Hesse's contemporary response to the minimalism she adopted primarily as an armature for her own emotive expressiveness.

Harold Rosenberg once said that if art went backwards it would become handicraft and if it went forward it would become media.

Wieland, who has made films and quilts and a cake and a garden and a perfume, epitomizes the integration of these supposed polarities. In developing her own quirky aesthetic, she has managed to ignore the traditional abysses between art and craft and media. Like much of the most interesting contemporary art, her *oeuvre* is "an odd combination of the new and the old."[14] The conglomerate nature of Wieland's art has dismayed some critics. John Bentley Mays called her 1983 show at the Isaacs Gallery "an untidy array"—which is just what I like about her work. He added that "cloudcuckoolands will interest the curator or scholar who someday tries to put together all the pieces of Miss Wieland's various, unusual career."[15] (And so they do.) Diversity allows the artist to break the patterns of high art and the grip of the ruling class.

Wieland is no "primitive," but she has managed to remain in some sense an outsider. She thrives on a tension *between* things—between craft and medium, female and male, earth and spirit, fact and feeling, pain and pleasure, activism and contemplation . . . passion and reason. Women artists are often *accused* of being synthesizers, as though synthesis were not the ultimate ingredient of transformation. The patronizing implication that men innovate, erecting the poles of thesis and antithesis, and women come along afterwards and smooth off the edges in synthesis is outdated. It is the synthesizers of either sex who open the gates to new fields so that the innovators can dash ahead—for a while. In 1981, Wieland told Lauren Rabinovitz in an interview printed in *Afterimage* that she was "better able to synthesize now. I felt *The Far Shore* was pulling together everything I knew so far in life. Really it was what I knew so far about art, but that was what I knew about life—the artist struggling and the life of the artist."

Wieland's art is frequently called "intimate," although compared to that of many women it offers little visible autobiographical revelation. It is intimate because it offers interstices into which the viewer can enter with his or her own associations. As Lewis Hyde says in his beautiful book *The Gift:* "An essential part of any artist's labor is not creation so much as invocation. Part of the work cannot be made, it must be received. . . . It seems correct to speak of the gift as anarchist property because both anarchism and gift exchange share the assumption that it is not when a part of the self is inhibited and restrained, but when a part of the self is given away, that community appears."[16] Wieland has said that she wants "to give the people of Canada a sense of themselves."[17]

Wieland is also interested in the process of communication itself. From one-of-a-kind paintings to the feature film, from the mass-produced but individually savoured artist's book to the one-of-a-kind, collaboratively produced and widely accessible quilt in a Toronto subway station, she has explored different ways to reach different kinds of people. A combination of word and image is usually the best way to reach broad audiences, and Wieland uses words to "illustrate" the visual language, instead of vice versa. A good example is the recurrent theme of the speaking mouth as a connector that doubles as an erotic orifice and an instrument of intelligence and contact. Wieland has used it since her Pop Art days, but unlike the passive "movie star mouths" of Warhol or Wesselmann, hers are active; they have something to say. In film and quilt they sing "O Canada"; in a 1973 litho they articulate "The Arctic Belongs to Itself"; in *The Far Shore* the two lovers playfully and silently "speak" through magnifying glasses. Her most notable use of this image occurs in the 1972 film *Pierre Vallières,* where a

French-Canadian separatist revolutionary delivers a powerful monologue about liberty in regard to woman and nation (in French, with English subtitles). The viewer sees only his speaking mouth and can concentrate on the voice and the "opening up" of the ideas.

Wieland's sympathy for bicultural Canada, which is an integral part of *The Far Shore,* can be seen as an expression of the dialectic (or polarity) in which women exist. Bilingualism becomes both a negative and a positive metaphor: for the different languages spoken by male and female—for lack of communication and for a potential communication that integrates two identities without either melting down the other. In this light it might be surmised that Wieland's frequent allusions to Trudeau's byword—"reason over passion"— are less approving than ironic, an acknowledgement that passion could just as easily dominate reason.[18] On the other hand, Wieland might also have been expressing dissatisfaction with her own preference for passion, which puts her at odds with the "male ways" that are said to work best in this society. The term "anti-imperialism" itself means something quite specific to feminists, suggesting connections that Marxism ignores. Wieland's patriotism is qualified when she says she favours nationalism only for weak countries,[19] for a Canada perceived as a woman being raped culturally and economically by the big guy to the south.

One of the sources of Wieland's generosity may have been her early training in commercial art and film animation. There she worked easily and naturally with others and gained a respect for visual clarity. Her first films emerged from communal games played with talented co-workers at Graphic Films in Toronto; she subsequently collaborated with Wendy Michener, Mary Mitchell, Betty Ferguson, Dave Shackman, Ken Jacobs, Michael Snow and Hollis

Frampton. *True Patriot Love* at the National Gallery of Canada in 1971 offered a warm welcome to her doubly refreshed consciousness of being a woman and a Canadian. The show opened on Dominion Day with a celebration centred on an *Arctic Passion Cake,* which served as a bier for a bloody, slain polar bear.[20] Three huge quilts were made with the artist's sister, Joan Stewart; "champion knitter" Valery McMillin made four worsted Canadian flags; Joan McGregor of Halifax embroidered the last letters of generals Wolfe and Montcalm (150 hours' work); a group of Acadian women from Cape Breton hooked an Eskimo song into hangings.

The quilt has long been used as a metaphor for women's networks and collaboration. Wieland's more than eight-metre-long *109 Views* (of Canada) extended this idea to the state. She also used her quilts as "cover-ups," as codes to be read by women, which has historical parallels. Outwardly beautiful, white, and pure, they bear hidden messages. As Kay Kritzwiser wrote: "Quilts are family. They are secure coverings belonging to an unmechanized world. But Wieland's quilts are really banners for this generation's pilgrims. . . . Her work has always been a mixture of deadly fact and fancy. . . . Wieland at her most innocent is Wieland at her most wicked. Look at those deceptive plastic pockets. They're gaudy and slick, but when you pull out the little pillows stuffed into them, you are made aware of Vietnam and national greed and wanton destruction of the earth . . ."[21] *The Water Quilt* is lovelier and subtler. When the organdy flaps exquisitely embroidered with sixty arctic flowers are lifted, they reveal pages from a book about a U.S. plot to steal Canada's water resources.

The book *True Patriot Love,* which doubled as a catalogue for the show, is the only artist's book Wieland has made, but it ranks with

the films as a major work. An overlay of humanist and ecological concerns on nature and science, it "rides on" a "real" book, complete with coated stock and hard cover—appropriately an illustrated government publication on the flora of the Canadian arctic archipelago. Some pages remain in their original state; some are only minimally interrupted by one side of a paper clip or a handwritten note. Other pages are covered with snapshots and texts (including a Gaelic tale and an early script for *The Far Shore*), pressed flowers and images of the art works in the exhibition. They are not "glued down" but float over the precise flower drawings and scientific descriptions like sketches for a collage in process. "By rephotographing I make the images my own," said Wieland, anticipating postmodernist "appropriation." "The pages of the book became the landscape to which I wed the images. The main theme of the book is really ecology." The reader is offered a mysterious, layered experience, both public and private, elusive and accessible.

Collaboration is, paradoxically, a declaration of independence for the contemporary artist. It rejects isolation and alienation as the artist's natural fate, while acknowledging the inevitability of general public resistance to "new art." In the *True Patriot Love* exhibition, Wieland did not just collaborate with another artist, but with surrogates for the public she hoped to touch—women from different regions and social sectors of Canada. Like Judy Chicago after her on an even grander scale in the *Dinner Party* project, Wieland did not just "do outreach," she actively involved a part of her audience who, when entering the museum, would find a welcoming, somewhat familiar ambience, which was, of course, strictly unfamiliar as art to most museum goers. By making her show an exchange with her chosen audience, Wieland exemplified what Hyde calls the "gift society," as opposed to the market.

The fragments of collage and the joining of collaboration can also be read as hopeful metaphors for Canada's bicultural heritage. Actually, it's a tricultural situation, with Anglo and French Canadians joined by the uninvited U.S. corporate culture; and at its base lies a fourth element—the Inuit and the Indian, with the Métis as a transitional group—all of them relatively invisible, in Wieland's work as in Canadian cultural life in general.

When Wieland visited Cape Dorset in the Arctic in 1979, she saw immediately the "deep division between the whites and the Eskimos." In an effort to bridge that gap, she worked briefly with an Eskimo woman artist named Soroseelutu.[22] On the same trip she discovered a new interest in colour, light, mythology and "the spiritual" revealed in the power of the extraordinary arctic light. (She has likened her recent work, in which she discovers the image in light, to the Eskimo concept of discovering an animal in stone.)

Presumably, further recognition of indigenous Canada would have been achieved had Wieland and Judy Steed, her co-producer on *The Far Shore,* been able to follow through on their plans to make a second feature film, this time of Margaret Laurence's novel *The Diviners,* scripted by Margaret Atwood. The novel unabashedly and undidactically explores issues of race, class and gender against a backdrop of recent Canadian history. The Anglo writer-heroine's Métis lover represents the homeless artist. Similarly, in *The Far Shore,* Eulalie and Tom—the French and Anglo artists—are those who know where home is or what a homeland is worth. The Tom Thomson figure might also be a stand-in for the indigenous Canadian (or for the early French trappers and traders) in that he is in the process of fusing his background with his foreground, becoming through art a new kind of "half-breed" who would ideally mature into the "true Canadian," at home in his new land—not through

imposing his will on it but through coming to know it, in all senses, including the erotic.

At the heart of Wieland's work lies a micro/macrocosmic vision. Perhaps the best definition of a political artist is one who looks around her, who is vulnerable to experience and environment—both her own and other people's. At a Wieland retrospective the viewers, like the artist, have to adjust their vision to close-up and long-distance. The microvision, an intimate landscape of self and body, gives way to an intermediate view of sexual and domestic landscape, and then to the macrovision of the political landscape, and the ecology. It is Wieland's double identification with land and state that endows *The Far Shore* with an erotic interpretation of nationalism. Wieland the woman becomes the landscape, while Wieland the film director stands back and becomes the authority, or state. The two merge in a patriotic ecstasy that is also a funeral eulogy for lost hopes.

From the 1964-65 film *Water Sark* (which Rabinovitz says ''ritualizes self-discovery'' by emphasizing ''physicality, sensuality, and spirituality'')[23] to the sinking sailboat paintings of the 1960s to *The Water Quilt,* the drawing *Birth of Newfoundland* and the film *The Far Shore,* water has consistently been the medium of transformation in Wieland's work. Its meanings have ranged through femaleness, creativity, orgasm, death and rebirth. Christopher Hume has called her a ''searcher for the ecstatic'' and discerned in her recent paintings ''proto-mythic landscapes where the female principle is supreme The world of men with all its technological power and self-destruction has been left behind. Hers is a universe washed clean of guilt and fear, glistening in its fresh innocence.''[24]

He might have been describing the single "ecstatic" passage in *The Far Shore*—the brief time when the lovers are alone together in the wilderness and make love in the lake. Yet fear and death lurk at the edges of the frame and catch up to the lovers (artists) soon enough; they also die in the lake. Like *Rat Life and Diet in North America, The Far Shore* ends in tragedy. Optimism and pessimism, fun and fear, utopia and disaster are present in most of Wieland's work. Sitney recognized this dark side when he called *Reason over Passion* an ecological dirge, not a poem of becoming so much as of what might have been. . . . With its many eccentricities it is a glyph of her artistic personality; a lyric vision tempered by an aggressive form, and a visionary patriotism mixed with ironic self-parody."[25]

In 1971, Wieland consciously turned away from the irony that characterized her New York work toward a sincerity that made her more vulnerable, sacrificing distance from nationality and gender. For some onlookers this was a turn away from sophistication and high art toward craft, sentimentality and propaganda. But Wieland saw it as a positive step that brought with it a further commitment to social responsibility and to collectivity. In 1971 she said that irony had become "too frivolous. . . . We have to get to the very essential thing now, the land, and how we feel about it. . . . It's important just to feel the beauty of everything, to be as positive as possible."[26]

At this moment when a "global" culture is taken for granted by the international art market, the issues of "positive imagery," "naïveté," "idealism," "localism," "primitivism" and social responsibility are particularly significant. Perhaps only "at home," in Canada, could Wieland have dared to do a show like *True Patriot Love* or, ten years later, like *The Bloom of Matter,* at the Isaacs Gallery, with its goddesses and cherubs framed in ovals amid a

deliberately artificial environment of dusty rose walls, tea table, daffodil trellis, potted hyacinths and tulips. In Canada she is loved and can confidently be free and honest with herself and her audience because she *has* an audience. (The U.S. is not as fond of its artists; they rise and fall as pets or stars, but not as family members.)

Marshall Delaney's ambivalent review of *The Far Shore* was typical in its combination of fondness and bafflement. He simultaneously praised and damned the film for its "Wielandism," comprised of "innocence, naive and sentimental charm, sexuality, melancholy, blatant symbolism, parody, ecology and art."[27] Carole Corbeil located another problematic element in *The Bloom of Matter*: "a soft, semi-mystical humanism which informs and often booby-traps her work, as it did in *The Far Shore*."[28] While I would call Wieland's best work more earthy than mystical, and would say that *The Far Shore*'s unique beauty leapt over the trap, it is true that she does not always achieve the allegorical distance she seeks or the delicate balance between the stylized and the stilted, sign and symbol. In fact, such a balance might even work against Wieland's true originality, that longing for the impossible that gives her art an endearing poignancy, that ambitious, restless edge of Celtic "becomingness."

Today it is painting that provides Wieland with her future. She talks about Chardin and Tiepolo. In the coloured-pencil drawings of goddesses, she made deliberate retrogressions to Victoriana and eighteenth-century hedonism, a joyful interim that sometimes produced work related to the currently fashionable neo-classicism (which, like the profoundly expressionless neo-expressionism, is often *truly* reactionary). Yet since that series, a dualistic edge has resurfaced from her aqueous fantasies. Out of the depths of her own,

very modern experience, Wieland is making major works of collective significance, such as the painting *Experiment with Life* (1983), in which a flaming naked woman flees a burning town. Human (and animal) life escapes from a chemical disaster, or a war, or a nuclear holocaust. There may still be hope.

The title itself could be the title of this retrospective, indicative of the artist's continuing vitality. Wieland's new domestic landscape is provided by a lovingly remodelled house presided over by a mounted deer's head. After a sunny and stormy thirty years of art making, she is still considered "eccentric." (And it's still impossible for a feminist or a socially concerned artist to be perceived any other way.) The macrocosmic aspect has expanded into a mythology that takes the familiar serial or quasi-narrative form, though in autonomous works. In 1982 Wieland told Penelope Glasser that her subject was still the fusion of people, animals and landscape. She said a figure would emerge and seem to be pointing to the next drawing, "and I'd try to find out what she was pointing at. So they led me along . . . all the things I really like. . . . Things I've loved. The whole family of characters I've made before . . . into one place."[29] The visions of unity keep coming.

Marie Fleming

Joyce Wieland

A PERSPECTIVE

I

This retrospective exhibition is the first afforded a living Canadian woman artist by the Art Gallery of Ontario. It is appropriate that the artist should be Joyce Wieland. She is recognized both for her efforts and success as a role model for women artists and for the large, varied and influential body of work she has produced. Her female viewpoint, grounded in experience, is focused with wit and directed with audacity at concerns both inside and outside the formal realm of ''art.'' Wieland not only posited explicit political, feminist and ecological issues in her art a good decade before such practice was common, but also developed a form that effectively incorporated the content.

Wieland's importance in establishing the presence of women artists in the Canadian scene is indicated in exhibitions. In those concerned with Toronto painting of the fifties and sixties (National Gallery of Canada, 1972; Art Gallery of Ontario, 1983), she is one of the two or three women represented; the other women were, in 1972, Hortense Gordon and Alexandra Luke, members of Painters Eleven, and, in 1983, Christiane Pflug. Also revealing are major group shows of contemporary Canadian art abroad. Through the

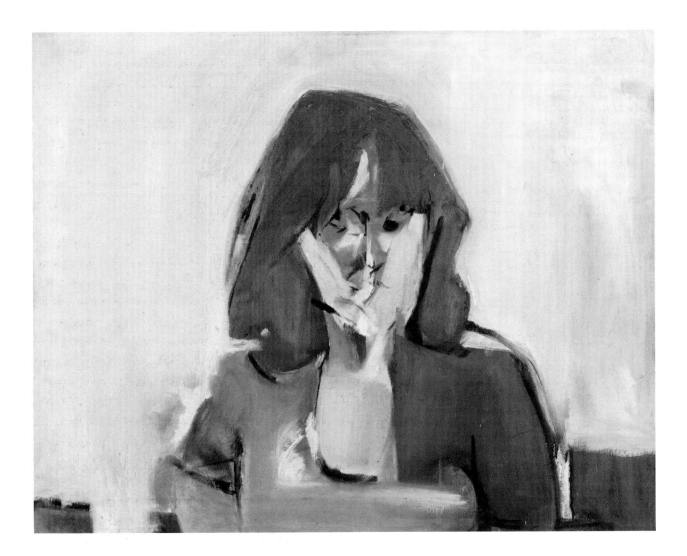

PLATE 2
Myself *1958*
Oil on canvas
56.0 × 71.0 cm
Private Collection, Toronto

sixties the main exhibitions were: *19 Canadian Painters '62; Fifteen Canadian Artists* (1963); *Nine Canadians* (1967); *Canada: art d'aujourd'hui* (1968); *Canada 101* (1968); *Eight Artists from Canada* (1970); *49th Parallels: New Canadian Art* (1971). Of these, two (1963 and 1967) included no women; one (1962) included two women—Rita Letendre and Wieland. In the other four, the one woman represented was Joyce Wieland.[1] Moreover, she was the first living woman artist to be given a solo exhibition at the National Gallery of Canada.

Wieland has already had two retrospectives—at the Vancouver Art Gallery in 1968; and at the Glendon College Art Gallery, York University, Toronto, in 1969—or even three if the National Gallery of Canada's major exhibition *True Patriot Love, Véritable amour patriotique* (1971) is regarded as a retrospective. Why another? At the time of the Vancouver and the Glendon shows, Wieland was, respectively, thirty-six and thirty-seven years old, barely in mid-career. Although graced with a retrospective element, the National Gallery's exhibition was actually an extraordinarily extensive development of the title's theme interwoven with Wieland's concerns for ecological and female issues. The purpose of the present retrospective is threefold: to present the fresh work of the late seventies and early eighties in the context of her whole *oeuvre;* to give an overview from this perspective of a strong body of work, diverse in media and sometimes content but unified by the personal aesthetic that informs it; and to acknowledge the role Wieland has played in contemporary Canadian art.

The work of Joyce Wieland does not lend itself to easy classification. Indeed, it tends to be viewed by the public disjunctively, partly because of the variety of media—among them oils, quilts and films

—and partly because of hiatuses in the pursual of a medium. The relatively unproductive period in 1962 and the interval between the "filmic" paintings of the sixties and the mythological ones of the eighties are examples of such breaks. Wieland is not a theorist. Although she closely questions ends and means, she does not systematically postulate them or necessarily align them with previous determinations. Wieland became aware of her basically anti-theoretical stance when Marxists attacked her film *Rat Life and Diet in North America* (at a New York showing in 1968) on the grounds that a political film should not be funny and that animals were not worthy subject matter. She realized she did not want to belong to any group—political, economic, feminist, artistic—for which she must surrender or compromise her aesthetic, humour, or joy in her subject. Hers is a language of imagination and emotion, of intuitive insights and incisive humour. Her concerns are obsessively pursued; her procedures often show evidence of the hand, of being body-related. Wieland responds to her physical, cultural and sociopolitical environment in her own way. She senses "what is in me to do" as well as what "is in the air." She finds sustenance in her own nature, her experience and her work. Not surprisingly with an artist whose work has a personal, often autobiographical dimension, Wieland's *oeuvre* shows a sense of the flux of life.

Art naturally is related to the person and culture that produced it. Yet works differ greatly in their subjective or objective orientation. A work may be theoretically grounded and self-referential. It may reflect, in varying degrees, a more spontaneous and intuitive process or may pertain to specific events or situations in the person's life. In the latter cases, the consideration of the work on its own terms can be supplemented, and indeed is enriched, by relevant associative

readings and biographical references. It is worth noting that the emphasis on autobiography, narrative and behaviour discernible in performance and video work of the sixties became more prominent in the art of the seventies.

Joyce Wieland was born on June 30, 1931, to English parents who had immigrated to Toronto in the mid-twenties. Her father worked in various capacities at the Royal York Hotel, but he also retained a keen interest in the family tradition first of the pantomime and later of music hall in which he had been trained as a child. (He had performed as one of "The Five Wieland Brothers.") This tradition he attempted to pass on to his three children—Joyce and her older sister and brother. Wieland's father died when she was seven; her mother, when she was nine. The three children then made the first of many unsettling moves. The older ones were working and, Wieland recalls, "overnight, from being a spoiled brat, I had to learn to use a gas stove, to turn on the gas, make it light and get the meals for them The next thing I knew my brother came home one day in uniform [during World War II] and that was the end! That was it!" Despite years of therapy, Wieland still finds it hard to talk about those times.

Many of her childhood memories surface later in her work— blood on the sheets, chalk on the blackboard, the loss that is unexplainable, the blue-lined foolscap that she loved, Doctor Doolittle books with Hugh Lofting's illustrations and Beatrix Potter's "Peter Rabbit" series that she discovered in the public library at Dovercourt and Queen. "I didn't think anything was more beautiful than Beatrix Potter's drawings." From early childhood Wieland loved to draw. Absorbing American comic strips and movies of costume dramas, she drew cartoons, creating her own serial, *Agent*

X9. Her woman spy was perpetually making herself up and trying to decide what to wear, activity that brings to mind the performance with make-up years later in *Womanhouse,* an environment made by members of a feminist art program.[2]

From fall 1944 to spring 1948, Wieland studied at Central Technical School, Toronto, under Doris McCarthy, Elizabeth Wynn Wood, Virginia Luz and Robert Ross. "Meeting Doris McCarthy," Wieland states, "was a big moment in my life . . . [she] understood that I liked art better than anything." McCarthy, together with the guidance teacher, persuaded Wieland to switch from the general course in which she was enrolled to the art course. Wieland is unstinting in praise of her teachers: "They were the very best. They're the ones that got me really excited." McCarthy remembers Wieland as "very talented, very creative" and "beautiful."[3]

McCarthy was important to Wieland in another way—as a role model of a woman artist. Wieland was already strongly influenced by the examples of her mother—"the dignity she conferred on domestic objects and work"—and of her sister, Joan, who, when their father died, had left school to get a job. Although Joan was the elder by nine years, she was both a friend and a mentor to her younger sister, telling and dramatizing stories (Joan of Arc at the stake being the favourite) and introducing Joyce to the library, to opera broadcasts on Saturday afternoons and to summer concerts at Varsity Stadium.

After Central Tech, Wieland worked for four years at the commercial art house E.S. and A. Robinson, and for a brief period at Planned Sales, which she left in 1953 for a three-month sojourn in Europe.[4] On her return to Toronto, she free-lanced, painted at night and between jobs and, through the Toronto Film Society, became increasingly interested in the history of film. "I had this great desire to

work with film," Wieland recollects. In the mid-fifties she became associated with Graphic Films, a company producing commercial, educational and training material largely in the form of film animation—an association that proved important.[5] She met filmmakers George Dunning, Jim McKay, Warren Collins and Bob Cowan and artists Graham Coughtry and Michael Snow. (In September 1956 she married Snow.) Her work in film animation became a structural source to which she returned in her films and paintings of the sixties. Her involvement in personal filmmaking with Collins, the camera operator at Graphic, was equally significant as the beginning of her serious and continuing commitment to film.[6] At this time also an interest in sexuality was stimulated by the book on Picasso's *Suite Vollard* that Dunning brought to Graphic's offices.[7] "It influenced all of us." Wieland responded to Picasso's eroticism with erotic drawings from a female point of view. (In *The Magic Circle* a woman holds a diaphragm aloft; in *The Way She Feels* a nude squeezes her breasts together with her arms, plumping and pushing them forward.)

Wieland's paintings of the later fifties are generally figurative; the scene is domestic and the emphasis is on human relations. The shallow space and angularity of form allude to cubism, but the colour tends toward warm, bright, close-valued hues (red, orange, pink, yellow) sharpened by acidic tones. The influence came generally through the work of the American artist Attilio Salemme.[8]

Myself (PLATE 2), of 1958, signals the importance of drawing in Wieland's work and of the self as an essential subject. The portrait has an introspective quality; the left eye, seen in profile, turns the face to look into itself. The portrayal does not suffer from veiled reference (more obvious in earlier work) to Picasso's double-faced

FIGURE 2
Morning *1956*
Oil on canvas
50.6 × 66.2 cm
The Artist

23

representations—in particular *Girl Before a Mirror,* then in the collection of the Museum of Modern Art, New York, and usually on permanent display.[9] Wieland had been visiting New York with increasing frequency since 1950, as well as reading *Art News,* an influential American art magazine.

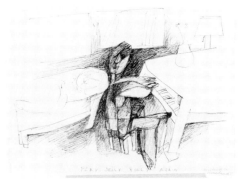

Wieland's "love of pure drawing" is evident in the quick ease of both the spare line sensuously describing a woman's figure in *Play Jelly Roll Again* (FIGURE 3) and the rich tissue of lines reverberating around the piano. She speaks of translating drawing into paint. "Eventually," she says, "I became as comfortable to draw in paint as in pencil." *Myself* gains expressiveness through paint handling— the free drawing and looser brushwork literally confine the image (the self) and formally tie it to the surface. *Man Turning,* of the next year, has the blurred form and shifting proportions of a person in motion and is experienced largely as outline shape. The figure has become an abstracted presence moving toward the soft background void. Analogies can be found in Graham Coughtry's *Moving Figure* or *Emerging Figure* of 1959 and, more faintly, in Michael Snow's early work, such as the 1955 collage *Seated Nude.*[10] (Wieland quotes Snow as saying, many years later when they separated, "We made each other.")

The period 1959-60 was one of "cross-currents and turning points" in Wieland's work. (It was followed in 1961 by an amazingly productive year.) As *Man Turning* shows, by 1959 Wieland was responding to the gestural freedom of abstract expressionism, "the essential impulse of Toronto painting in the sixties as in the fifties."[11] Wieland writes of Willem de Kooning's painting *February,* which she saw that year in New York's Riverside Museum. She found it "a work of immense physical presence . . . rooted in the

24

FIGURE 3
Play Jelly Roll Again
Ink on paper
18.0 × 24.5 cm
Private Collection, Toronto

vital energy it has accumulated from its creator'' and, in Dadaist terms, ''a culmination of an evocative series of 'happenings' in paint.'' She noted that, ''the speed . . . [of the brushwork] gives the forms urgency; . . . large brushes produce drips or dripping . . . [like] blood spattered on the road at the scene of an accident; a stroke made with colour *is* the form.''[12]

The central intention of abstract expressionism was to lay bare the very heart, the interior energy, of an experience. While sharing this intention, Wieland generally retained allusions to the natural world, integrating a personal referencing system with abstraction. This reflected in part her basic humanism, in part her empathy with Dada, its concern for content and its use of humour and also, perhaps, her intuitive recognition of the mixture of abstraction and figuration achieved by Joan Miró, and by de Kooning in his ''Women'' series. With her subversive wit Wieland had a natural affinity with the Dadaists—''They're artistic in a *general* way. . . . They see things whole. Their jokes are about life.''[13] As David Burnett writes, ''The concern with neo-Dada was a mark of Toronto artists' continuing involvement with what was happening in the United States, but it was also a feature of developing independence.''[14] ''We were all looking at it like crazy in those days,'' Wieland recalls. The focus was on the work of Marcel Duchamp and, to a lesser extent, on that of Kurt Schwitters and Americans like Jasper Johns, Robert Rauschenberg and Jim Dine.[15] William Rubin emphasizes that ''so-called neo-Dada'' from the late 1950s was ''plastically oriented,'' and that while the artists turned to ''specific iconographies that reached back through surrealist object-art to Dada . . . [they] depended greatly on their [abstract expressionist] predecessors for handling and compositional devices.''[16]

Redgasm (PLATE 32), of 1960, is a critical "crossroads" painting. At first glance it seems abstract; then, seeing the outline of a small penis, the viewer proceeds to read other sexual references in both line and shape. Circular forms in various extensions and approximations dominate Wieland's painting for the next couple of years, reflecting the female sense of form.[17] But the shapes also speak of the influence of Miró and his predilection for the erotically oriented ambiguities of biomorphic shapes and meandering lines. "I made a very conscious decision," Wieland explains, "to go really into one person's work I liked, to think about it and look at it again and again; and not to be influenced by the group around me, and so find my own way. It helped me sustain myself."[18] To study Miró's work Wieland used the catalogue of his 1959 exhibition at New York's Museum of Modern Art. Only with this foreknowledge can the viewer perceive in *Redgasm* analogies with Miró—in forms, in their orchestration across the surface, in their erotic connotations, even in line. Wieland's work stands clearly on its own, the influence intuitively assimilated. Also, the colour is quite different; it is sombre.

Line in *Redgasm* is lucid, descriptive and independent of colour/form. It outlines penis and testicles, vagina and arrow, and languidly shadows, emphasizes and makes buoyant biomorphic shapes. Wieland's infectious humour surfaces in the graffiti-like drawing thumbing its nose at the Establishment. As white chalk on a dark background, the line also simulates Wieland's childhood memory of white chalk on a blackboard.[19]

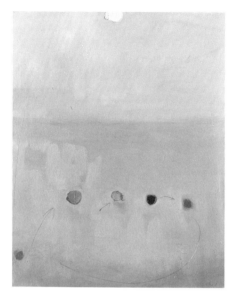

FIGURE 4
Summer Days and Nights *1960*
Oil on canvas
102.0 × 81.5 cm
*Courtesy The Isaacs Gallery,
Toronto*

II

The paintings of 1960, 1961 and 1962 fall roughly into three groupings. A few rather lyrical and lean works of 1960 include *The Kiss, Northern Lights* and *Summer Days and Nights,* which were executed largely in the Quebec countryside. Others are akin in sensibility to *Redgasm,* dark, brooding and urban. Still others are simplified stain paintings (1961-62). Those in the first group are spare in form and colour. Detail resides in incidental effects of paint handling and faint directional arrows, drawn and incised. *Northern Lights* and *Summer Days and Nights* (FIGURE 4) are abstracted landscapes, structured by horizon lines and rounded colour notes that float in airy space. *The Kiss* (PLATE 3) is concentrated feyly on a small central area where the image emerges in three loaded brushstrokes, two impastoed horizontals crossed and kissed on the left by an abbreviated vertical.

A collage-like aesthetic is operative in the paintings grouped with *Redgasm*—among them *Wall*, *War Memories*, *Cityscape*, *Notice Board* and *Laura Secord Saves Upper Canada*.[20] Disparate materials and images are combined—chalk, pencil, paper, cloth, mirror, plastic tape, an envelope scrap (addressed to "Dr. Levitt")—as well as arrows, letters, numbers, penis, flag and plane. Line may not wander as freely as in *Redgasm,* but it retains a childlike, hand-drawn independence. The letters and numbers have no symbolic value; rather they represent an instinctive response to shape.[21] Arrows were familiar from the work of Miró and Paul Klee. But Wieland's—chalk-like or scratched—resemble graffiti, become characters or multiply, as in *Wall*; or they may subversively contradict themselves, as in *Laura Secord Saves Upper Canada*. Pri-

PLATE 3
The Kiss *1960*
Oil on canvas
81.5 × 63.5 cm
Collection of Mr. and Mrs. George
H. Montague, Toronto

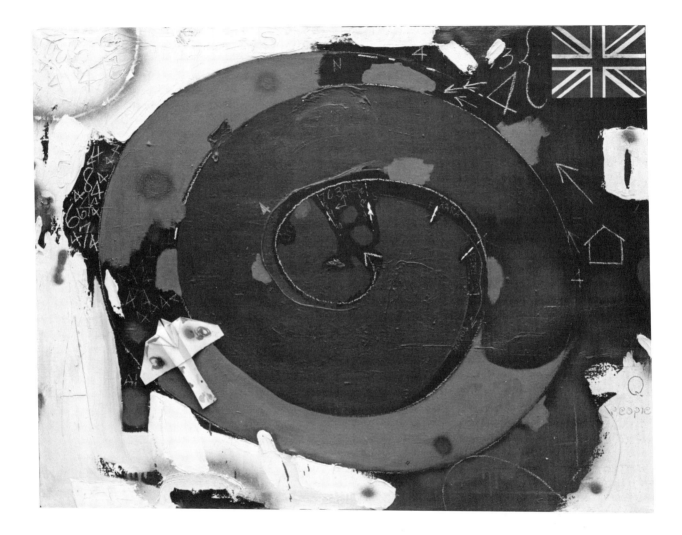

PLATE 4
Laura Secord Saves Upper Canada
1961
Oil and collage on canvas
101.6 × 132.1 cm
Collection of the Canada Council
Art Bank/Collection de la Banque
d'oeuvres d'art du Conseil des arts
du Canada, Ottawa

marily, they reflect and direct movement, animating the surrounding area. A moving spiral activates *Laura Secord Saves Upper Canada,* while in *Time Machine* the cycle of ovulation continuously circles the womb.

Laura Secord Saves Upper Canada (PLATE 4) is an amazing amalgam of images, among them a folded-paper plane, simple and slight but replete with childhood memories; and the Union Jack bracketed to the number ''3,'' indicating, as in a lesson, the composite nature of the flag. It is also the first manifestation of Canada as a subject. *Time Machine* (PLATE 31) can be related in form to the central imagery of William Ronald and, in its cynical title, to Dada's machine eroticism. But both references are incidental to the strength of the work's magnetic presence. *Wall, Notice Board, Accident* and *Cityscape* specifically reflect incidents of the urban environment, bits of everyday life. In *Wall* (FIGURE 5) and other related paintings, the apparent depth of layered colour opposes surface emphasis of drawing, drips, ridges and odd materials; the tensive pull between the two is played against other tensions—among differing scales and degrees of legibility, for example—and other movements, circular or directional. Later motifs or themes appear rather tentatively—the child-sized penis and sketchy vagina in *Redgasm* (PLATE 32), a small shrouded heart in *Wall,* enlarged the next year in *Notice Board* (PLATE 33) to directly confront the viewer above an equally enlarged penis. A grid, barely discernible in *War Memories* (PLATE 5), takes shape in *Notice Board*; a pair of lips subtly dominates *The Kiss;* and *Northern Lights* speaks of the appeal of the ''true north'' and hints at northern mysticism.

With repeated circles, collaged material (cloth) and chalk-like line running punningly along the bottom edge, *Hallucination,* a

FIGURE 5
Wall *1960*
Oil and collage on canvas
213.4 × 152.4 cm
Collection of M.S. Yolles and
Partners Ltd., Toronto

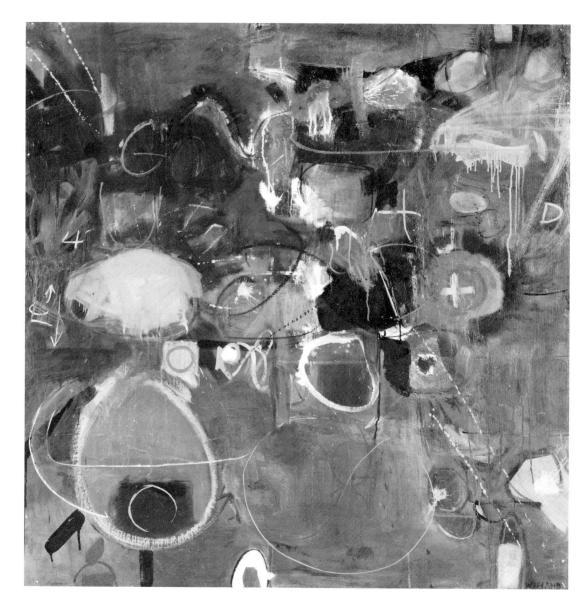

PLATE 5
War Memories *1960*
Oil on canvas
122.3 × 122.3 cm
Collection of Ms. Betty Ferguson,
Puslinch, Ontario

major painting of 1961, relates to the preceding works; at the same time it differs significantly from them. The expanded scale and openness of organization align the piece with two large stain paintings of the same year. Graduated sizing of the disks from medium-small to very small and a pixilated quality are, on the other hand, Miróesque. Tiny balls dance or group with bigger ones; the spaces between are alive with potential movement.

Hallucination's largely pink and green coloration is somewhat similar to that of *Balling* (PLATE 6), the big stain painting that actually preceded it. These two and *Time Machine Series* (PLATE 34) are the only large works Wieland produced until the quilts of the late sixties. She was then using as a studio the "beautiful, old coach house" of George and Donna Montague. "I got into the big work because I had a big space," Wieland remembers. "And I did a lot of things to do with imprinting myself "—one (now lost), a different kind of action painting, a record of movement, of walking, skipping, dancing past a canvas with a brush in her hand. Only a couple of small, red-ink studies for the scheme remain. Rapid sketches of image or structure generally precede paintings. Some are developed into finished drawings; some, like those for the stain paintings, are mere jottings.

Balling and *Time Machine Series* are also self-impresses. "I didn't know what those things were when I made them," Wieland comments. She talks of the importance of subconscious material and adds, "I had this deep necessity to make them." She now recognizes the content as "sex poetry" and "an imprint of my state: my infertility."[22] The huge amoeba-like shapes are hermaphroditic, open to interpretation as womb and penis. Recently Wieland commented on Miró's painting *Amour* (FIGURE 6), illustrated in black and white in

FIGURE 6
Joan Miró
Amour *1926*
Oil on canvas
144.8 × 114.3 cm
Collection of Wallraf-Richartz
Museum, Cologne
© *1986/Vis-Art*

32

PLATE 6
Balling *1961*
Oil on canvas
182.8 × 234.3 cm
The National Gallery of Canada,
Ottawa

the Museum of Modern Art catalogue: "It looks like a womb. Yes, that must have really impressed me." A large centralized white form, veiled by a streaky wash, so fills the composition that its bottom edge is cut off by the frame. A likeness to *Balling* is apparent, when the latter is read in female body terms. But one further notes in *Balling* the empty egg-shaped hole in the centre; the outer line, uneven in agitated motion; the spermatoid splashes of paint; and the pink blobs, arrow-directed to circle the image like the ovulatory and menstrual cycle of *Time Machine*.[23]

Lauren Rabinovitz offers an alternative perspective on the work:

> as a slang term for sexual intercourse, the title also refers to the painting as a representation of an orgasmic phallus viewed in extreme close-up. Wieland's unique representation of the penis portrays it in erotic terms traditionally associated with female sexuality—delicacy, sensuality, gentle activity.... Because the point of view lacks any sense of depth, it portrays a phallus without representing or alluding to phallic proportions. Slyly mocking the traditional pornographic and commercial presentation of the penis as a powerful weapon, the flat emphasis allows from a woman's point of view the erotic celebration of heterosexual intercourse.[24]

Time Machine Series can likewise be viewed in terms of female and male genitals or even as a more primitive, cellular growth seen under a microscope. The title, of course, refers to the earlier *Time Machine* (PLATE 31) painting, and thus favours an explanation by way of the female body and its cycles and of machine eroticism. But both

stain paintings express subconscious material, whereas later readings "benefit" from current, developed viewpoints. Sandra Paikowsky, placing the works in the context of Canadian art, has said that "these paintings represented the purest female imagery painted in Canada to that time."[25] They are more than expressions of sexual imagery and/or energy; they are also affirmations of identity and of the creative instinct. The circle or sphere has been explained as a symbol of the self, as expressing the totality of the psyche in all its aspects, including the relationship between woman/man and the whole of nature, as representing the self transposed to a cosmic plane.

Balling is characterized by looseness of paint handling and a centralized, balanced composition—the pink disk on the right is counterpoised by the hole's off-centre placement and by the smaller, paler, higher circle to the left. Structural simplicity gives play to the flecks, splatters, washes and drips of paint, which are as much the vocabulary of the work as the forms. Although *Time Machine Series* is only slightly larger than *Balling,* it achieves a sense both of magnified scale and of space. Largely because of the placement of the image (centred closer to the left, at one third the width) and of its smaller size (relative to the image in *Balling*), it (the image) exists, floating, slowly swirling, in a blue field. The intensity of hue compensates for the image's smaller size to retain the sense of scale. Movement is more complex than in *Balling*: the mass rotates counter-clockwise; globules (spermatoid?), adhering to the perimeter, bend away from the thrust of the motion; interior circles follow their own irregular cycle. Contiguous hues of red, orange and yellow combine in the projection of colour scale and both intensify and are intensified by adjacent complementaries—

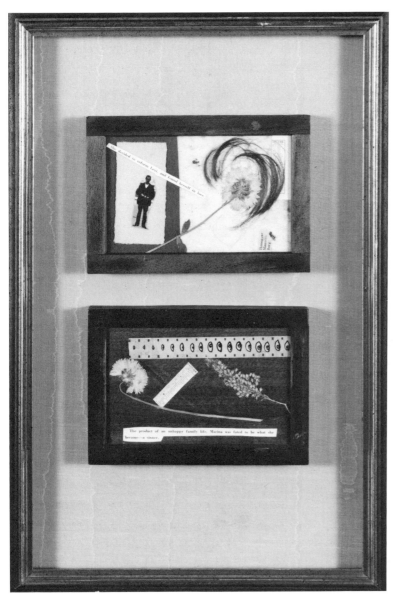

PLATE 7
Untitled *1955*
Collage
9.0 × 15.0 cm each
Collection of Mr. and Mrs. George
H. Montague, Toronto

the deeply recessive green core, the spreading blue and the vibrations between these. Saturation gives way to thin washes, transparent veils. The painting breathes. It speaks with directness, vitality and authority.

Aspects of the stain paintings—lyricism, layering of colours, newly important edges of shape or wash, roughed and bleeding or clearly defined—appear in Wieland's *Summer Blues* series. She produced this group of some twenty to thirty collages in the Montague coach house, using as supports such ready-to-hand materials as flattened cardboard boxes and the backs of placards presenting alcohol-drinking statistics. Collage was not a new medium for Wieland. Two works dating from 1955 (now framed together) show her working on a minute scale. One includes a pressed flower, a bit of a French calendar (''*Janvier*''), a thin strip of film animated with painted eyes, graduated in size, and a legend, clipped from a movie ad layout, that reads, ''The product of an unhappy family life, Marina was fated to be what she became—a sinner.''[26] As a tongue-in-cheek narrative, it is Dadaist in spirit; as a collection of personal mementoes, it has a quiet Victorian aura—showing two sides of a very complex person.

The *Summer Blues* series may be among Wieland's more abstract work, but subtitles support appreciation of the moods evoked—*Walking* (FIGURE 7), *In the Water, Rain, The Island* (FIGURE 8). The colours tend to be limited in number and light in value, except in a few—such as *Summer Blues* and the witty *Goodbye to the Hatracks* (PLATE 8), one of the series, although differently titled—which are dark and dense, with dramatic juxtapositions.[27] Many are structured by an underlying rectilinearity despite numerous diagonal and curvilinear elements. Because of the modest scale of the

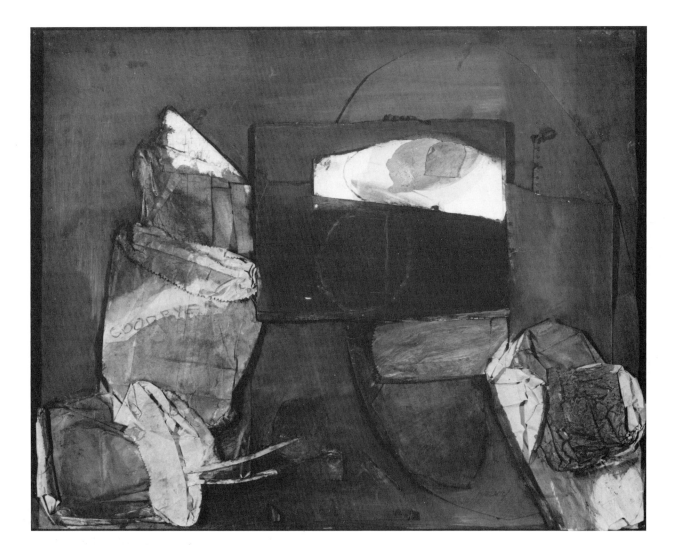

PLATE 8
Goodbye to the Hatracks *1961*
Collage
55.9 × 71.1 cm
Courtesy The Isaacs Gallery,
Toronto

FIGURE 7
Summer Blues—Walking *1961*
Collage
54.7 × 70.0 cm
Collection of Carmen Lamanna,
Toronto

works, rectangular material set parallel or almost parallel to the edges immediately brings those edges into play. The glued-on material is sometimes cut, more often torn—the cut edges provide clean, legible shapes; the torn manifest particularity of profile and a strong sense of the artist's hand. With the protrusion of loose ends and of layered, tubular or crumpled matter, the works become literally three-dimensional.

Summer Blues—Walking turns scrap material and loose paint handling into a *plein-air* scene. The sky is streaked with moving wisps of cloud; the right-hand figure appears to be wafted along by a gentle breeze. Precision of harmonies of spacing, shape and edge suggest careful choices; but the back of a discarded placard was used as support; and backs of old forms, gently torn and overpainted became the figures.[28] Brown paper wrapping—with its strong colour, its heavy textured material and its roughly torn, even somewhat charred edges—provides a foil. Line works as pencil mark both structurally and decoratively; as edge, it is clean, or softly burred, or jagged; as faint wrinkle, it is horizontally oriented and opposes the verticality of the figures. The space is open, the mood whimsical and joyous.

Quite different in flavour are *Summer Blues—Ball* (PLATE 36) and *Summer Blues—The Island*. They have a tougher presence, partly derived from the materials and partly from the rougher, almost careless handling. The first is oil on canvas mounted on masonite. But the canvas has distinct horizontal creases, wrinkled edges and a corner missing; it is itself collaged material as well as ground. *The Island*'s support—flattened cardboard, rectilinearly indented with deep fold marks and taped edges and showing its worn condition in tears and surface scratches—likewise announces its materiality. The

39

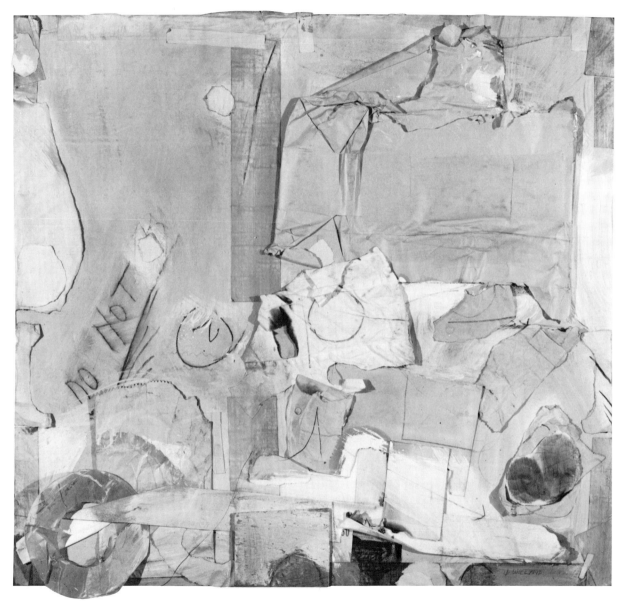

PLATE 9
Summer Blues—Do Not *1961*
Collage
76.0 × 77.5 cm
Courtesy The Isaacs Gallery,
Toronto

circular theme is dominant in both works as positive and negative shapes, drawn in pencil and chalk, incised and expanded into cylindrical form. Colour and rhythm, particular to each, play on the used and discarded, renewing them as a form of "blues."

From working in collage Wieland moved to cloth, treating it according to its physical characteristics and its domestic references. *Clothes of Love* suggests punningly the clichéd Blue Monday, women's wash day. But here the cloths hanging on the wires "to dry" are rags, paint-sloshed and drawn on. Of mixed sizes, colours, weights and textures, they are affectionately arrayed in an inverted storm-window frame. *Érection des coeurs* combines in the French translation the English title *Heart On* (PLATE 35) and its punning reference, "hard-on." The unstretched linen recalls the loose support of *Balling,* and its implication. Hearts of different dimensions and tones appear now as innocent symbols of love, then as fleshy vaginas. However, the red-ink staining, Wieland recollects, "is a really old memory of my taking care of my mother, her haemorrhaging, and blood on the sheet. It occurs all through my work—that red impinging on some white." It could also, she adds, reflect the child's later confusion when first faced with the shock of menstruation. This draped, patched, "stained" work takes women's circumstances as subject matter. And it covers the anxiety of the past with the joyful hearts of the present.

Valentine's Game for Small Circles (FIGURE 9), the title of a red-ink drawing of 1961, plays at confusing a "snakes-and-ladders" pattern with hearts and rings and phallic shapes. Another ink drawing compartmentalizes female body parts, hearts again and machines. Numerous drawings from the "Lovers" series date back at least to 1957. Those of 1961 delight in deftly depicting with a simple

FIGURE 8
Summer Blues—The Island *1961*
Collage
59.1 × 83.2 cm
Courtesy The Isaacs Gallery,
Toronto

41

pencil line (often on a chalk surface) intermingled forms, breasts and buttocks, a penis and, perchance, a broken heart. "They reflect fleetingly the postures of love . . . the subjects leaping, dancing, flying apart, clinging together; the effect is one of whirling rushing eroticism."[29]

Wieland's cartoons sport a very different line—not delicate, sensuous or modulated, but quick, even, almost childlike, describing exaggerated characters, their legs or necks sometimes shortened to fit the space. One of 1960, covering two sheets with sixteen frames, portrays a woman with a bowl of apples and ballooned stream-of-consciousness comments. She begins, "Loving apples, biblical transience of life, immortality, death like lights out, a lot goes on when dark . . ." and concludes in the last frame, "every dog has his day . . . and every cat two afternoons." Another cartoon, of 1961, advertises the Here and Now Gallery, which had mounted Wieland's first solo show. In the final frame an artist, his head in his hands, moans, "Oh, God, art hasn't saved me . . ."; the canvas beside him is a centred mass of scratches.

Rather than the simultaneous verbal and visual narratives of the cartoons, *Josephine's Last Letter to Napoleon,* also of 1961, combines these aspects in a script. It presents writing as drawing—or rather, drawing as writing—suggesting a synthesis of the normally separate areas of reading and looking, and prefiguring their joint identification in the quilts. However the script is largely illegible; it flows in one direction and then another; it is agitated, tight and curled, embellished with a few flourishes, or extended loosely and as unevenly as the spacing between the lines. It is gestural writing echoing through mime the desperate emotions of Josephine in a last letter before she died.[30]

FIGURE 9
Valentine's Game for Small Circles
1961
Ink on paper
20.0 × 25.0 cm
Courtesy The Isaacs Gallery,
Toronto

FIGURE 10
The Lovers *1961*
Graphite and chalk on wove paper
27.6 × 21.4 cm
The National Gallery of Canada,
Ottawa

FIGURE 11
Lovers *1962*
Pencil on paper
18.4 × 26.9 cm
Collection of Mr. and Mrs. George
H. Montague

FIGURE 12
Lovers in the Park *1962*
Pencil on chalk on paper
15.2 × 23.0 cm
Private Collection, Toronto

43

The year 1962 was a rather arid one for Wieland, and in the fall she
and Snow moved to New York City. Wieland explains the move:
"Mike and I were making a lot of trips there. . . . He felt that's where
he should be, and I certainly felt that what was going on there was
incredible—things were really happening. So I went because he
wanted to go . . . I was excited but scared."[31] Wieland titled an early
1963 work *Stranger in Town* (PLATE 37). A greeting, ballooned as in
her cartoons, is both familiar ("howdy") and distancing
("stranger") echoing perhaps Wieland's relationship to her new
environment. Hanging strips of painted cloth bring to mind *Clothes
of Love,* while those with empty speech balloons imply an awkward
silence. But the colour is loosely applied, rich and resonant.

"This is a more romantic painting than some of the others . . .":
Snow's comment overpainted on the 1963 *Numbers* is ballooned
like the greeting in *Stranger in Town,* with no indication of the
speaker's presence. The culminating work of the numbers series,
Number Picture (FIGURE 13) stars the favourites: 8, 4, 2. It is larger
than average and is structured with a loose grid. If it suggests the late
fifties "Numbers" paintings of Jasper Johns, it is as playful comment.
Numbers together with letters had crept unobtrusively into
Wieland's work in 1960 (*Wall, War Memories*), a nostalgic re-
collection of school blackboards. Moreover in *Number Picture* they
serve a different purpose. In the Johns paintings the numbers are
part of a system; the system is the image, and being coexistent with
the paint surface, tends to become object-like. On the other hand, in
Wieland's painting the numbers are individualized, and an interior
painted frame emphasizes "picture-ness." The work luxuriates in

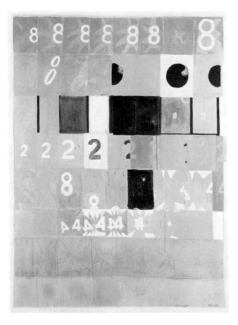

happy colour and playful wit, teasing the viewer's eye as it seeks order or some key to a seemingly irrational system. Only a slight variation in tone or a faint pencil line may mark divisions between grid units. The latter compound the viewer's problem by varying in size — in width, in height and in number — as a quarter unit slides in at the right. Numbers are scratched into the paint, overlaid in the background colour, smudged or reversed, and their separated, elongated parts become segments of some other figure. Progressively the 2s seem to get larger, the 8s to fall out of sight and the 4s to couple, but the steps in the progression are uneven, and the eye must return to check its reading. The shifts in size then seem to situate the numbers at various depths within the picture, declaring them to be objects stranded in space. It is tempting to speculate whether the numbers are carriers of meaning — since 4 is half of 8, 2 is half of 4 and there are 8 units down and 8 across the top. I think they are not, however; rather, 2 acts as the visual intermediary between 8 and 4. Numbers imply counting, and counting involves time. Here time is consumed visually as the eye travels back and forth, up and down and around. Numbers are a way of ordering, are limited and artificial; here they have taken on an animate mutability.

The paintings of 1963 are generally small, and structured with grids or film frames. They reflect the new milieu in various ways. Although their imagery is related to Pop Art, their size and paint quality are quite at odds with the coolness and scale of Pop. Wieland recollects: "I was terrified of the art scene, and something in me resisted becoming part of it. I didn't know what I wanted, but I kept doing what I felt I had to do and needed to do. I just took what I could from it [the art scene] without losing sight of something in myself — something that would never be developed if I were to become part of a movement."

The early works of 1963 are about the neighbourhood, downtown New York and the people. Wieland and Snow had found a loft in an "ancient" building at 191 Greenwich Street, near the Battery, Fulton Fish Market and Sherman's, the health-food store, "a hotbed of ecology, food and people." Ships on the Hudson River were visible, and the area's shops and bars were patronized by sailors and others coming off boats. And, nearby, Wieland discovered the South Street Seaport Museum and its wealth of material—ship models, artifacts, photographs and such. "It was all very new to me," Wieland remembers, "and I absorbed it through the paintings." *New Yak City* (FIGURE 14) relates in concept and form to the cartoons, acknowledging Pop Art's legitimating of such a style in painting. Characterization is cartoon-like but is conveyed only through heads and hands; line has a simple bluntness; speech balloons proliferate, although they are often left empty; hands assume the speaking role with comically animated gestures. Little hearts appear, taking the sting out of the caricatures. *The Battery*, a rich, finely tuned composition of related, should-be-related and unrelated images, includes at the bottom a horizontal film strip of three frames (echoing the structure), animated by a "moving" car. Cross-references occur through similarities—of scale as much as of image, colour or shape. Foreground and background directly interact (without middle ground) in a way that characterizes her films.

In *Fine Foods* (PLATE 10), the TV screen becomes a structuring device as well as an advertising vehicle. Set one above the other, four units associate food, love and boating. A sense of animation is provided by a sailboat slipping by in the background and personal words of love, in tiny speech balloons, disappearing beside the screen-sized command "EAT." In the final frame, EAT has retreated to counsel the greenness of the distant shore. Colours, sharp and

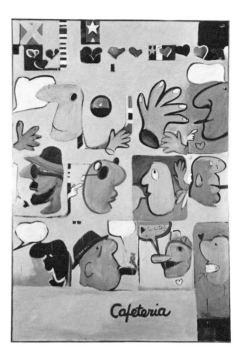

FIGURE 14
New Yak City *1963*
Oil on canvas
132.1 × 91.4 cm
Collection of Hincks Treatment Centre, Toronto

46

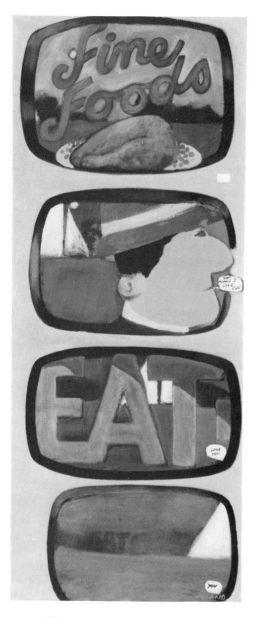

PLATE 10
Fine Foods *1963*
Oil on canvas
86.5 × 35.5 cm
Collection of Carmen Lamanna, Toronto

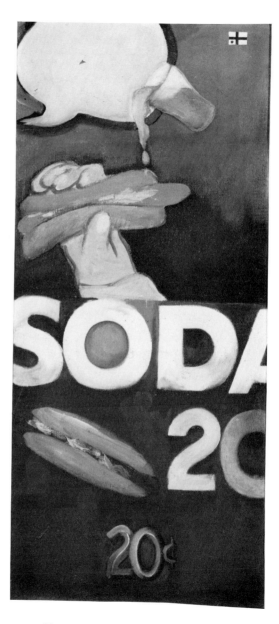

PLATE 11
Sodascape *1964*
Oil on canvas
65.5 × 29.5 cm
Courtesy The Isaacs Gallery, Toronto

aggressive, bawdily shout for attention, while the man, the consumer, contradicts his ballooned sentiments with a blank flat face. Are the images projected by televisions? Or are they reflected by the screens and black frames, which they wilfully overlap? Neither. Words and images, relationships and sequences merely play at logic.

Murder in 1921 wryly caricatures a public preference for violence and melodrama. In the penultimate frame the man declares, "Ah! There he is . . . And now he dies . . ."[32] The characterizations relate to those in *New Yak City* and remind one that the 1963 works are peopled with men and their body parts. A sly association surfaces between phallic and sociopolitical power. Wieland was aware of trying to hold on to her identity as a person and as a woman in a "machismo" environment. In a similar format to that of *Murder in 1921,* she invests a domestic still life—a milk bottle and two glasses—with nuances of colour and handling and subtleties of placement and spacing. Delicacy covers deadly ingredients in *Strontium 90 Milk Commercial* (FIGURE 15). And then one notices in *Murder in 1921* the fine, insistent way words turn up—on the wall, on the building, on the framework itself.

The First Integrated Film with a Short on Sailing (FIGURE 16) unites not only black and white persons and vertical and horizontal readings, but also a big-screen production with cosmeticized players, a small animated short of a seascape, television screens and cartoon speech balloons. Wieland combines, as Hugo McPherson writes, "mass-media forms in patterns which suggest both the sad-hilarious fragmentation of modern life and the subconscious phallic implications of such familiar things as a hotdog or the human hand."[33] A major source of the developing grid format was the "fascination of doing the drawings, the storyboards for animation."

FIGURE 15
Strontium 90 Milk Commercial *1963*
Oil on canvas
20.3 × 25.1 cm
Collection of Mr. and Mrs. Irving
Grossman, Toronto

48

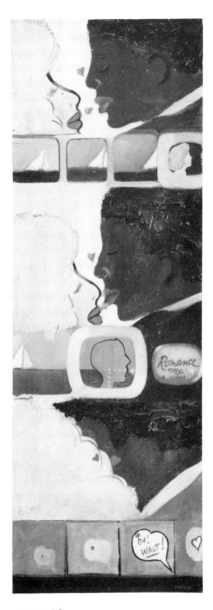

FIGURE 16
The First Integrated Film with a
Short on Sailing *1963*
Oil on canvas
66.0 × 22.7 cm
Private Collection, Toronto

She had been trained at Graphic Films not in full animation aiming at naturalism but in the imaginative, free-wheeling tradition of the National Film Board. She acknowledges the connection between storyboards and comic strips, but indicates that the use of "words superimposed over the frames of the painting . . . also stems from working in animation, working on TV commercials and realizing, in some strange way, the value of words connected with film."[34]

A few works literally appropriate film form by horizontally aligning two, three or four filmstrips; usually one is 8 mm and the others are 16 mm. Often in a narrow central band an abstracted penis reacts to the movements portrayed—and, in *Flicks Pics #4*, (PLATE 14) finally swims upward as the vessel sinks. The title reminds the viewer that movement resides in the quick flick of the eye down the filmstrip frames. Erotic symbolism is suggested by the close association of boat and penis and the analogy of water and the human "fluid body" or unconscious—the mother-imago—although Wieland has denied such an intent. In *West 4th* (PLATE 39) a phallic cigarette becomes a dominant player, serialized lips appear for the first time and the pencilled words "causes cancer" link the painting with the artist's other mischievous comments on health issues (*Strontium 90 Milk Commercial; Solidarity, Art, Organic Foods*) and with the later environmental pieces.[35] Since the late fifties, Wieland had been reading such writers as Adelle Davis and Wanda Phillips, and although she treated her concern with lightness and humour, she would pursue it with her usual obsessiveness.

The influence of various American artists on certain pieces has been suggested: Jim Dine's on the fleshy heart/vaginas in *Heart-Break,* Andy Warhol's on *Penis Wallpaper* (FIGURE 17), or Claes Olden-

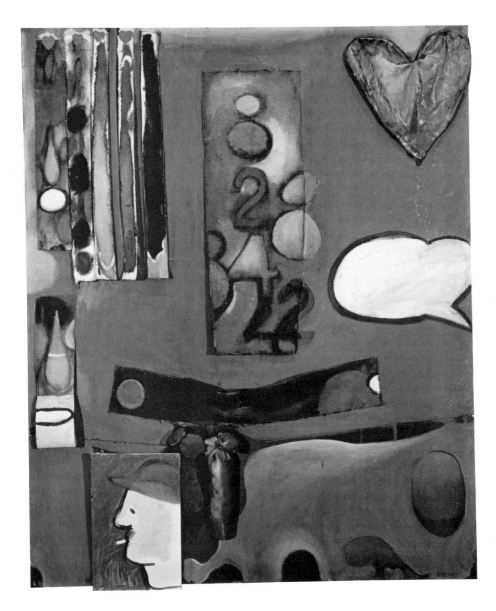

PLATE 12
Necktie *1963*
Collage and oil on canvas
94.0 × 76.2 cm
Private Collection, Montreal

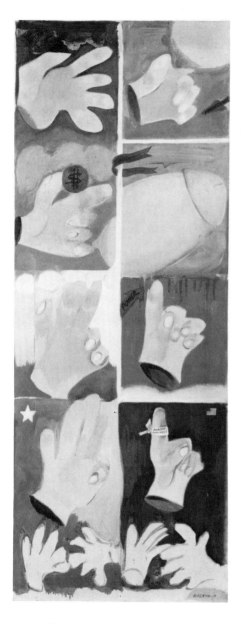

PLATE 13
The New Power *1963*
Oil on canvas
106.4 × 40.6 cm
The Artist

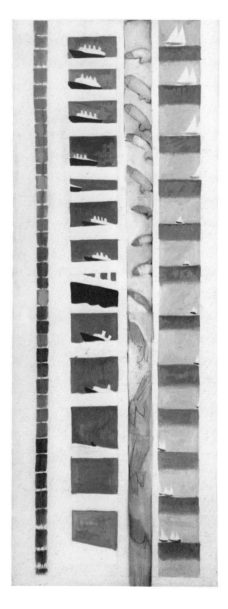

PLATE 14
Flicks Pics #4 *1963*
Oil on canvas
106.7 × 40.6 cm
Collection of Carol and Morton
Rapp, Toronto

burg's on *Nature Mixes* (PLATE 38). However, Dine didn't develop his heart motif until 1966 and Warhol's *Cow Wallpaper* also dates from 1966. Wieland did not see Oldenburg's 1962 Green Gallery show, in which he first exhibited his "soft" sculpture; nor was it represented in the Sidney Janis *New Realists* show, nor in *Americans 1963,* although the latter included the metaphoric *Ray Gun* (newsprint on wire frame).[36] Oldenburg did become a major influence later. Nor locally does *Nature Mixes,* which is an innocent, whimsical transformation (hand into flower into penis), really relate superficially to Dennis Burton's *The Game of Life* (1960), a "response to primitive art" that in its four quarters, develops pictograph-like variations of four erotic organs.[37] Burton's is an inventory; Wieland deals with the theme of movement and change, one involving the other, both demanding time. In the mid-fifties she had made sexually descriptive drawings; by 1960 she was delineating penis and vagina in paintings and using ambiguous shapes with erotic connotations and a tendency to metamorphose in the viewer's eye. Moreover, numerous drawings and watercolours delight in transformative play. *Hands Film* (FIGURE 18) delineates in pencil, gestures, expressions of the hand: clenching, spreading, pointing, signalling and changing, finally, into a penis. *The Man Makes a Full Circle,* a watercolour, gleefully converts a male bust into a bloated face, a female breast and a circle that gradually shrinks to become a speck—a tiny egg? Other works on paper come to mind—*Nose Close-Up, U.S. Flag, Envelope into Face.*

Even more numerous are drawings and watercolours of sailboats, tugboats, liners; some end in tragedy as the vessel suddenly slips below the sea. In *Ship Passes* the units change in size. The sailboat, sitting on the horizon, uses sixteen units to move out of sight; but the

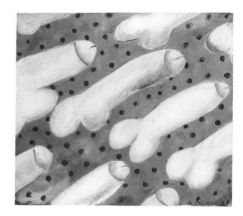

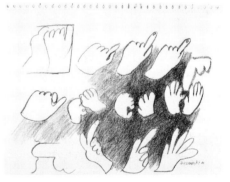

FIGURE 17
Penis Wallpaper *1962*
Oil on canvas
20.5 × 23.0 cm
Private Collection, Toronto

FIGURE 18
Hands Film *1963*
Graphite on wove paper
21.5 × 27.9 cm
The National Gallery of Canada, Ottawa

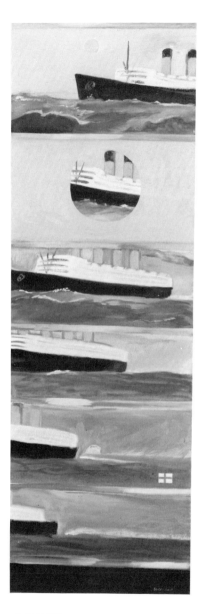

FIGURE 19
Boat (Homage to D.W. Griffith)
1963
Oil on canvas
91.5 × 30.5 cm
Private Collection, Toronto

horizon line has been rising and the water increasing till it pushes like a wave at a narrowed frame.

Paintings develop similar subjects in narrative form, vertically like a filmstrip or horizontally like a film-animation storyboard in a multi-unit grid system. Progressive visual readings are constantly interrupted by zooms or fades or jump cuts or insert shots, cinematic devices that normally do not hamper the narrative but rather dramatize it. Sometimes the iris mask invented by D.W. Griffith is used to concentrate on a circular area for close-up, as in *Boat (Homage to D.W. Griffith)* (FIGURE 19), and later *Sailboat Sinking* (1965; PLATE 43). Sometimes a blank unit announces a skipped frame, exposing both the illusion and the actual materials. *Sailboat Tragedy and Spare Part* (PLATE 1) wittily recognizes the fallibility and the obsolescence of today's material goods. A spare part is provided, but its detailing (boat starting to sink) fits neither the blank unit nor any others except for one (second from left, bottom row). Perhaps the spare part, by forcing the viewer to observe its presence beyond the limits of the frame, wryly notes the concept that purports continuity of the art work with the world.

Wieland was well aware of the prevalence of the grid in much contemporary work, but her use of form grew out of her work in animation. The grid maps the surface of the painting, tending to create pieces of time and space. The grid disrupts the perception of depth, so that the subject is simultaneously in the space within the frame and on the surface beside it. With Wieland these aspects are further complicated: images overlap the frame (as in the very painterly *Sailboat Tragedy No. 1*); speech balloons and other extreme close-ups sit on or near the surface; tonal variations of sky and water,

shifts in scale or angle of object and changes in viewing perspective interrupt continuity.[38] As in her films Wieland makes the viewer aware now of materials and process, the feel of paint and the way it is laid on; now of simple narrative—no—of a single event, maybe just a passing moment. And the framework itself is hand drawn, uneven. The grid unexpectedly provides the possibility of movement; in self-contradictory fashion, it announces its own malleability. Movement is a central concern. The simplicity of the subject and its repeated use emphasize this. "The way things move," Wieland comments, "and are animated, to me are very personal."

The works deal with tragedy in a matter-of-fact way. The boats sink as easily and with as little cause as the hand becomes a flower—one is as much a metamorphosis as the other. But the small ships, like the toys of childhood, leave a sense of loss when they disappear. "Wieland has commented that her preoccupation with disaster was first based on personal paranoia and the difficulty of dealing with notions of death and loss."[39] She no doubt knew Warhol's 1962 paintings of disasters, while at the same time she was responding to the Seaport Museum's photographs and documents with such a painting as *The Ill-fated Crew of July 6, 1937* (FIGURE 20). In a 1964 interview Wieland elaborated on the effect of the New York milieu: "Part of the power here is the tradition of sensationalism and vulgarity. I've been here two years, and still I haven't taken all of the force in There is the American fascination with disaster and grotesque happenings, in the newspapers and on TV, for instance, and it has come out in the work I've been doing."[40] In her 1961 essay on de Kooning's *February,* Wieland wrote of "the kind of energy which radiates from events, such as great battles, or death on a winter highway"—as presaged in her 1960 painting *Accident.*[41]

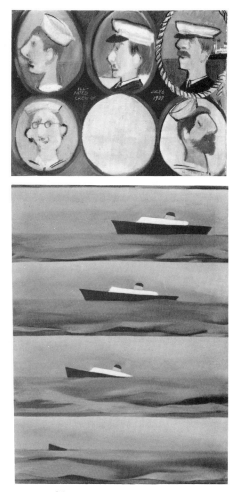

FIGURE 20
The Ill-fated Crew of July 6, 1937
1963
Oil on canvas
14.8 × 20.0 cm
Courtesy The Isaacs Gallery, Toronto

FIGURE 21
Sinking Liner *1963*
Oil on canvas
81.3 × 61.3 cm
The University of Lethbridge Art Collections, Lethbridge

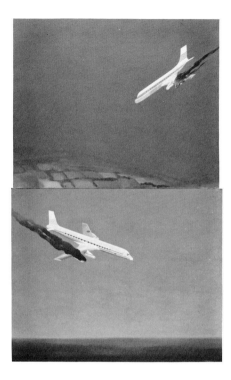

And in 1965 she added, "You know, I'm a happy person, but at the same time I'm fascinated by disasters. Here one minute, gone the next. I save pictures of disasters."[42] She associates "disaster and being taken by surprise, by horrible fate, when all is lost," and she singles out the assassination of John Kennedy as affecting this vision. An ink drawing of 1964, (*Assassination Film #4*) *Flag into Head,* is one of several ink drawings showing a head going through various transformations to become finally the U.S. flag. A watercolour *Death from Chocolate Cake*, on the other hand, playfully satirizes disaster and health-food themes.

There is no hint in the ship paintings of the nineteenth-century theme of the storm-tossed boat; rather the sinkings occur with a calmness that can itself be chilling. However, Wieland's plane disasters portray a grimmer event. They are less whimsical, more explicit. The cause depicted is fire; the result, shown or implied, is a visible crash. These disasters are not sudden, mysterious disappearances; they carry no sense of metamorphosis. In *Tragedy in the Air or Plane Crash* (PLATE 40) the plane catches fire, twists out of control, plummets to earth and becomes smouldering rubble. The sequence can be followed despite changes in viewpoint and variations in cloud and sky effects. Indeed these alterations animate the progression almost as much as the plane does. Yet a sense of calmness persists in the tall panel of sun-filled sky and the row of tiny flowers. *Double Crash* (1966; FIGURE 22) has both a strange remoteness and a more sinister aspect. Reduced to two greatly enlarged panels, it pits two planes not just against fire but illusively against each other and the quiet vastness of space.

FIGURE 22
Double Crash *1966*
Oil on canvas
201.5 × 127.7 cm
The Robert McLaughlin Gallery,
Oshawa

IV

In 1964 Wieland produced a number of three-dimensional assemblages related to the "filmic" paintings. A few suggest animation; but the majority are idea boxes reflecting a neighbourhood, a theme or a memory. The outlook is more candidly, determinedly female: the faces depicted are those of women; the recurring colours are strong, blatant pinks and blues; domestic knick-knacks appear, and meaty heart/vaginas proliferate. Wieland describes *Water Sark,* her film of 1964-65, as "a kind of desperate self-portrait."[43] Jack Smith's *Flaming Creatures,* which she had seen earlier, in late 1963 or by June of the next year (when it was judged obscene by the New York Criminal Court) had made a strong impression on her. "This guy was making very personal, very painful statements about his private life. After that I could express anything I wanted to express. I felt totally free."[44]

For the framework of the assemblages Wieland used discarded wooden boxes found outside shops, or crates from the harbour area, many stamped with the directive "Cooling Room." From job lots on the streets she collected toys, plastic flowers, bits of cloth and so forth. Sets of boxes varying in height and depth, but more or less of the same width, became *Cooling Room I* and *II* (PLATES 15, 42). In the first, plastic tugboats chug across two rows of paired boxes, while below are a damaged and charred tin plane up-ended against open sky, a half-door hinged to cover an area twice its size and a multitude of largely hidden "secret" things—for example, a chocolate ice cream cone and some narrow red tubing shaped and tied like an inverted heart. The rigidity of the boxes is a foil for the irrational, useless doors, impulsively concealed "treasures." In some, such as

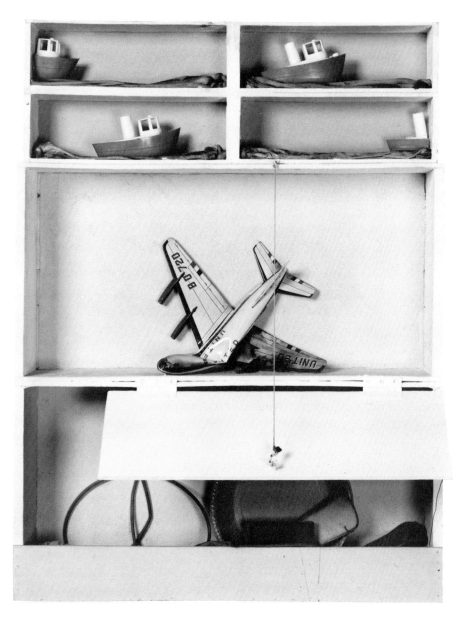

PLATE 15
Cooling Room I *1964*
Mixed media construction
73.7 × 58.9 × 27.9 cm
Private Collection, Toronto

the ghostly *Passengers* (FIGURE 25), keepsakes have been sewn into stuffed and gessoed cotton hearts. Like a tactile icon, a large red heart, wet with plastic and hung on a line to dry, dominates *Cooling Room II.* The shape and colour of the red clothes-pins are repeated in the engines of a crashed plane. Double smoke-stacks of a red plastic ship reflect the twin humps of the heart and leave between their forms an opening for the Cunard liner's single phallic stack. Below, four coffee cups have accumulated ("I drink a lot of coffee and I may be surrounded by eighteen dirty cups"). They acquire animation as the viewer's eye follows the accretion of lipstick and then returns to the first, untouched cup, which has a spoon in it and three sugar lumps beside it. Types of realities—of an object, a photographic reproduction, a manufactured toy simulation, a hand-crafted symbol—vie with one another. The impress of lipstick implies a bodily act; it will be repeated later in the *O Canada* lithograph.

Other works are ecological (*Do Not Use DDT*), feminist (*Young Woman's Blues;* PLATE 41), personal (*Dad's Dead;* FIGURE 23). *Young Woman's Blues* bawdily pits phallic plane against vagina-heart, aggressive form against penetrable space, open site with constricting enclosure, above with below. On the other hand, *Sanctu Spiritus* (FIGURE 24) alludes to the Hispanic neighbourhood "uptown, on the West Side. Going along one street where our friends the Haynes lived, you could see in the windows wonderful colours . . . and the kind of light bulb I put in . . . I think I saw the words [of the title] on a little shrine in a church supplies store-front." The feathery plastic flowers, the frilly doily, the delicate golden frames on the photogenic "all-American" girl with a diadem on her head, a doll's bed, a ceramic cat—all convey sympathetically an

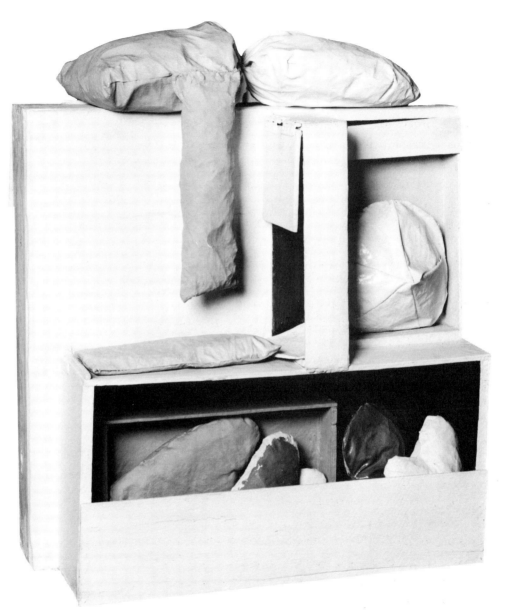

FIGURE 23
Dad's Dead *1965*
Mixed media construction
70.5 × 56.1 × 24.8 cm
Courtesy The Isaacs Gallery,
Toronto

FIGURE 24
Sanctu Spiritus
Mixed media construction
59.2 × 22.5 × 22.0 cm
Courtesy The Isaacs Gallery,
Toronto

FIGURE 25
Passengers *1965*
Mixed media construction
66.7 × 22.5 × 11.5 cm
Courtesy The Isaacs Gallery,
Toronto

intimate interior of fine detailing and simulated effects. The framed photograph comes in two sizes, price-tagged at twenty-nine and thirty-nine cents, and simultaneously comments on general (male) "appreciation" of the housewife's role and enshrines that role.

Wieland waxes enthusiastic about Claes Oldenburg's work. "He was one of the most important artists in my life. . . . The idea ['soft' sculpture] was so inspiring. And I had to relate that in my own terms, to make something about my life." Oldenburg's large-scale "soft" sculptures possess an inherent quality of metamorphosis and erotic ambiguity and are also the product of so-called women's crafts, sewing and padding of distinct shapes. His forms had qualities that already informed Wieland's work, and her use of stuffing in the 1964-65 assemblages and the plastic hangings of 1966-67 reflected not only Oldenburg's influence but also her own move into three dimensions. Moreover, the themes and the character of Wieland's art remain distinctly her own. "It is never neat," Harry Malcolmson wrote in 1967, "and the lines and shapes are usually askew. It has a lovable, spilled cosmetic sloppiness to it."[45] He continues: "She came to use plastic, she says, partly because plastic sheet is rather like the film strip . . . porous to light and also a reflective surface. Not only does it have this visual vitality, but it has a marvelous sheen and sensual feel." As Wieland also explains, "plastic was so available; it was all around and it was in the air. I liked the material; I laminated it, I sewed it, I treated it like a traditional fabric. I started the idea of putting, of pocketing, of enclosing stuff in it."

The plastic hangings have, as well, a "filmic" format. They present a vertical succession of images as in a filmstrip, although a sequential flow is not easily discerned. Several refer to films—

Stuffed Movie (FIGURE 29), *Larry's Recent Behaviour* (her own film of 1964; FIGURE 26), *D.W. Griffith and His Cameraman, Billy Bitzer* (FIGURE 27), *War and Peace, 8 mm Home Movie* (FIGURE 31). Others become totems, vertically aligning images that have been grouped ritualistically to make a family—"things that had to do with living in a loft . . . works in progress, works in the future, works from the past and people." Others are a type of "portrait clothing," a concept Wieland had toyed with since working at Toronto Workshop Productions on costumes—"costumes that had to do with the essence of that person or that character." An early plastic piece and the first quilt were made for and about children. *The Space of the Lama* (FIGURE 33), for Munro Ferguson, has his delicate face haloed on an orange field and below, in succeeding squares, objects of his world. The *Michael Montague Quilt* (FIGURE 36) is a covering for the child's cot, with a sailboat, an arrow, hearts, numbers and a pair of red lips "collaged" on it.[46] This latter is a travelling art work, "in the spirit of Duchamp," that can be folded up and carried away.

Some plastic hangings, such as *Home Art Totem* (FIGURE 28), resemble a Victorian string of small frames, all of different shapes and colours, that combine quilted and plain, opaque, transparent and tinted plastics. The stuffed frames hold photographs, often of quilt details. The stitching is as casual (Wieland used an industrial sewing machine) as the paint application in the "filmic" paintings. Some—*War and Peace, 8 mm Home Movie,* for example—resemble a narrow filmstrip with lively introduction and ample conclusion. However, the sequence from frame to frame more easily follows an abstract route of pattern and colour than a narrative line. Other hangings introduce political comments. So, with a nod to Pop Art, luscious red lips spew out a section of the U.S. flag, torn and

62

FIGURE 27
D.W. Griffith and His Cameraman,
Billy Bitzer *1966*
Mixed media
50.5 × 33.0 cm
*Courtesy The Isaacs Gallery,
Toronto*

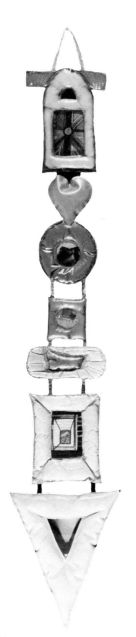

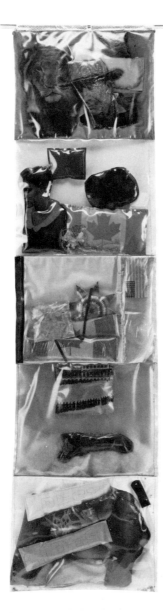

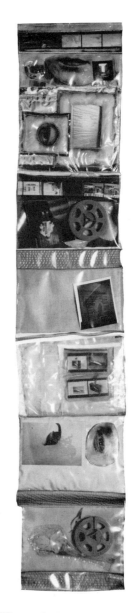

FIGURE 28
Home Art Totem *1966*
Mixed media
117.0 × 23.0 cm
Collection of Edie and Morden
Yolles, Toronto

FIGURE 29
Stuffed Movie *1966*
Mixed media
142.2 × 36.8 cm
Vancouver Art Gallery, Vancouver

FIGURE 30
Home Movie *1966*
Mixed media
104.6 × 20.0 cm
Collection of Geraldine Sherman
and Robert Fulford, Toronto

FIGURE 31
War and Peace, 8 mm Home Movie
1966
Mixed media
76.0 × 10.5 cm
Courtesy The Isaacs Gallery,
Toronto

FIGURE 32
Home Work *1966*
Mixed media
106.0 × 24.0 cm
Courtesy The Isaacs Gallery,
Toronto

FIGURE 33
The Space of the Lama *1966*
Mixed media
124.5 × 40.5 cm
Collection of Ms. Betty Ferguson,
Puslinch, Ontario

stained red by the wounds of others. Titled *Betsy Ross, look what they've done to the flag that you made with such care* (PLATE 16), the work combines a sensuousness of material and shape, an ambiguous suggestiveness of image and the wit both of a literal Band-Aid, ineffectually sized and placed, and of a "hidden" meaning (literally hidden, on the back)—a text for the photograph, lurking in the wound. A more direct condemnation resides in the seemingly simple and amusing piece called *N.U.C.* (PLATE 17). On a puffy circle, ironically the green of the countryside and the shape of a badge, is collaged a transparent pink plastic dollar sign containing a newspaper picture—a rose-coloured view of soldiers photographed in a devastated land. Suspended from this is a plastic heart, proudly sporting the stars of the flag. It opens to reveal the stripes and, in pockets, neatly folded newspaper clippings; one reports the U.S. budget and program for killing crops in Vietnam; the other tells of the trial of a Marine for premeditated murder and mutilation.

By comparison, *Patriotism* (PLATE 46) is as warm and cuddly as a child's doll and, like the child at school, wholeheartedly salutes the flag. It is anthropomorphic in shape and, reading down, includes: the Union Jack, tinted a "distancing" blue; a clearly legible detail of *Confedspread* (PLATE 47); the Canadian flag as the two arms, one playfully inverted; stills from her film *Patriotism, Part I;* details of lips; and, at the feet, a deeply blued U.S. flag. All combine to represent an expatriate's unquestioning yearning and open declaration of "love" for Canada, a theme that would be fully expressed in Wieland's 1971 exhibition.

And there is the wonderfully slapstick *Don't Mess with Bill* (FIGURE 34). From a slick red penis/arrow—Cupid's?—hangs a magnifying glass, a warning to a friend.[47] The plastic hangings culminate in

FIGURE 34
Don't Mess with Bill *1966*
Mixed media
9.0 × 29.0 cm
Courtesy The Isaacs Gallery,
Toronto

PLATE 16
Betsy Ross, look what they've done
to the flag you made with such care
1966
Mixed media
56.0 × 34.3 cm
Collection of Edie and Morden
Yolles, Toronto

PLATE 17
N.U.C. *1966*
Mixed media
63.0 × 28.0 cm
Courtesy The Isaacs Gallery,
Toronto

two rich mosaics of colour, *Puerco de Navidad* (FIGURE 35) and *Confedspread.* The first captures again Wieland's impression of the Hispanic community—but not as in *Sanctu Spiritus,* which was evocative of the delicacy or intricacy of, say, fine needlework. Here she celebrates the love of strong colour, psychedelic pinks and oranges, fuchsia and yellow, and the flavour of the neighbourhood stores conveyed by price tags, labels, little things displayed in pouches. *Confedspread,* with its different-sized Canadian flags and variously coloured maple leaves, is both a pattern of rich effects—of texture, colour, degree of transparency and three-dimensionality— and an analogue of Canada—its lakes and green belts, prairies and snow.

While Wieland was working on the *Michael Montague Quilt,* she started designing others. Her sister, Joan Stewart, was a quiltmaker. "She needed work. She didn't have any money, and I liked what she was doing. . . . I cut things out, basted the quilt, and my sister completed it."[48] Wieland wanted to make art accessible to everyone and, at the same time, invest it with many levels of meaning. "At that time," she recalls, "I thought they [the quilts] should be used for special occasions like birthdays, anniversaries, that they should have some celebratory use . . . on the first day of spring or for the first snowfall." Wieland never considered or was concerned if others thought that the techniques—cutting and basting, sewing and quilting—which are traditionally associated with crafts and denigrated as "women's work," or the possible practical uses of the quilts placed the objects outside "art." Rather she incorporated materials, techniques and associations into her subject matter. Later she would write, "Getting into the making of quilts as a woman's work was a

FIGURE 35
Puerco de Navidad *1967*
Mixed media
104.0 × 68.0 cm
Courtesy The Isaacs Gallery,
Toronto

68

conscious move on my part. . . . There was a highly competitive scene with men artists going on there [in New York]. It polarized my view of life; it made me go right into the whole feminine thing."[49]

In January 1967 Wieland was describing the pieces both as quilts and as collages. She recognized that they related not so much to the plastic hangings as to works like *Summer Blues* and *Heart On.* The *Square Mandala* (FIGURE 37) recalls the 1961 painting *Hallucination* in its appliquéd and quilted circular motifs. However, the forms cluster inside one another instead of around larger ones. The composition, although denser than that of *Hallucination,* emphasizes a somewhat similar central concentration and open spacing with small clusters of interest toward the edges. According to Wieland, the quilt is based on the Union Jack and is a take-off on the accumulation of crosses. "And it's the flag as a mandala, especially the British flag." A strangely hypnotic quality holds the viewer in contemplation: various geometric forms, circular centring motifs and delicate and strong colours vie for close attention. Two other early quilts pay homage to film and are also based on a central image. *The Camera's Eyes* (PLATE 44) radiates colour almost as intensely as film does and wittily offers double or triple readings. *Film Mandala* (PLATE 45) is quiet—stable but illusive. Quilted into its central red square is the shape of a narrow, 8 mm reel. Vertical quilting seems to negate slight shape changes; colour advances and recedes.

Just as strong feminist currents were developing in Wieland's work of the sixties, so too were nationalistic and ecological ones. Certainly Wieland's and Snow's loft on Chambers Street made environmental questions hard to avoid. Polluted water—"We used bottled water for tea"; polluted air—"past the danger point"; and electricity that didn't work were constant reminders. References to

FIGURE 36
Michael Montague Quilt *1966*
Quilted cloth
121.5 × 88.0 cm
Collection of Michael Montague,
Toronto

some issues had occurred in work of 1963 and 1964: *Strontium 90 Milk Commercial* and *Do Not Use DDT,* for example. A 1967 cartoon, *The Life and Death of the American City,* is "dedicated to Jane Jacobs, Adelle Davis, Rachel Carson." The cartoon, which was the source for graffiti-like drawings on a wooden fence in the Art Gallery of Ontario exhibition *This City Now,* depicts, among other startling situations, a couple trying to picnic beside waste pipes and under billowing smoke from the "Sunshine Chemicals Company." "Eat your sandwich before it gets dirty," the woman admonishes the man. The cartoon also presents proposals for "The Air Pollution Mask," including a plastic "nose baggy"; and combines the sign "Welcome to Lake Walden," a bird plummeting to earth ("The last bird"), a rabbit flat on its back ("Side Effect, Death"), and a "text," attributed to a well-known U.S. congressman, Henry R. Reuss of Wisconsin, that ends: "By all the logic of oceanography, there could not be an iceberg there and, sure enough, there was not. The iceberg was a mountain of detergent foam, floating serenely along the water." *Canadian Forum* later published (December 1968) a section of the cartoon beside an article titled "The Great Stinking Sea."

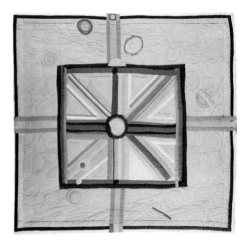

FIGURE 37
Square Mandala *1966*
Quilted cloth
179.0 × 173.0 cm
Private Collection, Toronto

V

Wieland often returned to Toronto, where she exhibited her work at the Isaacs Gallery in solo shows (1963 and 1967) and in regular gallery artists' groupings. In New York she showed her films, but not her paintings. "Because of the kind of creativity that was involved and the circumstances in which they [the film underground] lived, it was a community that mostly did not feel a sense of competition but more an appreciation for the art blooming out of a certain kind of personality. . . . I was influenced by the painting scene, it's true, but I felt that I had nothing to add, nor did I want to become part of it." Wieland concentrated a lot of energy during these years on her films: *Patriotism, Part I* (1964); *Patriotism, Part II* (1964-86); *Water Sark* (1964-65); *Peggy's Blue Skylight* (1964-86); *1933, Hand Tinting, Sailboat* (1967-68); *Catfood, Rat Life and Diet in North America* (1968); *Reason over Passion* (1967-69).[50]

While in Toronto for her 1967 show, Wieland stayed with Diane and Abraham Rotstein, the latter an economic historian and writer in the department of political economy at the University of Toronto. In his articles and the texts of talks he had given, Wieland found support for her developing opinions. "She always had a good appreciation of the Canadian economic quandaries," Dr. Rotstein comments, "and was always sensitive and alert to questions of sustaining and reinforcing an indigenous Canadian society."[51] Wieland was reading *The Canadian Forum* and such other authors as Melville Watkins, Walter Gordon and George Grant. She was looking for a way to combine the aesthetic component with current problems without turning the work into propaganda. "I wanted an art that

could embrace these concerns and also retain beauty, texture, humour and such. Then, there was either one or the other—art to raise money for something but never really dealing with the issue; art and videos that were like talking heads."

Laura Secord Saves Upper Canada (1961; PLATE 4) unconsciously set the stage for Wieland's later attempt to do the same. While in New York her politicization first took the form of protest—in *March on Washington* (1963; FIGURE 38)—and overt, sardonic criticism— in the *Betsy Ross* flag and *N.U.C.* Wieland tends to be a "workaholic"—avidly researching any area or situation that interests her. She had studied American history, the lives of the presidents, the Vietnam War. By 1967 she was reading "a lot of Canadian history" and writings of Canadian nationalist economists. Already *Patriotism* (1966-67; PLATE 46) manifests the change in direction; *Confedspread* (PLATE 47) celebrates Canada on its centennial. A journey from Toronto to Vancouver in the winter of 1967-68 showed Wieland a land that "amazed" her, that cried out "to be discovered through art." The 1968 *Reason over Passion* (PLATE 48) and the French version, *La raison avant la passion,* relate to Canadian politics, recognizing the election at the Liberal Party convention in April 1968 of a new leader and prime minister of Canada. The quilts also mark some critical decisions on Wieland's part and a "blooming" of an art particularly her own. She took a bilingual political phrase, translated it into cloth (trilingualism), stuffed it (substance/rhetoric), gave it colour (distinctive character), shadowing (side effects), hearts (love) and quilted support (coverlet/platform) and enshrined it in a frame like a sampler's motto extolling domestic virtue. In the quilt Pierre Elliott Trudeau's assertion of the need to place reason above passion in government, and a feminist issue—the

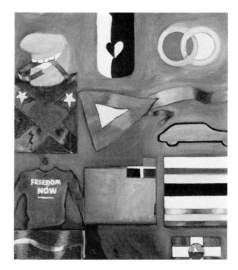

FIGURE 38
March on Washington *1963*
Oil on canvas
50.8 × 45.7 cm
Courtesy The Isaacs Gallery,
Toronto

72

irrational denigration of so-called women's work—are combined.[52] The irony in uniting a strong, boldly presented rationalist statement with the softness and warmth of a bed-covering and its connotations is clear.

Wieland has married image and word, seeing and reading and line as a means to structure and as a bearer of meaning. As both aspects retain distinctiveness of character, the conjunction is full-fledged; the interaction is more complex than in *Josephine's Last Letter,* with its blurring of form and text. The quilt's words, which are soft, puffed up, multi-coloured and have a want-to-touch-it tactile appeal, suggest reading by touch as well as by eye. The words project in relief as signs; they separate also, and become individualized letters with the irregularities of the hand-made and the potential of animation. A multitude of little hearts, some innocent, a few fleshy, surround the motto. Each quilt is a collage of political statement, social issue, artistic expression and such human qualities as warmth and humour. In Wieland's words, creating quilts involves "taking something you can know, trust and love—quilts that keep you warm and mean hearth and home—and using that in the modern sense as a platform for dialogue."

The stuffed letters, large, soft and lightly tacked to the quilts, acknowledge Oldenburg's influence, but they reveal as well the intuitive intelligence with which Wieland assimilated that influence. She does not remember seeing his early, little-known soft calendars, one of which was in the 1962 Green Gallery show. Apart from these, Oldenburg's "soft" pieces generally are giant-scaled discrete objects, concerned with their own mutability and without narrative or temporal aspects. Wieland's letters, on the other hand, are both objects in themselves and act as a unit to convey meaning

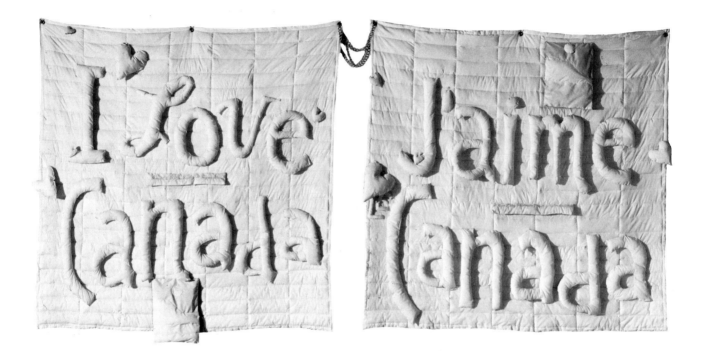

PLATE 18
I Love Canada—J'Aime Canada *1970*
Quilted cloth assemblage
153.1 × 149.8 cm and
160.5 × 154.9 cm
Mackenzie Art Gallery, Regina

through reading, narrative and time elements. Such factors, transferred to the materials and techniques, work with the quilted ground to establish matter and process as women's craft.

Wieland's use of words is likewise distinctive. Her soft, descriptive lettering differs greatly from Greg Curnoe's flat, mechanical-looking type representing landscapes; or from the cool, carefully shaped statements of linguistic equivalence of such artists as Lawrence Wiener; or from the long uninflected dictionary quotes of artists like Joseph Kosuth. Wieland's content is positive and usually political, her approach subjective and her script hand-drawn. She has a feel for the quality of words; her sense of their denotative capacity, their graphic character and their literary uses is evident already in her films and, to a lesser extent, her "filmic" paintings. Often she chooses a poem or a poetic phrase that succinctly evokes a multitude of impressions. She establishes a rapport between the content and the character of the letters—whether the "dialogue" between them is one of quiet irony, reminiscence or repetitious ritual. And as with other linguistic works, the viewer reading/speaking in the present creates at each moment of that activity an additional area, an auditory space.

A statement by Pierre Trudeau is also the source for *Man Has Reached Out and Touched the Tranquil Moon* (PLATE 19), an extraordinarily simple and evocative work.[53] Stuffed white cotton letters are individually bagged in clear plastic. The words extend up the wall while, attached as the base, a plastic-encased Canadian flag rests on the floor. The elements form a shape of strange anthropomorphic suggestiveness, a sophisticated, almost ethereal distillation of the formal conceit of *Patriotism* (PLATE 46). Metaphor imbues the visual manifestation as it does the literary component.

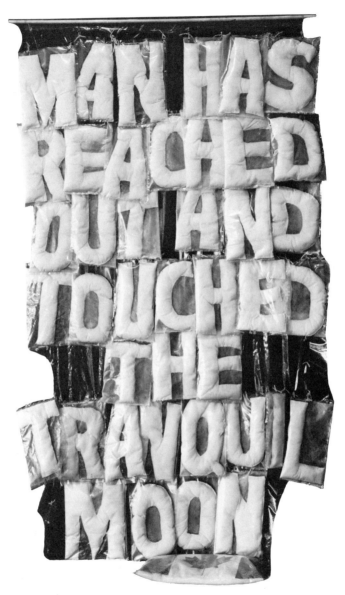

PLATE 19
Man Has Reached Out and Touched
the Tranquil Moon *1970*
Mixed media
298.5 × 163.2 cm
The National Gallery of Canada,
Ottawa

Each letter, contained in the sealed silence of its small space, intimates a vast otherness. As well, the colourless plastic and the bleached letters seem to reflect the cold paleness of the moon. In another work of 1970, *O Canada,* the white letters are scarlet-backed so that, as they spell out the first verse of the anthem, they cast rosy reflections of ''glowing hearts'' on the white ''arctic'' ground. The latter, quilted in squares, gives each letter a frame and the whole a measured rhythm.

During 1970, Wieland taught for three months in Halifax at the Nova Scotia College of Art and Design. While there, she produced the *O Canada* lithograph, which consists of the lipsticked impressions of her mouth as it formed the syllables of the national anthem. As Dennis Young writes, ''. . . *O Canada* has the quality of reification, since the artist 'stamps' the stone with her own mouth . . .; by which decision she links the work to her early 'pop' art as well as to 'body art,' and at the same time makes an engaging mélange of her major themes: erotic and patriotic love.''[54] The open, circular configurations have been related to vaginal images. While Wieland did not consciously intend such a reading, she concedes that it could nevertheless have been unconsciously incorporated. Sexual analogy does seep into heart images; both motifs appear early in her work. In the lithograph, animated, soundlessly singing lips are conjoined with a simple and direct symbol of love for Canada, the national anthem. Its ritualistic chanting by school children is recalled; Wieland had silently intoned it in her film *Reason over Passion;* now she drew the singing mouths on cotton for *O Canada Animation* (PLATE 49), leaving the drawing with the Haligonian embroidress Joan McGregor to be stitched in red, white and blue.

Later, enlarged three-dimensional lips animate with mouthed song the vertical cloth filmstrips for *The Maple Leaf Forever I* (1971) and *II* (1972; PLATE 55).[55] The lips in the first case are embroidered, in the other, colour-pencilled, both strongly tactile. Each pair is framed in a cut section of the thick white backing, which is intricately quilted with maple leaves. The cut edges mark frames, display both the materials and the process and emphasize phonetic reading. The sculpted mouths of the *Maple Leaf* quilts are somehow more erotic in their labial configurations than the lithograph's open lips with vaginal connotations. The former enjoy a sensuousness of material, the latter lend themselves to abstract readings through pattern, repetition and variation. Where the image is so simple, the slightest modification is amplified and celebrated.

The lip motif and the lipstick medium (first used in 1964 on the coffee cups in *Cooling Room II*) are further explored in later lithographs and their embroidered counterparts. In *Facing North— A Self-Impression* (1974; PLATE 20) Wieland placed her own face on the stone for a self-impression and signed each print with an actual lipsticked kiss. Fingerprints mark the upper right and lower left corners. The various self-imprints make the viewer aware of the maker and her body. The embroidered mouths of *Squid Jiggin' Grounds* (1974; PLATE 56) embody in their ball-shaped configuration the rolling movement of the sea. Except in cases when words of unfamiliar songs appear below the lip/mouth image, titles work like listings in some order of service. There is a feel for the space and quality of the page, whether paper or cotton, that is found in medieval illuminated manuscripts.

To return to 1971, two works of that year, *Montcalm's Last Letter* and *Wolfe's Last Letter* (PLATE 54), now framed together, are not

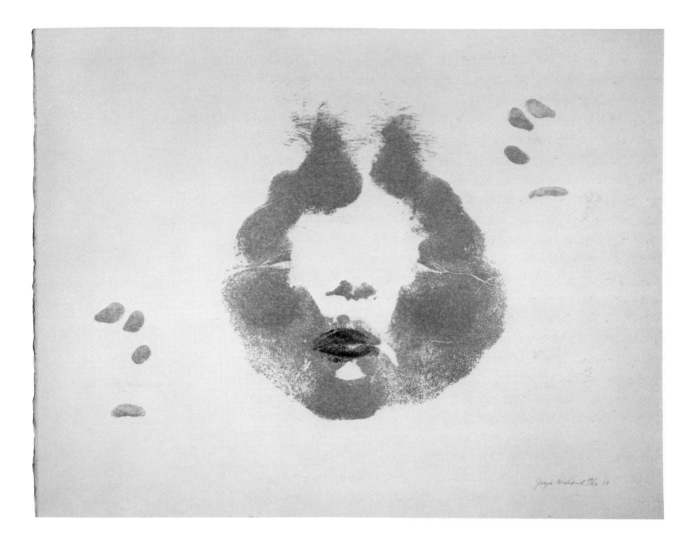

PLATE 20
Facing North—A Self-Impression
1974
Lithograph
33.0 × 43.2 cm
Courtesy The Isaacs Gallery,
Toronto

only concerned with the page as space but also with writing as both drawing and history. The letters were written just prior to the 1759 Battle of the Plains of Abraham, General James Wolfe's on September 12, 1759, and Louis-Joseph, Marquis de Montcalm-Gazon's on September 13, 1759. Embroidered on heavy linen by Joan McGregor, they are slightly enlarged and contain everything on the originals, even the ink blotches. The English letter shows a straightforward, pragmatic use of the page; the French script enjoys the space, a generous flow of ink, a calligraphic style with modulated line and embellishments. In a somewhat similar fashion Père Charlevoix, a Jesuit who twice visited Canada early in the eighteenth century, compared "the French Canadian with the English colonist: 'The English colonist amasses means and makes no superfluous expense; the French enjoys what he has and often parades what he has not.' "[56] Both letters were transcribed in red, showing "red impinging on white," as though written in blood.

The two letters and *O Canada Animation* are among the works Wieland designed for her 1971 exhibition at the National Gallery of Canada. In 1969, when Pierre Théberge, curator of Canadian Contemporary Art, proposed a show—a retrospective or new work or whatever—"I was in such a state of shock," Wieland remembers, "it took me about a week to make up my mind, and I said yes. . . . It was happening at the right time and I could spread out . . . with all the elements—ecology, history, politics, the times, women, women's work and the power of all that."

The title of the exhibition, *True Patriot Love, Véritable amour patriotique,* is significant—as a phrase of the national anthem; as an unashamed acknowledgement of "love" as the operative word; as a simple statement of the show's major theme; as a factor recalling

such common experiences as singing the song in school. Wieland requested and received a grant from the Canada Council to produce new pieces for the show: *Arctic Day, Eskimo Song— The Great Sea, 109 Views, Flag Arrangement, O Canada Animation, The Water Quilt, Montcalm's Last Letter* and *Wolfe's Last Letter*. She involved expert craftswomen in working on the designs—knitting, embroidering, rug hooking, sewing.[57] Not only was this a practical solution but, more importantly, it involved other women and emphasized both the collaborative aspect of art and the value of traditional domestic "icons." "I wanted to elevate and honour craft, to join women together and make them proud of what they had done." Wieland recognized the importance of the contributions by payments for services, in acknowledgements in the catalogue and in all publicity. However the checklist indicates, and Wieland confirms, that she retained the traditional distinction between the artist who develops the concept and design and the master artisan who executes that design. With the exhibition's twenty works in cloth and related materials (wool, embroidery silk, plastic, etc.) Wieland gave the medium a striking prominence as well as fresh formal and contextual possibilities that would excite interest in both craft studios and art schools.

Wieland's ecological concept of Canada equates the land and the people, and she envisaged the collaboration of the craftswomen as symbolic of a way for the country to work and draw together—of a form of communication throughout the country. (Other Canadian artists who have touched on this type of interaction in their work include Greg Curnoe, John Boyle and Iain Baxter.) Wieland sought accessible means with basic symbols and focused content to express this idea.[58] She was ambitiously undertaking the creation of specifi-

cally Canadian images. Patriotic songs, flags and historical references were combined with the emblematic virgin whiteness of the Arctic and traditional domestic crafts. The different media used for the many pieces did not dilute the statement, but rather added a variety of textures that interacted with one another. Moreover, the exhibition, which took up the whole first floor of the National Gallery, presented the thirty-six works in an installation-like setting—pine trees, pond with live ducks, ecological arctic cake, Sweet Beaver perfume, piped-in songs of Canadian birds. Was the exhibition presentation a form of packaging? Or was it a stage set—in the theatrical sense and serving the same purpose—for the blank nowhereness of the modern gallery? (Such settings have been used by Whistler and others, and Wieland took this approach again later in her show of drawings, *The Bloom of Matter.*) Wieland's love of history and interest in theatre (she had worked on sets and costumes at Toronto Workshop Productions) fused in her ability to fictionalize and to dramatize—as when she drew *Josephine's Last Letter* or enacted Laura Secord's legendary walk or conceived *Arctic Passion Cake,* in which she offers Canada a mythology.[59] The exhibition catalogue, which is dressed like an official state document in a maroon, gold-lettered cover, is "about the film I want to do, and about the art I have produced and am producing for the exhibition.[60] It's been the richest interplay of all the things I've been involved with." The facsimile pages of the *Illustrated Flora of the Canadian Arctic Archipelago,* the paper clips photographed along with the inserts they hold, the fine white thread crossing pages, Wieland's handwritten notes—all dramatize the book, but at the same time interact so subtly with reproductions, details and snapshots as to make the catalogue a source of continuing discovery.

FIGURE 39
White Snow Goose of Canada *1971*
Embroidered crest
14.0 x 11.5 cm
Courtesy The Isaacs Gallery,
Toronto

Wieland's 1971 exhibition has been compared, by Lauren Rabinovitz, with Judy Chicago's *The Dinner Party* of 1979.[61] Rabinovitz points out that, unlike Wieland, Chicago did not pay her assistants or formally acknowledge their help, and that "while *The Dinner Party* encompasses and explores a more varied heritage in a more integrated fashion than *True Patriot Love*, it does not go any further than initial consciousness raising through recapturing obscured history." As a single work, *The Dinner Party* is naturally more integrated than Wieland's exhibition, which presented individual works produced from 1968 to 1971, as well as some earlier ones. Rabinovitz notes that the catalogues/books document "how the artists' assumptions about themselves and their social roles" affected their works: Chicago set herself up as a role model, and her book emphasized "her own creative process, psychological crises, and continuing role" in her exhibition; Wieland called herself a cultural activist, and her book with its "scrapbook appearance and method" both established "another domestic art ('scrapbooking') as a viable artistic method" and offered the reader "active artistic participation in a game . . . [creating sets] of photo/word/picture juxtapositions."

Rabinovitz also compares sexual imagery and the presentations, postulating references (unacknowledged by Wieland) to the pornographic connotations of patriarchal advertising. Chicago, she notes "literalizes the genital image . . . whereas Wieland played with and satirized mouths and their sexual analogies," cosmeticizing (lipsticking in the *O Canada* lithograph) and thus satirizing "how advertising uses women's bodies for commercial purposes"; then satirizing "the satire by allowing the same package [singing mouths] to reclaim women's artistic heritage" (*O Canada Anima-*

tion embroidery). Both Wieland's and Chicago's presentations are described by Rabinovitz as packaged and embodying internal contradictions—"packagings, whether advertising or religious, [being] historically considered major contributors to the oppression of women." Chicago's exhibit is called a religious shrine—"the three-sided table and 39 place settings invoke Christian Trinity symbolism . . . [and] using old packaging for new material . . . ignores the problem [of internal contradictions]." Wieland's ironic statement is considered "best exemplified by Sweet Beaver perfume . . . which she cooked up, bottled, and displayed for sale at *True Patriot Love*." Through references to the Canadian wilderness and to women's bodies "Wieland played on how the advertising industry participates as a patriarchal tool in selling images of women and of a culture." Whether or not Wieland intended them, the viewer can read such implications into the visual and textual material. As Rabinovitz concludes, *The Dinner Party,* although it appeared eight years later than Wieland's exhibition, does not set forth as bold a statement. Its "feminist rhetoric," she writes, "masks its conservative, religious underpinnings."

FIGURE 40
109 Views *1970-71*
Quilted cloth assemblage
256.5 × 802.6 cm
Collection of York University

109 Views (FIGURE 40) was the only work in Wieland's 1971 exhibition of a traditional landscape character. However, it is well-nigh impossible for the eye to perceive it simply as such. The large scale of the work and the smallness of the units induce the viewer's gaze to keep moving across and up and back and down—to be carried by abstract qualities and relationships and to treat the work as a mosaic of photographic stills. *109 Views* reflects the cross-country journey of the film *Reason over Passion* and thus Wieland's own trip in the winter of 1967-68 from Toronto to Vancouver when she rediscovered Canada—its beauty, its vast space and its grandeur.[62] "[I] realized how much I loved it. It's to do with comparison but it is also to do with living without it."[63] With that sense of lost childhood that flavours much of her work Wieland continues, recalling "a very strong memory of a map being pulled down on a roller . . . this fantastic Board of Education map, which was like . . . beautiful pinks and greens, words such as Keewatin, Hudson Bay, and a tiny point at the bottom, Toronto . . . the unimaginable vastness of this, which seemed even bigger as a child . . . the words 'Dominion of Canada' in a big arc going across . . . and the description of the richness of this expanse. . . ."

Over eight metres wide and with more than 109 units—"a few extra crept in"—the work is irregular in its outline and orderly in its parts, whether large or small, vertical or horizontal or square. Except for the blank strips that work as intervals of space and time, the views usually sport frames in a variety of widths, colours and even numbers. The scenes are landscapes in the tradition of the Group of Seven—unspoiled, uninhabited. They form a vibrant collage of lakes and mountains, orange suns and ringed pale moons, icebergs and snow peaks, green expanses, fir trees crowning a horizon line or

reflected in water, bits and pieces of space and time. They present sensuous relationships with ever-altering rhythmic changes and, in the end, a temporal as well as a visual elongation, a highly romantic travelling shot of Canada.[64]

Several works focus on the Arctic as a symbol of "the True North." *Eskimo Song—The Great Sea* (PLATE 53), a two-part, bilingual piece (Inuit and English), hangs a veil like a light flurry of snow over words of the Eskimo song.[65] Arctic-white letters rest on pale shards of colour floating on that sea, moving with its rhythm. *The Water Quilt* (PLATE 50), as Wieland says, combines innocence and grim reality. Conjoined are arctic wildflowers and sections from a book on Canada's energy problems, including a proposal by a U.S. congressman to trap arctic waters and by various means convey them south "to help meet the needs of the western states for irrigation, industry, power, recreation, and municipal conservation."[66] The work is composed of sixty-four square white cotton pillows with brass grommets in all four corners; the same number of excerpts from James Laxer's *The Energy Poker Game,* photo-printed on sensitized cotton and mounted on the pillows; sixty-four images of arctic wildflowers embroidered on squares of white Egyptian cotton, the squares being attached to the pillows like flaps to hang over and veil the texts; and sailor's rope tied through the grommets to hold the pillows together and form them into a square of eight rows of eight units each.

The configuration is that of a soft, inverted grid, with the grid lines created by the dark thin shadows of space between the pillows. Volume and void have been reversed. The grid, instead of resting on the surface, now lies deep behind that surface, a void. The area within the grid, which would normally either be flat with the

surface or offer windows of space, instead projects volumetrically. There is a sense of wholeness, the whole reflecting the part and the part the whole (both are square or almost square). Softness resides not just in the pillowing but also in the element of approximation that lightens the weight of the grid—the slight modulation in edges and alignments, the off-register reiteration by flap sides, the mutilation of corners by rope and grommets. The grid, as a line of space, is literally divisive; paradoxically, the corner, usually a boundary for interior containment, has become a means of exterior unification.

The work has a repetitive insistence that carries the eye freely all over it. But the flora inhabit space not time. Delicate in form and colour, they are exquisitely embroidered on cotton so fine its semi-transparency reveals a hint of some darker form below. On closer examination the hidden image is seen as lines of type, illegible but with the persistent progression of argument. The text demands sequential reading; it exists in time and refers as well to past and future time.

The viewer always seems able to discover new aspects, analogies and subtle paradoxes in this work. There is the sensuous factor of materials: of grommet, rope, thin cotton, silken embroidery. There is the analogy between the cotton's semi-transparency and that of water; and there is the reference of sailor's rope and grommets to sails and boats and, again, water. The work presents a fragile plant life dependent on water and a text claiming that "the resource is little needed."[67] Elegant, fragile, strong and moving, *The Water Quilt* appears simple and obvious in its rightness.

Arctic Day (PLATE 52), a homage to the landscape, animals and plants of the Arctic, consists of 160 round cushions, on which are mounted circular drawings in coloured pencil. To achieve the effect

she wanted, Wieland used a pencil with a hard wax mount; and to get a cloth with the right texture for these pencils, she tried out many different materials. Bright-coloured cloth circles—red, blue, yellow, orange, green, pink—back the cushions and cast a soft glow on the white ground. As with shadows, when under strong light the colour deepens. And it was the illusion of shadows on snow that Wieland sought. The cloth cushions cluster in a large circle as though drawn by some magnetic force, the larger in the centre, the smaller trailing off the perimeter. Does the insistent circular motif suggest reference to the Arctic circle or to the circling of the midnight sun? The arrangement recalls somewhat the form of *Balling* and *Time Machine Series,* but the connotations here seem to relate microcosm and macrocosm and to suggest besides an ideal, albeit a lost ideal.

The arctic flora and fauna appear so delicately drawn it is as though they are seen through a mist, or a veil, or are in the process of fading away. The drawings constitute Wieland's first use of coloured pencils, which became a major medium for her in the late seventies. The *Arctic Day* drawings are more illustrative than later ones, but they have a special quality—showing a tentativeness and vulnerability that convey her fears for the Canadian North.

Another type of drawing much in evidence at this time was the cartoon, no doubt because of Wieland's politicization and the cartoon's position as a natural and historical stage for political content. In one, a character with a money-bag belly calls, "Come on Bill we're going to buy Canada back" (published in *Time,* July 12, 1971). The cartoon *Aqui Nada* satirizes the development of the Arctic and, symbolically, the past exploitation of the country. It tells the story of Lapin du Nord, a rabbit who falls in love with a caribou,

is almost raped by a machine-like creature with a "drilldoe," and is saved and embraced with ardent caribou love. In another somewhat later cartoon, *Canadian Liberation,* a female moves from thinking about how to serve her country, to serving a god and, eventually, literally, man, only to be chastized for not being involved in Canadian liberation. This cartoon and *Aqui Nada* were both published in *The Canadian Forum.* The style is open and uses a minimum of background details; it shows a reliance on line, with little shading. There is a certain affinity with James Thurber's style, although the delineation tends to be more angular than his, rougher and embellished with a good dollop of self-mockery. In a delightful cartoon (published in *Carot*), *The First Bombing in English Canada,* the almost crude and careless haste of the drawing is parallelled by the haste with which two women bomb a closed Howard Johnson's, abduct a pro-American waitress, take her to the "CANADIAN CONTENTment CAMP" and the "THOUGHT PROTECTION CENTRE" and eventually fly off with Johnny Canuck into the wild blue yonder.

FIGURE 41
Défendez la Terre/Defend the Earth
1972-73
Quilted cloth assemblage
193.0 × 716.3 cm
Collection of National Science Library, Ottawa

VI

Late in 1971 Wieland returned with Snow to live in Canada.[68] She became deeply involved for a year with Canadian Artists Representation (CAR) and in working and demonstrating for several causes, including an artists' fee schedule for exhibitions at public galleries and the plight of the Cree Indians, who were about to be displaced by the James Bay hydro-power dam. The latter situation focused her ecological concerns.

Quilts with a strong environmental emphasis—some in the form of poems—were executed in the next few years. (During this time, Wieland was concentrating her energies on raising money for and producing her feature-length film *The Far Shore*.) In the quilt *Laura Secord* (PLATE 57), the poem's stuffed white words, handwritten in sloping capitals, are attached to a white ground; tiny white florets lie scattered at the bottom, and a faint glow from coloured backings grows behind the text.[69] Laura Secord's journey involves ''carrying seeds from which a nation grew''; the ground is quilted in long curving lines like those charting wind behaviour, or perhaps nature's own furrows. *Indian Summer* (PLATE 58), which presents

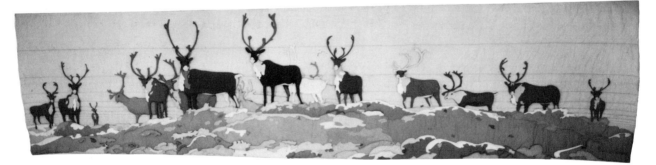

FIGURE 42
Barren Ground Caribou *1978*
Quilted cloth assemblage
Collection of Toronto Transit
Corporation, Toronto

Wilfred Campbell's poem, has a child's careful, round, somewhat awkward script and a child's forgetfulness of such things as punctuation.[70] The white cloth ground, quilted with lines of blue, recalls the blue-lined foolscap used in schools. The letters are painstakingly basted with small red stitches—stitches that flicker under light when the eye closely observes them, a changing intensifying aspect subtly like that of sumacs gradually turning red.

In 1974 and 1978 Wieland executed two large commissions. The first, *Défendez la Terre/Defend the Earth* (FIGURE 41), calls for conservation of the world's natural resources. Appropriately, it was made for the National Science Library, Ottawa. Acaulescent, yellow-centred flowers, in various tones of mauve and blue, float on a white ground so quilted with green basting stitches as to suggest the rippling surface of gently moving water. A slow current seems to carry the flowers, cradling them, and to distend somewhat the title letters. The other commissioned work, *Barren Ground Caribou* (FIGURE 42), was produced for the Toronto Transit Commission's Spadina Subway Station (Kendal Avenue entrance). Wieland's largest quilt—approximately two metres by nine metres—is also the most illustrative. But it is so with a childlike, gentle delight: fifteen caribou pause in their annual migration in a vast but somehow safe space. The only animals depicted in stuffed form, when viewed close up they barely escape a toylike quality. Indeed, the work has the clarity, the tenderness and the mixture of fantasy and innocence that is found in the illustrations of Beatrix Potter, whose books Wieland has cherished since childhood.

For her feature-length film, *The Far Shore,* Wieland used the unusual method, for this genre, of making storyboards. The film,

conceived in September of 1969, was shot during 1974-75 and premiered in August 1976. Between 1972 and 1975 Wieland made three series of drawings, visualizing the film scene by scene. The drawings outline Wieland's "ideas of how the action of the film should unfold and express her vision of the setting"—often with added notations on camera movement.[71] For script page 67, for instance, there is a delicate colour drawing, "Eulalie cuts the film in half by diving in the lake." And colour sequence 23 reads, "camera pans paddle in sunlight. . . ." The emphasis is on such visual means as the play of light on surfaces and the interaction of rich colour, varied texture and selective detail—aspects that both reflected the eye of a painter and would later characterize, more markedly than before, paintings of that artist.

The strain of making *The Far Shore* was enormous. "It was exciting, but took too long to get the money [to finance it and keep complete artistic control]. It turned into a most gigantic burden, was never-ending, and almost killed me. It used up a kind of basic energy." Wieland had to rest, and she again sought psychiatric help. Two self-portraits of 1978 are intimate and amazingly direct. The smaller one (PLATE 59), only 20.3 cm by 20.6 cm, is seen full face, with the eyes looking candidly at the viewer. The round neck of the shirt and the roundish mop of hair focus attention on the face. Subtle brushwork not only models this countenance but fairly renders the light on it. The portrait has an open and yet introspective air and conveys both strength and vulnerability. While looking at the viewer, the artist is also in a mirror, contemplating herself.

In November 1978 Wieland flew to Cape Dorset in the Arctic to make lithographs. "The window where I sat [in the Eskimo print shop] faced the Bay of Cape Dorset, and I began to notice light more

FIGURE 43
Buttercup with Flowers *1981*
Watercolour
25.4 × 25.4 cm
Collection of Mr. and Mrs. George
H. Montague, Toronto

92

. . . certain kinds of radiances around the edges of objects. And I began to see the primary colours, the breakdown, which I had never noticed before . . ."[72] Wieland related this mystical sense of light to a statement of Lawren Harris's about gaining spiritual nourishment from the Arctic. Indeed Harris, a theosophist, spoke of the Arctic in majestic terms as "the great North and its living whiteness, its loneliness and replenishment . . . its call and answer—its cleansing rhythms," and as the very source of "spiritual flow."[73] During 1979-80, Wieland became involved for a couple of years with anthroposophy, a breakaway offshoot of theosophy. Both philosophical systems endeavour to deduce the phenomenal universe from the play of forces within, for theosophists, the Divine Nature, for anthroposophists, the nature of humanity. Wieland was also aware of the mystical significance these and other systems of belief attributed to colour and light. "I've been reading religious books all my life. There's about two hundred downstairs." Among them was Teilhard de Chardin's *Hymn of the Universe,* in which he writes of a representation of Jesus where everything seemed to merge and Christ's garments were composed of "matter, a bloom of matter, which had spontaneously woven a marvelous stuff out of the inmost depths of its substance."[74]

The Bloom of Matter was the title of Wieland's 1981 show of coloured drawings at the Isaacs Gallery. The exhibition was the result of two and a half years of almost continuous work. Wieland found that she could experience the mystical quality of light in her bright upstairs studio.[75] "I began again to see in a different way, seeing light broken down on the paper I was working on . . . I found the image in the light on the paper."[76] It was an intuitive process, unconsciously interweaving many threads—mystical and partaking

PLATE 21
Victory of Venus *1981*
Coloured pencil on paper
41.9 × 53.3 cm
Collection of M. L. Hammond,
Toronto

PLATE 22
The one above waits for those below
1981
Coloured pencil on paper
39.4 × 50.8 cm
Collection of the Canada Council
Art Bank/Collection de la Banque
d'oeuvres d'art du Conseil des arts
du Canada, Ottawa

PLATE 23
The End of Life as She Knew It *1981*
Oil on canvas
59.7 × 81.3 cm
Private Collection, Montreal

PLATE 24
He Giveth Her Tulips Light *1981*
Oil on canvas
24.6 × 31.9 cm
Collection of Mrs. H. Mary
Kershaw, Toronto

of William Blake's mysticism; impressionistic and enjoying the light, movement and colour (as well as format) of the work of Giovanni Battista Tiepolo.

The first coloured-pencil drawings were worked in just three hues—blue, rose and yellow—and sometimes with only a single figure in a landscape—like *The Venus of Kapuskasing,* a giant goddess straddling a scattered settlement. Gradually the drawings got more complex in concept, figuration and prismatic colouring. In some, cavorting figures recall Wieland's 1961 drawings, the "Lovers" series. But now the subject is the processes of nature and growth. "People are growing underground, and animals are growing with people. It's the magic of growth and how energy runs through everything."

In *The Birth of Newfoundland* (PLATE 61), a wonderfully integrated work, one thing turns into another almost before it can be identified—air into water, water into fish. A sensual goddess floats on the waves while the elements flow over and through her and fish nibble at her genitals. *The one above waits for those below* (PLATE 22) combines a gentle calm and clarity in the upper portion, where a deer and a mythological figure tarry on a grassy knoll ringed with tulips, and bewilderment in the lower, as faint bodies of human and animal become neither really present nor absent. *Death of Love* depicts a pig's head. The title was not intended, Wieland says, as a reference to the tired cliché "male chauvinist pig," but rather as an intimation of the pig's sad, trusting expression that had so struck her that she carried the head home from market to paint. The imprint of death is visible on the animal's bruised forehead and in its closed eyes and the trickle of fluid from its mouth; yet a quiver of life seems to flush its soft skin and to hold the yellow daffodil in its mouth.

The formats of the works are generally circular or oval, giving them an eighteenth-century air, but also referring back to the strong presence of rounded forms in Wieland's work of the early sixties. Whether palely contoured or striated, the forms appear weightless, and they intermingle and interlace with a mystical and a pagan animism. They inhabit a female world in the process of creating its own mythology.

Although they constitute a break in continuity, a group of water colours of the Turkish coast Wieland made in the summer of 1981 demand attention. They, too, are intimate in scale but have a breadth of view that is remarkable. One can feel the air, sense the moisture from the sea and the quality of light, and appreciate the changing nature of the sky (PLATE 65).

In the previous year (1980) Wieland had started to paint small circular or oval works with themes similar to those of the drawings, but extending also into religious subjects, a *Flight into Egypt (After Tiepolo)* (PLATE 64) and a semi-religious *Mother and Child* (PLATE 25). The woman in the latter contemplates the infant with great tenderness and a strange sadness, as though she is holding either the child she will lose or the child she cannot have. This painting and *He Giveth Her Tulips Light* (PLATE 24) retain the linear qualities of the drawings; however the colours are much stronger. Techniques also vary—rather than presenting a network of lines, scumbling, for instance, provides a build-up of thin paint layers that conduces in its way to atmospheric effects. *Goddess of the Weather* offers a distant view, from a high vantage point, of a sunlit and shadowed hillscape under a deep and clouding expanse of sky. With its detail and small figures and in its instinct for an expanding panorama, it has something of the character, unconventional for its time, of a sixteenth-century South German landscape.

PLATE 25
Mother and Child *1981*
Oil on canvas 42.2 × 41.9 cm
Collection of Lynn McDonald, Toronto

PLATE 26
Guardian Angel *1982*
Oil on canvas
22.5 × 25.0 cm
Collection of Julia and Tim Hammell, Toronto

Conversation in the Gaspé (PLATE 63), of 1980, indicates a different, more personal direction. The format is rectangular, though still small, and ordinary people are portrayed as relatively modest-sized figures in a landscape setting. A man and a woman sit comfortably, nude, deep in conversation, on a verdant shore. Their postures imply an indifference to nakedness and, hence, both an idyllic world without material goods and, in this setting, something of the sense of the provocative and the ridiculous suggested by Manet in *Le Déjeuner sur l'herbe*. The relationship between the two figures is strongly felt. The curve of the man's trunk is complemented by the opposing curves of the woman's head and breast and of the crescent moon in the sky. The setting sun (unseen) colours the beach and warms the nude bodies; the viewer finds in the woman a reflection of the artist. Similar in character to *Conversation in the Gaspé* is a 1983 painting with the lengthy title *She will remain in the phenomenal world filled with ignorance, with her sheep, and not go with him* (PLATE 66). A naked woman, shepherd's crook in hand, says no to an angel, the spiritual teacher with his feet in clay. A confrontational situation in different guises would become the pivot for three large paintings begun that year (*Experiment with Life, The Artist on Fire,* and *Paint Phantom*). Here the pale moon and its reflection balance in weight and concept the man/woman polarity.

Experiment with Life (PLATE 27) portrays a horrific eruption of violence—indeed of evil—and the energy of such forces. A figure fleeing into the painting's right edge turns his pale bearded head to look backwards—up the long slope where houses burn, and at his disintegrating hand. A goose's looming shadow stretches to his heels, while the bird's frightened face appears at the left. The

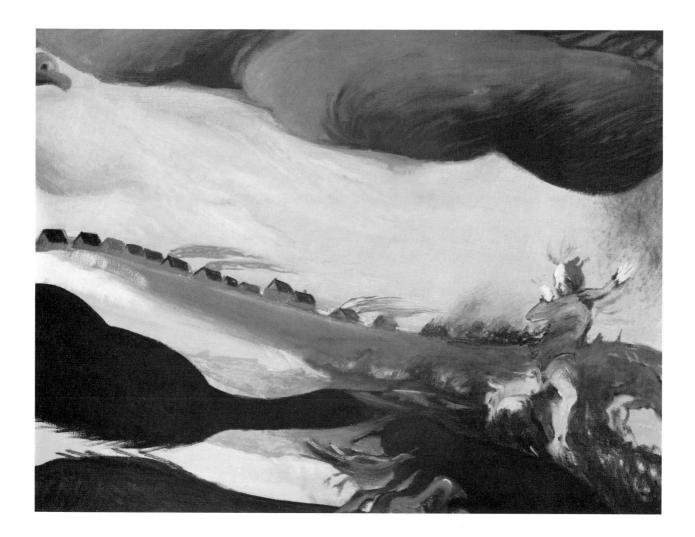

PLATE 27
Experiment with Life *1983*
Oil on canvas
62.1 × 82.4 cm
The National Gallery of Canada,
Ottawa

ground beneath the figure is on fire as are his feet, his shirt and his hair. A huge, lowering cloud darkens the neighbouring field and lets fall on his outstretched hand a strange shower of ashes.

Wieland describes the painting's development: "I started it as a kind of disaster in the suburbs, as though they bombed Scarborough; and then I left it. The figure hadn't appeared or the flames. It was around for eighteen months. One day I picked it up. I had a very strong feeling [that] I wanted to express something about Vietnam and the thousands of people killed by experiments with chemicals —incredible experiments they did on human life. . . . When I paint something like that, I have a terrible need to do it. The need was so great that it just came out in an hour and a half after waiting eighteen months."

Loose paint handling and flickering strokes of colour emphasize the swiftness of figure and flame and the suddenness of the whole catastrophe. The composition deploys major figurative elements near edges so that they encircle and imbue a central open area both with the portent of movement and even calamity and with, paradoxically, in contrast, a deceptive calm. The sweep of blue sky recalls the long panel of open sky offsetting the burning plane of *Tragedy in the Air or Plane Crash* (PLATE 40). The disaster theme has reappeared with a new intensity. The sense of necessity, of urgency that Wieland spoke of, and that surfaced also in the two other large works of this year, may account for the amazing yet unmistakeable air of authenticity that is conveyed. Although the works seem related in figuration and allegorical content to work of a new generation of Toronto painters, they are distinguished both by this unique sense of authenticity and by an imaginative correlative—so that they contain not just the form but the essence of the struggle.

In *The Artist on Fire* (PLATE 67), Wieland portrays herself with a bit of history and a lot of ambiguity. Unconsciously she added French eighteenth-century notes both to her appearance (with hair drawn back as she recalls Mme. de Pompadour's in portraits of the time) and to the background (with a memory of Versailles reflected clearly in a pond). The painted figure on the canvas went through four metamorphoses—he started as an angel and finally became "Napoleonic . . . although he has a laurel wreath on his head, and I left the wings in . . . I allowed this to happen." Wieland had begun the painting because "I just felt on fire. I was burning up . . . like a kind of passion about painting." The work can be viewed from various overlapping perspectives—as a whimsical *tour de force* extolling an artist's creative capacity, as painterly play with the illusions of painting, or as a blackly humorous sexual reversal in the politics of art and of power. The artist has recreated herself, a memory of a building and a reflection of that memory—illusions of delusions. A painted canvas interacts with elements outside it, and foliage in the upper corners resembles drapery-like coulisses. Is the background a stage set, the painting a theatrical production? And then the canvas on the easel becomes yet another staged event, and so suggests the conceit of many mirrors reflecting from one to the other both interior and exterior aspects.

Everything is interrelated. The artist and painted figure are separated in space but united visually in posture by flickering fire, and conceptually as maker and her handiwork. The artist's burning compulsion is expressed literally in the flames curling up her torso. But the painter is unconcerned; she knows the flames metaphorically—psychic fire on her back and sexual fire on her brush. She both elicits and paints the male figure's erection. Indeed, here,

woman creates man. Historical references seem to humour this perception of power exchange: Mme. de Pompadour, Louis XV's influential mistress and virtual prime minister for almost twenty years; Versailles, their magnificent court and seat of power; and Napoleon, who had his marriage to Josephine annulled for purposes of gaining an heir. Does this man with wings and upraised arms, with a flame-coloured bird of paradise kissing his tongue, seek transfiguration, another metamorphosis? Is he the alter-ego of the artist? Fire is a universal symbol of transformation. The artist consumed by fire is the fire—is that symbol.

Paint Phantom (PLATE 68) is one of the most personal works Wieland has produced. In progress for one and a half years, it is both allegory and catharsis. Two mythic-sized figures, silhouetted against the night sky, wrestle on the curved landscape of the world. They refer to more than one personal confrontation over the period of production and so take on a larger symbolism. The references are, in one instance, to the artist's struggle with her recalcitrant, rainbow-hued material; in another, to incredible, protracted arguments that were so violent they could only be depicted as physical. And again, the work testifies, Wieland declares, to "what the struggle and the pain of it was, to be in love with things that were dead, having made them into something more magical than they ever were, and then having to try to destroy them so that one could get on with one's life."

But most often and most importantly, the figures represent the two sides of consciousness—the male, here dominant and cruel; and the female, frightened and fighting to disempower the other. Wieland explains in therapists' terms: "I never really knew my father, and so the father in me turned out to be a monster." The

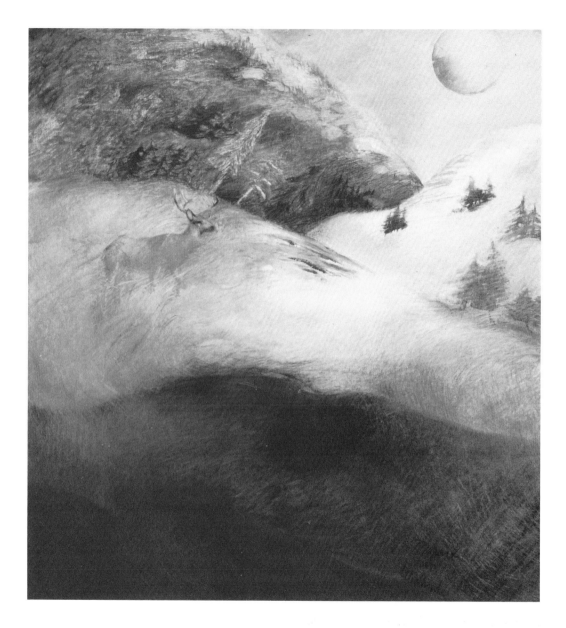

PLATE 28
Mozart and Wieland *1985*
Oil on canvas
137.2 × 129.5 cm
Private Collection, Ottawa

desperate woman pulls at the male skin/costume to expose what is underneath. She punches his chest and her fist goes through the body to his back. The painting, Wieland declares "is about puncturing phantoms that we make so real. And it is a quest for self and wholeness." The figures wrestle in a surrealist space, towering over diminutive trees and mountains beside a wholly visible moon, its brightened crescent shining for and on a strip of earth below. The forms likewise partake of the surreal and symbolic: in the rabbit-like ears, peeling and flapping arm skin and tail-like extrusion of the male; and in the severed legs of both—the woman's still life-coloured and life-activated, the man's dark and dead. The figures are lit by some unknown source that makes the layered colour shimmer and the skin look opalescent, and that stains the clouds with an intensity of hue analogous to the fury of the struggle.

From 1984 to 1986 Wieland was largely involved with finishing the films *A & B in Ontario*, *Peggy's Blue Skylight*, *Patriotism, Part II* and *Birds at Sunrise*. A painting of 1985, *Crepuscle for Two* (PLATE 69), returns to the intimate scale and the theme of figures in a landscape of *Conversation in the Gaspé*. The faint indication of a rainbow belongs naturally in the after-rain softness of the air. The loose divisionist technique with which she has modulated the colours greys the evening light and warms the shadows. The feeling for the quality of light becomes almost palpable in *The Wanderer* (1984-86). A man fully clothed, with a cap on his head and a pack on his back, traverses a brooding landscape. At the opposite side of the canvas sits a nude woman, her head cocked, her eyes unfocused, listening it seems, to some extrasensory vibration. The distance between the figures is fragile; tension somehow resides in the space

itself. Loose strokes of colour or of a dry brush animate areas here and there without obscuring detail, giving a sense of movement to the grass and the air, to the nuances of colour in the air and to the plodding pace of the wanderer. A sensitivity to the power of detail, to effects of texture and of closely related colours gives the painting a richness that delights the eye.

Wieland is presently working on some very loose, almost automatist paintings. Essentially linear with in-dwelling crude figures later sketchily developed, they indicate a new direction that will, in any case, be intuitive and personal, as her work has been since she again took up the oil medium in 1978.

PLATE 29
The Spirit of Canada Suckles the
French and English Beavers *1970-71*
Bronze
6.0 × 19.3 × 12.5 cm
Collection of Dr. Jean Sutherland
Boggs, Ottawa

PLATE 30
Bear and "Spirit of Canada" *1970-71*
Bronze
8.0 × 19.5 × 13.2 cm
The Artist

VII

Wieland's filmmaking, which is treated separately in this catalogue, closely interrelates with her work in these other media. Probably the first cross-reference is the tiny filmstrip in the 1955 collage with the legend "The Product of an Unhappy Family Life. . . ." From then until the mid-seventies there was a certain congruence of motifs (e.g., sailboats), of themes (female sexuality, Canada's vastness), of subjects (self-portrayal, politics) and of concerns (women, ecology, accessibility). Although the different media also influenced each other, the effect of film on Wieland's painting, drawing and other means of expression is particularly notable and is most obvious in the New York period. It includes format, cinematographic devices (close-ups, fades, jump-cuts, etc.), formal "filmic" play between foreground and background and "animated" sequences, material (plastic) and even content, which often deals as much with movement, change and time as with the depicted subject matter— and in the coloured-pencil drawings with the way, through movement and colour, light creates substance on the paper as it also projects, through film, images in time.

While Wieland's films have been shown internationally and, apart from *The Far Shore,* have received critical approbation, her other work has not been accorded the same enthusiastic response. Even in 1960, while Robert Fulford and Sara Bowser recognized her talent, others called her work "sophomoric" (Toronto *Telegram,* September 24) and "undisciplined" (*Toronto Daily Star,* September 24). With reference to her 1971 National Gallery show, William Ronald in a radio interview asked, "Is it art?" Her cocky reply: "I don't know. Maybe it is, maybe not." In 1983 her mythological

paintings were criticized for their sweetness and whimsy. Although Wieland was at first upset by the last criticism, she accepts these aspects knowing that she is intuitively expressing her own nature. This is one of her strengths; she dares to produce outside both the current art movements and accepted standards. Already in the mid-seventies, Wieland was directing the heroine of her film *The Far Shore* to read books on Antoine Watteau, Jean-Baptiste Chardin and Jan Vermeer, among others. In 1981 she was speaking of going ''back and examining the work of the distant past that is so alive, so full of the tumult of life. We've got to work ourselves back to some passion, to some belief.''[77] In the living-room of her row house in downtown Toronto, she has recreated a Chardin-like atmosphere ''with the furniture and the darkness and the light that seems to come from the top.''[78] Examined by today's criteria, his figures, too, would probably be described as sweet.

Central to Wieland's aesthetic is a sense of her own nature. She realized early in her career that her individuality and her femaleness were bound together and that the former had to include the latter. Moreover, for Wieland, being loyal to her mother meant being loyal to women. She identified strongly with her mother in the domesticity and the kind of creativity she showed. Not finding role models in the visual arts, Wieland turned to literature and history, to the books and lives of such women as Colette, Mme. Roland, Jane Austen, the Brontë sisters, Katherine Mansfield, L.M. Montgomery, Josephine, Mme. de Pompadour, and many others. She tried to find her own influences and her own sources outside those of the male-dominated art scene and of her former husband, Michael Snow. Indeed she was in a double bind, for as an artist married to another artist, she had not just to assert her own femaleness but also to

survive the cliché "artist's wife" (a useful coffee-maker and dish-washer) with its implied assessment of her work in terms of her husband's influence.

Wieland did not become a feminist until 1971, but as early as 1961 she was expressly giving materials uniquely female references, as in *Heart On*. She was aided in this by her natural tendency to be the "outsider," the subversive, the provocateur in the established order. By 1964 her artistic world was female-oriented; she was looking at areas men would not consider. In the quilts of the late sixties and early seventies Wieland was insisting on the importance of such domestic materials as muslin, wool, burlap and embroidery silk and of the effects of such craft techniques as stitching, appliqué-ing, rug hooking and embroidering. By 1971 she was developing a female mythology for Canada, producing *Arctic Passion Cake* and the tiny bronze sculpture *The Spirit of Canada Suckles the French and English Beavers* (PLATE 29), identifying the country as female and its economic and social exploitation by the United States with that of woman's exploitation in the male system.[80] In the late seventies and early eighties, she was creating a female world peopled with gambolling goddesses. This evolving structure erupted in a struggle of mythic scale in *Paint Phantom,* where woman confronts and betters man in the eternal love-hate dichotomy. Today Wieland is a member of the Committee of '94, formed to seek a woman prime minister for that year. In fact, since the mid-seventies she has luxuri-ated in her womanness, even allowing that irritant to feminism, a "feminine sensitivity" (delicacy, paleness, lyricism), to appear.

Wieland has shown over the years an amazing openness and sensitivity. She feels instinctively the movement of the time and the spirit of the place and incorporates them in her work. Often she

anticipates the mood. She was an ecologist long before the popularization of the movement in the 1970s. She was making political statements when it was considered "cheap patriotic claptrap" and embroidered and quilted pieces when they were viewed as "country-fair." Wieland's work was influential in widening the perception and practice of art to include both materials and techniques of women's crafts and subjects dealing with public issues—economic freedom, ecological protection and, what was then an anomaly, Canadianism. Her artistic commitment to these areas grew out of her social basis. It reflected a sense of responsibility both for "what you are" and for "the piece of land you're standing on," and a belief in art as a vital force expressing a people's conscience and speaking to that conscience.[79]

Her Canadianism may not be as outspoken now, or her humour as bawdy, but her joy in subject matter can be just as obsessive. She provocatively intertwines two old but seemingly contrary themes— female sexuality and northern mysticism. She paints with water colour small glowing portraits of flowers—a recurring motif, from *Nature Mixes* and *Tragedy in the Air* to *The Water Quilt, Defend the Earth* and many others. Although her work may wryly comment on other art, it is not art about art. It is not directed at theoretical aesthetics or ontological problems. Rather it translates into a visual language the emotional poetry of myth or lost childhood or nature's energy.

Her poetic imagination enlarges the aspect of a work—making it multilayered and giving a sense of mystery to figures, both human and abstract. Not only has she developed her own very personal images but she has also deployed them with originality and humour. Over some twenty-five years Wieland has developed and maintained

in her work a personal independence and vitality that has earned her the respect with which she is regarded today. In 1983, she was made an Officer of the Order of Canada in recognition of her stature as an artist. In the 1974 catalogue for the Isaacs Gallery at the Owens Art Gallery show, Wieland inserted two poems as her statement. One was Wilfred Campbell's "How One Winter Came in the Lake Region." The other (part of which is quoted here) was Anne Wilkinson's "Lens," which was the basis for Wieland's 1978-79 quilt of the same title:

> My working eye is muscled
> With a curious tension,
> Stretched and open
> As the eyes of children;
> Trusting in its vision
> Even should it see
> The holy holy spirit gambol
> Counterheadwise,
> Lithe and warm as any animal.

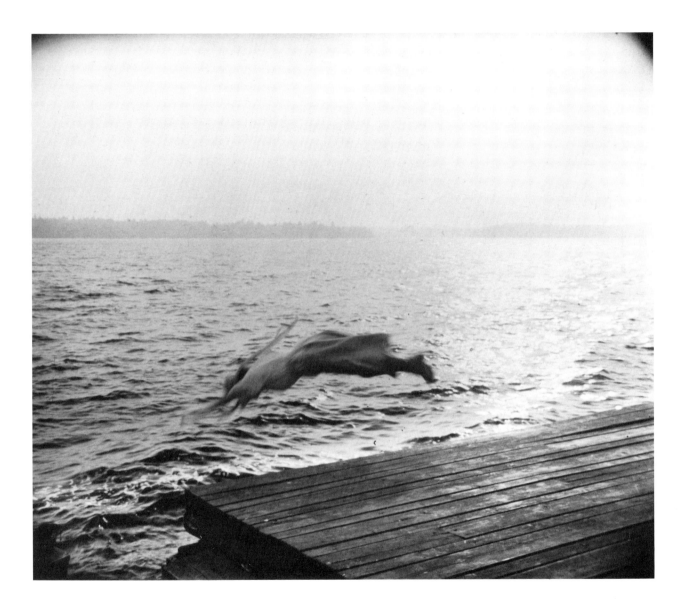

FIGURE 44
The Far Shore *1976*

Lauren Rabinovitz

The Films of Joyce Wieland

From the late 1950s until the present, Joyce Wieland has explored cinema as a means for personal expression. Her films, ranging from short Pop Art parodies to highly experimental documentaries to a feminist theatrical feature, have evolved in the dominant direction of North American independent cinema after World War II. But, within the parameters of independent filmmaking practices and aesthetics, Wieland has developed a uniquely feminist vocabulary that addresses women's experiences, attitudes and ways of speaking.

Avant-garde or independent cinemas offered women filmmakers like Joyce Wieland opportunities for artistic success because arts institutions before 1968 accorded cinema only marginal status. As feminist film scholar Annette Kuhn explains: "Low investments of money and 'professionalism' have meant that *avant-garde* cinema has historically been much more open [than the other arts] . . . to women."[1] The independent filmmaker individually or with a small group controlled the production process using inexpensive technology in what has become known as an artisanal mode of production. British feminist film critic Pam Cook has noted that this cin-

ema, concerned as it is with autobiography, intimacy and interpersonal relationships, was especially appealing to women.[2]

Women filmmakers, however, faced the same kind of secondary status within independent filmmaking movements that they experienced in the society at large in the 1950s and 1960s. For example, filmmaker Maya Deren was the butt of jokes among her male peers, who could not accept that a woman had intellectual theories regarding film as an art form.[3] Shirley Clarke could attract investors in her films only after she acquired male producers. This is perhaps the reason why Wieland, who had already established a career as a painter and was accustomed to the social pressures regarding an unorthodox career for a young woman in the 1950s, made the transition to film more easily than women who have moved directly into filmmaking.

Joyce Wieland's filmmaking career began somewhat unconventionally in New York City in 1963 when she attended a midnight film screening, organized by Jonas Mekas at the Grammercy Arts Theater. She was affected initially not so much by what she saw on the screen as by what was happening around her. People were bringing in both finished and unfinished films, some of them little more than idiosyncratic home movies. Mekas democratically projected all submissions, and when each film was over, the small, devoted band of filmmakers that comprised the audience discussed what it had just seen. Wieland liked the communal spirit and democratic acceptance at the informal, relaxed show. Soon (she had earlier made a couple of short parodic films while working at Graphic Films in Toronto) Wieland was making short, personal movies and showing them to her friends at the evening screenings.

Wieland was in New York City in 1963 because she had just relocated there with her husband, painter Michael Snow. Snow felt

that Manhattan would provide a better environment than Toronto for their artistic growth and would offer more prestigious critical attention.[4] But instead of frequenting the places where she would most likely meet other painters, Wieland gravitated to the small band of independent filmmakers living in downtown New York City. She admitted to being terrified of the intense competition and pressure and the high financial stakes of the New York art-gallery system.[5] She preferred the folksier, low-key atmosphere among the "underground" or independent filmmakers, and she admired the highly personalized, deliberately primitive films of Ken Jacobs, George Kuchar, Jack Smith and others.

PATRIOTISM, PART II (1964)

Wieland's first big success within this group was her 8 mm film, *Patriotism, Part II*. In *Patriotism, Part II* hot dogs march in time to a John Philip Sousa tune. The film reintroduced the serio-comic themes of social concern, urban disaster and political and sexual power that she was simultaneously asserting in such paintings or constructions as *Cooling Room II* (1964). It also echoed the phallic Pop imagery that she employed in paintings of rising and falling airplanes, ocean liners, cigarettes and hot dogs. Wieland's live-action, stop-motion techniques first imply the wieners' phallic symbolism when the animated dogs file along a bed and then over a man's body. She makes the point explicit when the man fondles a hot dog as though he is masturbating. Most importantly, however, the finale links phallic and patriotic signs as icons of political domination when a row of marching American flags wrap themselves around the hot dogs.

WATER SARK (1964-65)

In contrast to the vision of a world ruled by the phallus that she was developing in films and paintings, Wieland also cinematically imagined one small space where there was no such domination. In her second New York film, *Water Sark,* she represents a woman's familiar domestic space as the site for feminine self-discovery. In an autobiographical diary of the housewife at her kitchen table, Wieland asserts not only the value of a woman's point of view but of female ritual and language.

Water Sark establishes the kitchen table as a domestic altar and a world of aesthetic beauty—of exciting colours, tones, textures and compositions. Using mirrors, prisms, glasses of water and magnifying glasses as refractory media, Wieland filmed herself filming the objects around her. Her emphasis on the images' sensuousness and spirituality ultimately ritualizes a woman's cinematic self-discovery in the same way that filmmaker Stan Brakhage and others celebrated male self-identification in the late 1950s.

At the very moment when Wieland was reworking an established model of filmmaking for her mystical celebration of woman as an introspective subject, other developments were changing the dominant aesthetic direction of artisanal cinema. By 1965, a new style had emerged in the New York independent film community, a style that capitalized on Andy Warhol's highly publicized cinematic experiments from 1963 to 1965.[6] Later known as "structural films," the new movies assumed a rigorously intellectual and self-reflexive stance on the formal processes of filmmaking.[7]

Structural films investigated the physical properties of film itself as a flat material utilizing light, projection, printing procedures and

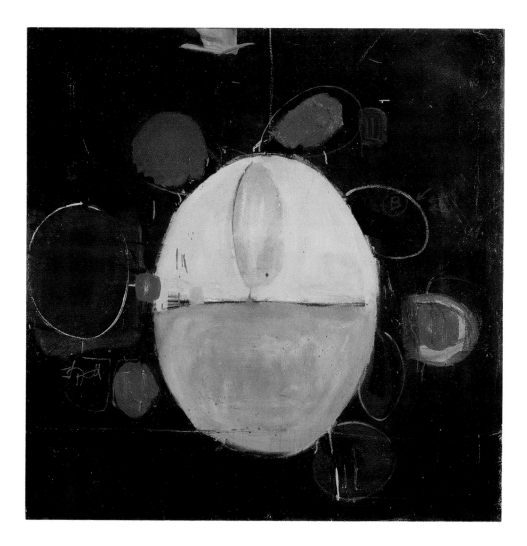

PLATE 31
Time Machine *1959*
Oil on canvas
114.5 × 114.5 cm
Crown Life Insurance Company,
Toronto

PLATE 32
Redgasm *1960*
Oil on canvas
71.5 × 117.0 cm
Private Collection, Toronto

PLATE 33
Notice Board *1961*
Oil on canvas
122.5 × 122.0 cm
Collection of the Canada Council
Art Bank/Collection de la Banque
d'oeuvres d'art du Conseil des arts
du Canada, Ottawa

PLATE 34
Time Machine Series *1961*
Oil on canvas
203.2 × 269.9 cm
Art Gallery of Ontario, Toronto
Gift from the McLean Foundation,
1966

PLATE 35
Heart On *1961*
Collage on cloth
177.8 × 251.5 cm
The National Gallery of Canada,
Ottawa

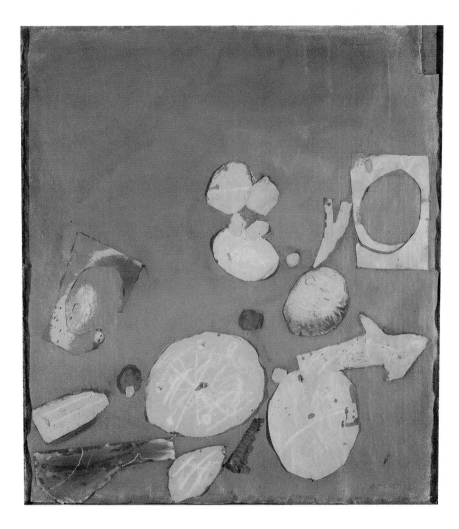

PLATE 36
Summer Blues—Ball *1961*
Collage
91.5 × 83.0 cm
Courtesy The Isaacs Gallery,
Toronto

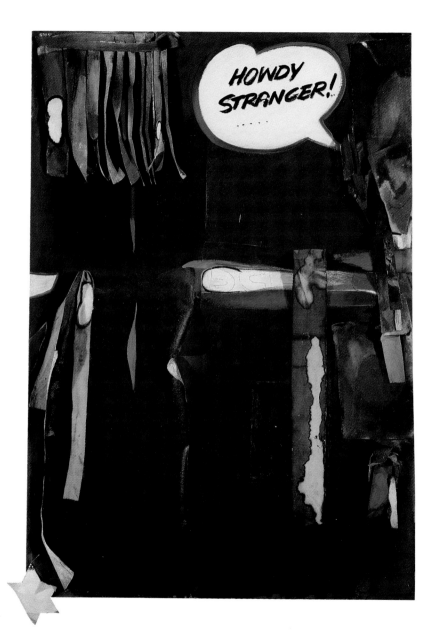

PLATE 37
Stranger in Town *1963*
Collage and oil on canvas
117.0 × 82.0 cm
Courtesy The Isaacs Gallery,
Toronto

PLATE 38
Nature Mixes *1963*
Oil on canvas
30.5 × 40.6 cm
Collection of Catherine Hindson,
Hamilton

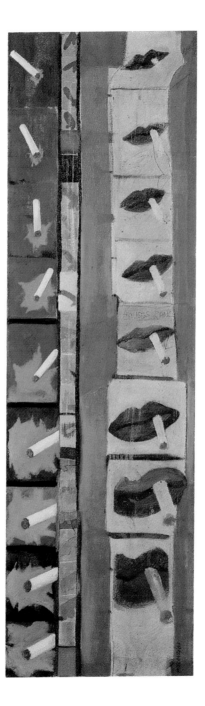

PLATE 39
West 4th *1963*
Oil on canvas
76.5 × 30.0 cm
Private Collection, Toronto

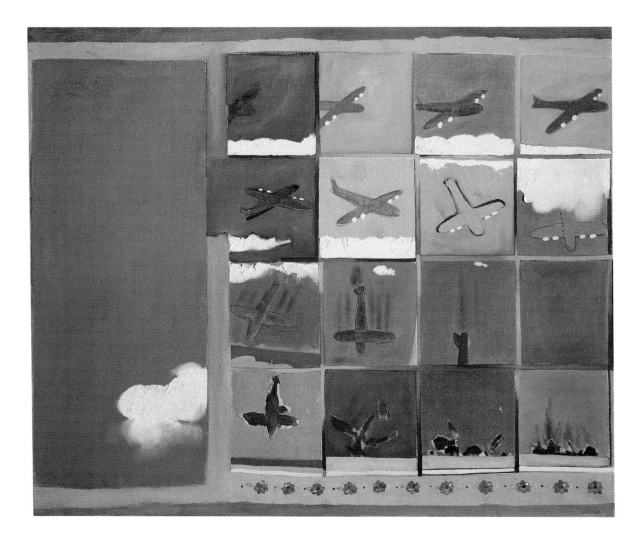

PLATE 40
Tragedy in the Air or Plane Crash
1963
Oil on canvas
128.6 × 157.2 cm
Vancouver Art Gallery, Vancouver

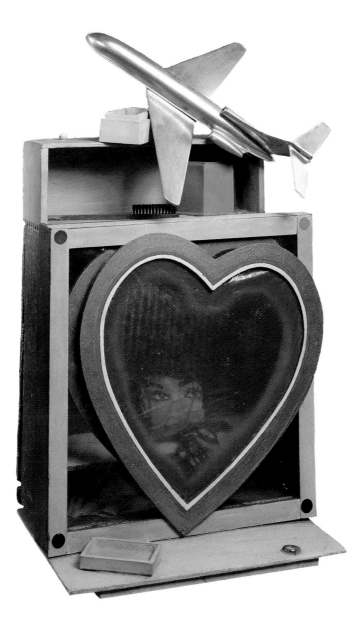

PLATE 41
Young Woman's Blues *1964*
Mixed media construction
44.5 × 33.0 × 22.9 cm
The University of Lethbridge Art
Collections, Lethbridge

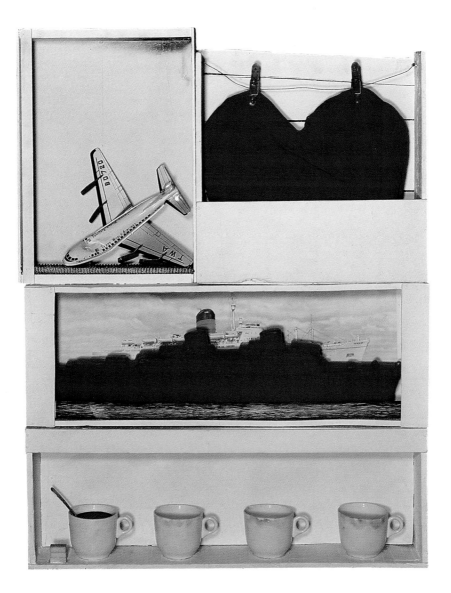

PLATE 42
Cooling Room II *1964*
Mixed media construction
114.3 × 94.2 × 18.1 cm
The National Gallery of Canada,
Ottawa

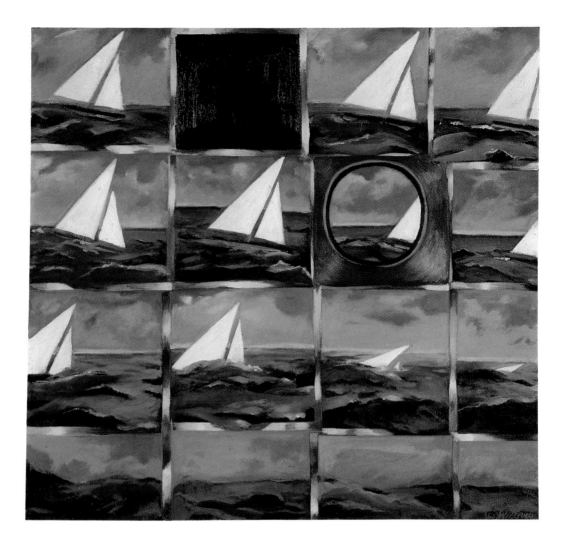

PLATE 43
Sailboat Sinking *1965*
Oil on canvas
76.5 × 81.5 cm
Collection of Ms. Betty Ferguson,
Puslinch, Ontario

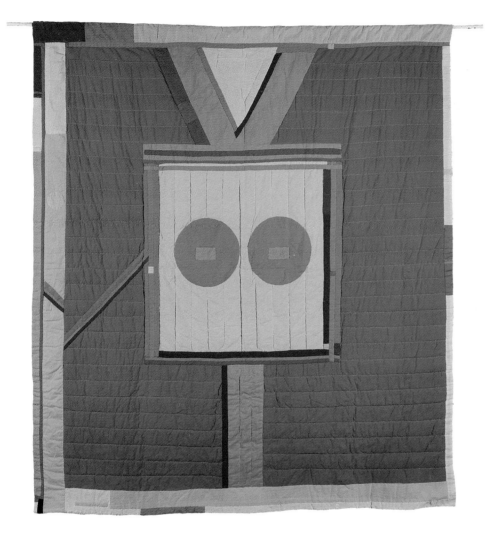

PLATE 44
The Camera's Eyes *1966*
Quilted cloth
203.0 × 202.0 cm
Courtesy The Isaacs Gallery,
Toronto

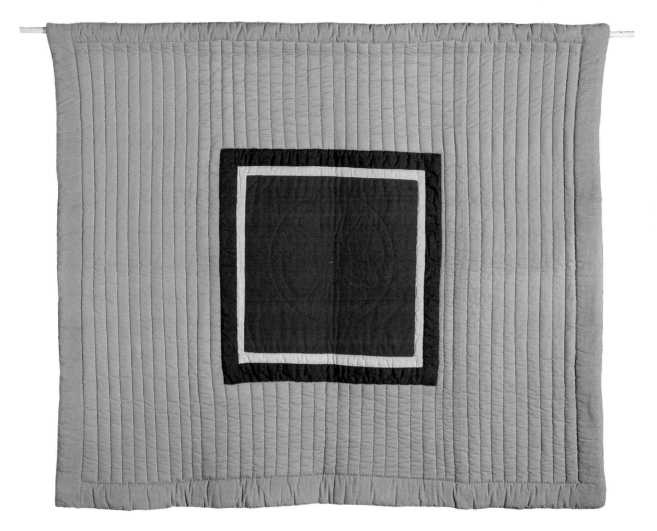

PLATE 45
Film Mandala *1966*
Quilted cloth
138.0 × 160.0 cm
Courtesy The Isaacs Gallery,
Toronto

PLATE 46
Patriotism *1966-67*
Mixed media
85.5 × 38.0 cm
Collection of Mr. and Mrs. George
H. Montague, Toronto

PLATE 47
Confedspread *1967*
Mixed media
150.5 × 201.9 cm
The National Gallery of Canada,
Ottawa

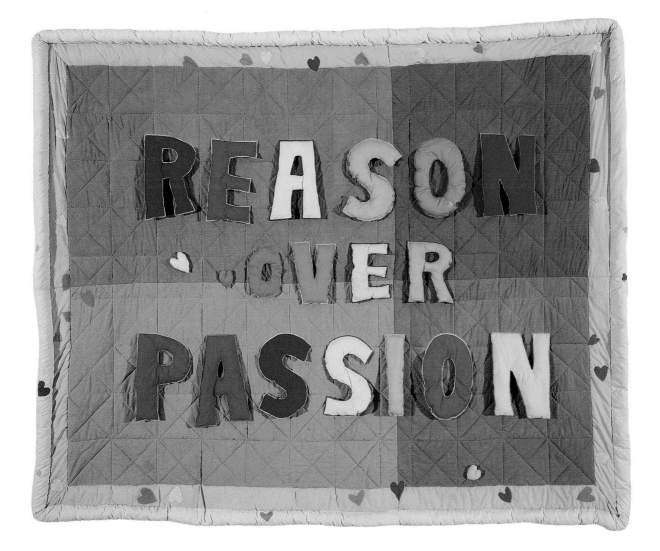

PLATE 48
Reason over Passion *1968*
Quilted cloth assemblage
256.5 × 302.3 cm
The National Gallery of Canada,
Ottawa

PLATE 49
O Canada Animation *1970*
Embroidery on cloth
107.0 × 114.0 cm
Collection of Edie and Morden
Yolles, Toronto

PLATE 50
The Water Quilt *1970-71*
Embroidered cloth and printed
cloth assemblage
134.6 × 131.1 cm
Art Gallery of Ontario

...erals ...aw materials with the United States. And, of course, the Liberals will not really notice having their sovereignty limited to orthodox free enterprise, since they have never been inclined to question its limits in any case.

Of course, there are many men of letters in this country who are still debating whether there is significant American control of Canada. They have not yet perceived the main course of Canadian history, let alone the possible alternatives for the Canadian future. Many of them will undoubtedly fail to recognize that the energy deal is coming. Once it comes they will not understand its implications. An inability to perceive the reality of conditions in one's country is quite naturally, endemic to colonialism.

The impending energy deal forces the Canadian people to face up to fundamentals in contemplating their future course. It will mark a genuine parting of the ways for Canada. To resist the energy deal,

— 47 —

PLATE 51
The Water Quilt *1970-71*
(Detail)

PLATE 52
Arctic Day *1970-71*
Coloured pencil on cloth cushions
247 cm diam.
The National Gallery of Canada,
Ottawa

PLATE 53
Eskimo Song—The Great Sea
1970-71
Cloth assemblage
251.5 × 96.5 cm and
96.5 × 259.1 cm
Collection of the Canada Council
Art Bank/Collection de la Banque
d'oeuvres d'art du Conseil des arts
du Canada, Ottawa

PLATE 54
Montcalm's Last Letter/Wolfe's Last
Letter *1971*
Embroidery on cloth
34.5 × 27.4 cm each
Collection of the Hon. John
Roberts, Toronto

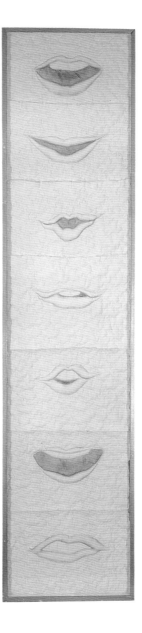

PLATE 55
The Maple Leaf Forever II *1972*
Coloured pencil on quilted
assemblage
218.4 × 50.2 cm
Collection of the Canada Council
Art Bank/Collection de la Banque
d'oeuvres d'art du Conseil des arts
du Canada, Ottawa

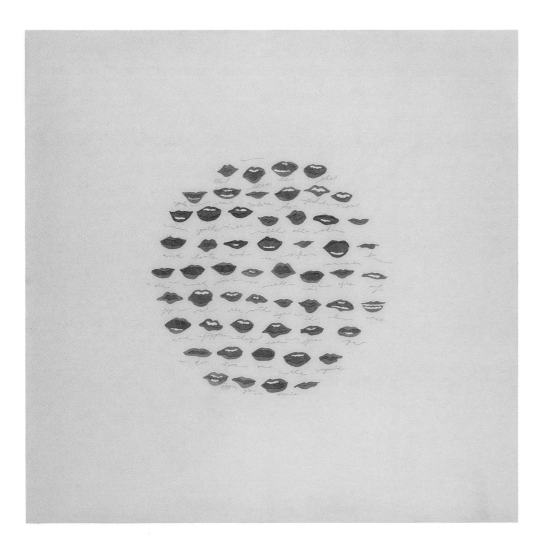

PLATE 56
Squid Jiggin' Grounds *1974*
Embroidery on cloth
80.5 × 80.5 cm
Courtesy The Isaacs Gallery,
Toronto

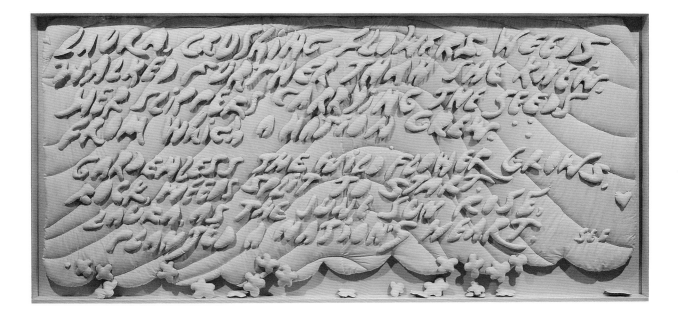

PLATE 57
Laura Secord *1974*
Quilted cloth assemblage
157.5 × 350.5 cm
The National Gallery of Canada,
Ottawa

Indian Summer

*Along the line of smoky hills
The crimson forest stands
And all the day the Blue Jay calls
Throughout the autumn lands*

*Now by the brook the maple leans
With all her glory spread
And all the sumachs on the hills
Have turned their green to red*

*Now by the marshes wrapped in mist
Or past some river's mouth
Throughout the long, still autumn day
Wild birds are flying south*

Wilfred Campbell

PLATE 58
Indian Summer *1974-75*
Embroidery on quilted cloth
233.7 × 203.2 cm
Collection of the Canada Council
Art Bank/Collection de la Banque
d'oeuvres d'art du Conseil des arts
du Canada, Ottawa

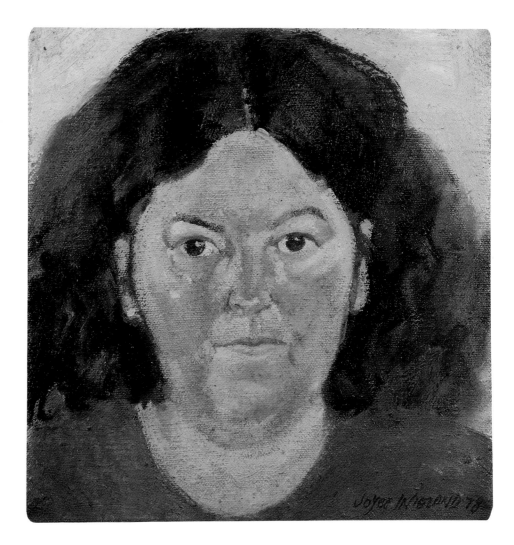

PLATE 59
Self-Portrait *1978*
Oil on canvas
20.6 × 20.3 cm
The Artist

PLATE 60
Soroseelutu *1979*
Lithograph
34.5 × 33.0 cm
Courtesy The Isaacs Gallery,
Toronto

PLATE 61
Birth of Newfoundland *1980*
Coloured pencil on paper
21.0 × 21.0 cm
Collection of R. J. C. McQueen,
Toronto

PLATE 62
Sunlight and Firelight *1980*
Oil on canvas
27.0 × 32.5 cm
Courtesy The Isaacs Gallery,
Toronto

PLATE 63
Conversation in the Gaspé *1980*
Oil on canvas
20.9 × 25.5 cm
The Artist

PLATE 64
Flight into Egypt (After Tiepolo)
1981
Oil on canvas
55.0 × 60.5 cm
Courtesy The Isaacs Gallery,
Toronto

PLATE 65
Lorymer *1981*
Watercolour
8.6 × 29.5 cm
Collection of Mrs. H. Mary
Kershaw, Toronto

PLATE 66
She will remain in the phenomenal
world filled with ignorance with her
sheep, and not go with him *1983*
Oil on canvas
25.5 × 38.2 cm
The Artist

PLATE 67
The Artist on Fire *1983*
Oil on canvas
106.7 × 129.5 cm
The Robert McLaughlin Gallery,
Oshawa
Purchase 1983

PLATE 68
Paint Phantom *1983-84*
Oil on canvas
121.9 × 170.2 cm
The National Gallery of Canada, Ottawa

PLATE 69
Crepuscle for Two *1985*
Oil on canvas
40.5 × 35.5 cm
Courtesy The Isaacs Gallery, Toronto

PLATE 70
Early One Morning *1986*
Oil on canvas
99.0 × 134.5 cm
Collection of Faye and Jules Loeb,
Toronto

the illusion of movement. They emphasized the tensions among the physical materials, the spectator's perceptual processes and the emotional or pictorial realities cinema has traditionally represented. The didactic goal of such self-reflexive address was to be an alternative to a tradition of expression based on verisimilitude and pictorial illusion.[8]

HAND TINTING (1967-68)

Wieland's short films made between 1965 and 1968 admitted "structural" issues of concern while they continued to analyse women's positions as social beings and to develop the theme of the disasters of political power and domination. For example, *Hand Tinting* (1967-68) loop printed and reversed (or made photographic negative) images of teenage black girls dancing, swimming and talking. Wieland reprinted the same sequence of film frames so that a repetitive or "loop" effect resulted in actions that recur but are never completed.[9] The girls' incomplete movements and gestures become isolated rhythms of social rituals. Lacking spatial depth and temporal completion, the repetitive actions negate the illusion of solid space created in realist cinema. They so destroy formal, illusionistic conventions that all that remains are facial and bodily signs for women of colour.

Such short films as *Hand Tinting* and *1933* (1968), *Sailboat* (1967-68), *Catfood* (1968), and *Rat Life and Diet in North America* (1968) legitimized Wieland's position among New York City's structural filmmakers. In his list of leading structural filmmakers, P. Adams Sitney included Wieland along with Michael Snow, Ernie Gehr, Paul Sharits, Tony Conrad, George Landow and Hollis Frampton.[10] Canada's leading art periodical, *artscanada,* reviewed

each of Wieland's new films from 1967 to 1970.[11] *Artforum,* the most prestigious North American art magazine, also asserted Wieland's importance as a structural filmmaker.[12]

However helpful such enlarged critical prominence may have been to Wieland's career, the structural film label led to the films' reception only within the confines of structural film's formalist issues. Critics ignored the political dimensions as well as the more feminine features of Wieland's films—their content of domestic interactions, the magnified point of view without any spatial depth and the sensuous colours, textures and shapes. Perhaps better than any other short film, *Rat Life and Diet in North America* demonstrates that Wieland's structural analysis interwoven with social protest and a feminine aesthetic sensibility make her films part of a radical cinema that reaches further than the narrowly defined concerns of structural film.

RAT LIFE AND DIET IN NORTH AMERICA (1968)

A loose narrative film (FIGURE 45) in the self-styled guise of an animal parable like those by Beatrix Potter (author of the "Peter Rabbit" tales), *Rat Life* tells the story of some gerbils who are political prisoners in the United States. They break out of captivity, elude their cat jailers and escape to Canada, where they start a co-operative organic farm. Sequences show the gerbils loose amid the dirty dishes of a finished supper while they are "on the lam." Later in the film, they nibble cherries during the cherry festival that is celebrated when they have won their freedom. The magnified images intensify the sensuous colours and textures of food, crockery

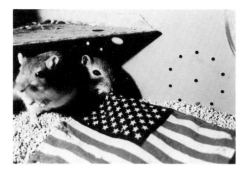

and cloth, creating an effect similar to that of Dutch still-life paintings. *Rat Life* reintroduces Wieland's humorous sense of play while it reiterates her personal trademarks of static and flattened space, expressive textures, intricately detailed movements and magnified gestures.

The continuous use of close-ups may have been necessary to scale the gerbils as actor protagonists. But the extreme close-up, a recurring Wieland point of view, also disrupts any perception of depth. Wieland further reinforces the perceptual impression cinematographically in frame superimpositions of titles and red crosses, capitalizing on the designs of commercial packaging that she learned during her apprenticeship at Graphic Films. She temporally undermines the illusionism through frame flashes of black leader film and other insert shots. The results celebrate the formal beauty of a miniature that becomes accessible only when it is magnified.

Wieland's whimsical children's tale is also a narrative whose story is conveyed in its coded recognition of Potter's animal picture books. It relies upon the viewer's familiarity with the dominant features that characterize the Peter Rabbit tales and other children's books: anthropomorphic heroes, simple words juxtaposed on images, concise narrative structure and brightly coloured representational graphics without any illusionistic three-dimensionality. Thus, through the codes of another popular domestic idiom, Wieland frees her narration from the need for detailed explanation or strict cause-and-effect progression.

It is ironic that a format calculated for sentimental and naive expressions should be so polemical. Wieland entertains highly didactic purposes in her examination of the cinematic materials (in-

FIGURE 45
Rat Life and Diet in North America
1968

cluding storytelling as a dominant feature in the history of cinema) and in the introduction of her theme—that the United States is an aggressive imperialist power dominating Canada. *Rat Life* makes explicit Wieland's identification with the victims of such political power and her commitment to art as an act of political discourse.

REASON OVER PASSION/LA RAISON AVANT LA PASSION (1967-69)

All around Wieland, people were expressing their anger at the United States' military involvement in Vietnam. In New York City in the late 1960s, Wieland lived within a social group characterized by its free-spirited romanticism, its antagonism to traditional American mores and values and its allegiance to left-wing political philosophies. In an environment in which college students, left-wing radicals and artists openly debated American foreign policies as well as the politics of art, a Canadian expatriate grew increasingly furious not only about American intervention in southeast Asia but also about U.S. exploitation in her home country. Wieland's feature-length film *Reason over Passion/La raison avant la passion* (FIGURE 46) is the artistic outcome of her anger, a statement that cemented her commitment to Canadian nationalism.

When Canadians expressed intensified concern in the 1960s about national pride as a means to combat U.S. hegemony, they thought that the electronic media seemed best able to stimulate such unity.[13] But Canadian television and movies were overwhelmingly the exported products of Hollywood and all but ignored Canadian issues and tensions. When journalists did represent Canadian culture, they fell victim to the electronic media's propen-

FIGURE 46
Reason over Passion *1969*

sity for pictorial, shorthand impressions rather than in-depth analyses. *Reason over Passion/La raison avant la passion* demonstrates the way in which the visual media—which use selected and edited images—substitute for first-hand experience of the subject they represent.

Largely comprised of Canadian landscapes shot with a hand-held camera from a moving car or train and then rephotographed from a moviola, *Reason over Passion/La raison avant la passion* presents the soothing, lulling clichés of the travelogue documentary. As referents to an encoded, picturesque unity more sophisticated than the children's book (*Rat Life*), the images are Wieland's basic material commentary on Canada's struggle for national identity and unity. Among the postcard-like impressions, Pierre Trudeau functions as a Canadian icon in much the same way that selected Canadian landscapes do. The Prime Minister, whose face signified to the rest of the world the myth of a unified Canada, is shown in freeze-framed close-ups (reminiscent of the technique in segments of *Hand Tinting*) accompanied by grinding machine noises.

Wieland's illusionistic fragments physically challenge their own verisimilitude and their ability to "explain" reality. The graininess of the rephotographed footage reduces the precision of depth illusion, deliberately making the images ineffective as photographic representations of reality. Superimposed subtitles heighten the images' function as flat backgrounds for a written text. The title superimpositions, themselves nonsensical permutations of the words "reason over passion," add neither contextual meaning nor any informational explanation of the pictures.[14]

An electronic beep sounded at regular intervals further alienates the viewer from the isolated visuals and, by its measured regularity,

emphasizes the film's slow pace. In other words, the sound builds into the parade of landscape shots a rhythmic measurement of the phenomenon of time passing while one watches a movie. Wieland heightens one's self-awareness with many structural tricks from her earlier works—in particular, repetition, slow motion, speeded-up motion, and jump cuts. The film's self-reflexive treatment of time leads to a contrast between viewing duration and the actual time represented by travel across Canada.

By dislocating the familiar codes and structures of travelogue documentaries, the film relies upon structural strategies to isolate itself from any experience independent of the cinema. The contrast between the opening and closing shots underscores the point. In the opening, Atlantic waves rolling in on Canada's eastern coast dynamically signify unspoiled land embraced by the sea. The film ends with a similar image; but the object seen is itself a postcard of the British Columbia coast. A popular form of the travelogue, the card also depicts sea bordering land. But as a landscape reduced to one frozen image, the postcard can only be a tangible object for consumption. *Reason over Passion* ultimately deconstructs the material processes of images and their roles in political ideology.

As her nationalism grew, Wieland felt a corresponding loss of the ideals that independent filmmakers cherished in the 1960s. As the New York artisanal cinema became increasingly absorbed into established museums and universities in the late 1960s, these institutions reversed the non-selective programmatic base that had first attracted Wieland to the independent cinema. Museums, universities and their critical organs valorized a group of films and a star system of artists.[15] Wieland's husband, Michael Snow, and her close personal friend Hollis Frampton were among the first beneficiaries of such an effort, a circumstance that must have particularly rankled with

Wieland who had worked side by side with both men since the beginning of their filmmaking efforts.[16]

The new cinema system supplanted a discourse of political art practice with one of intellectual aesthetic theory. Once this had happened, Wieland's attempts to participate in the filmmakers' discussions resulted in admonishment: "I was made to feel in no uncertain terms that I had overstepped my place [as a woman]."[17] Wieland became an outsider to the very group of structural filmmakers to whose aesthetic identity she had contributed.

Cut loose from her support group, Wieland returned to Toronto in 1971. While she simultaneously worked in other media and actively participated in the political protests launched by CARO (the Ontario branch of CAR—Canadian Artists Representation), she made two new short films. *Pierre Vallières* (1972) and *Solidarity* (1973) tackle contemporary Canadian political issues and create sympathy for the oppressed—in one, a Québécois separatist who is a political prisoner; in the other, labourers who are striking against a factory owner. The two films remain aesthetically rooted in structural cinema but have a popular accessibility that is not present in any of Wieland's earlier work.

PIERRE VALLIÈRES (1972)

This film (FIGURE 47) is based on a half-hour interview that Wieland and two other women conducted with the famous revolutionary Pierre Vallières. His activities supporting Quebec's secession from Canada had made him an outlaw and a folk hero. Wieland's film concentrates on a single physical detail of the man, Vallières's moustached mouth. For the movie's thirty-three minutes,

the visual image of the moving mouth fills the entire screen, while the sound-track is composed of Vallières's monologues on what he sees as Canada's two primary colonized groups: women and the Québécois.

Drawing on a *cinéma vérité* rhetorical style, the film focuses on a political oral narrative spontaneously presented in response to an interviewer's questions. But, though one expects from *cinéma vérité* that the character will unknowingly reveal some deeper truth about himself, the single image of the speaker's enlarged mouth does not initially seem well-suited for character analysis. This rather typical Wieland point of view (which is reminiscent of her 1971 *True Patriot Love* exhibition pieces *O Canada* and *O Canada Animation*) is a highly unusual practice in *cinéma vérité;* it is also a recurring feature of Wieland's structural films. The image of Vallières's mouth resurrects the structural technique of extensively examining a single picture in order to reveal something about how it conveys meaning.

In its magnified state, the large pulsating mouth—two pink, moist lips, coarse, black hair and a graceful tongue—has a physical similarity to female genitalia. If a linkage between mouth/lips and vagina is already symbolically inherent, the particular point of view here makes it visually explicit. But the image further inverts classic psychoanalytic interpretations of female sexuality as negative, unformed and passive and instead highlights the strong, sensuous movement of the lips.

The image also imparts an important cultural significance. The discoloured, crooked teeth framed by the two lips and moving tongue suggest the speaker's origins in the working class. The cultural hero here is ostensibly the colourful individual Pierre Val-

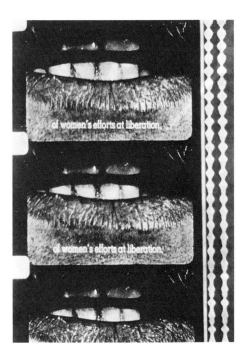

FIGURE 47
Pierre Vallières *1972*

lières, but Wieland has so individualized a single detail that it becomes an emblematic icon for sexual and political power. In totality, it is the man's mouth that becomes a social poetics about the interconnectedness of three elements: the individual, feminine sexuality and political power.

SOLIDARITY (1973)

Wieland renewed political and aesthetic harmony in her next film, made a year later with Judy Steed. Like *Pierre Vallières, Solidarity* is composed of documentary footage. Its images are from a workers' strike at the Dare food plant in Kitchener, Ontario. Like *Pierre Vallières,* it has a close-up viewpoint accompanied by political speeches that emanate from the image's field (diegetic sound). In this case, however, the closely examined objects are the feet of various picketers at a demonstration; the sound-track is made up of the electronically amplified speeches from the stage. For the first time in Wieland's film career, she made the political conditions of Canadian working women her exclusive subject matter.

In *Solidarity,* Wieland has finally found an alternative for creating spatial depth without depicting it pictorially in a realist cinematic manner. The moving camera and edited series of feet affirm a greater spatial field without defining any continuous geographic space. Whereas Vallières's voice acoustically marked an off-screen space as an extension of the limited, static frame, *Solidarity*'s electronically amplified speeches and crowd reactions only allude to an ambiguous space beyond the magnified frame. Wieland has produced an ''imaginary terrain'' filled with feet, women's strong voices and radical messages.

Solidarity is reminiscent of Wieland's earlier experimental films in that its magnified details are so isolated from any depth of field and are seen so closely that colours, textures and shapes become interesting features in and of themselves. The numerous mud puddles against which the feet are viewed are more evocative of *Water Sark*'s celebration of light-reflected surfaces almost ten years earlier than of *Pierre Vallières*. But, like *Pierre Vallières,* the magnified images have important cultural connotations. In this case the feet— sandalled, high-heeled, bare, black, white, etc.—reinforce the sense of crowd diversity and, more importantly, underline the multiplicity of ethnic, age, class and racial groups composing the demonstration. It seems appropriate that Wieland, who loves puns and ironies, may claim credit for progressing in a short span of time from watching what a leader says to concentrating on what the people's feet do.

Although these two films were unrehearsed documentary portraits of living political subjects, they only marginally entered into public discourse regarding the social issues they treated. Wieland's Canadian and American distributors instead marketed the films almost exclusively within an experimental film discourse that emphasized the films' structural qualities. *Pierre Vallières* and *Solidarity* played in experimental film categories at North American and European film festivals, colleges, museums and alternative film coalitions, where they were critically accepted within an aesthetic of structural film conformity.

THE FAR SHORE (1976)

Hoping to reach a wider public audience, Wieland attempted a breakthrough to the commercial cinema. She sought to infuse a popular idiom with Canadian ideological issues and feminist alternative practices. She expected that her plan might work in Canada where, at the time, any Canadian-made film was, by definition, alternative cinema. As Wieland's art dealer, Avrom Isaacs, observed: "Anyone else [but Joyce] would have known that you couldn't raise the money [to make a movie] . . . and they wouldn't have tried."[18] Few Canadian films could secure enough investors to be completed, and even fewer reached the public.[19]

However, a wave of optimism regarding the future of a Canadian film industry and new economic incentives had an ameliorating effect in the middle 1970s. A small number of commercial Canadian films were beginning to make an international breakthrough. The success of such films as *The Apprenticeship of Duddy Kravitz* (1974) and *Lies My Father Told Me* (1975) seemed to indicate the emergence of a Canadian film industry that would break the market monopoly of Hollywood films. When, in 1972, the Canadian government closed a tax loophole that gave private investors a more sizable tax write-off for films that were non-return investments, it halted investment interest in the failure of Canadian cinema. In 1975, the two largest theatre chains (Famous Players Limited and Odeon Theatres Limited) agreed to support the emergent Canadian film industry with a voluntary exhibition quota and an investment program.

Wieland's fund-raising efforts for her film benefited directly from such changes. Like other hopeful commercial projects, Wieland's film received public funding from the Canadian Film Development

Corporation, the national agency that promoted Canadian commercial filmmaking. But she required more than limited federal support in order to complete production and gain access to the exhibition network. With the changed atmosphere in 1975, she was finally able to get the necessary production funds from Famous Players Limited, and the corporation's backing assured her entrance into the commercial exhibition network.

Wieland's film (FIGURE 44) participated in this boom because, in its guise as a period melodrama, it appeared to be an ideal commercial vehicle—an apolitical, sentimental story about a pair of star-crossed lovers, one Québécois, the other English Canadian. It met the investors' need for a Canadian story, while its script did not stray too far from Hollywood generic conventions. *The Far Shore,* however, invokes social analysis through the heroine's discovery that, legally, economically and psychologically, marriage robs a woman of her independence and right to self-determination. Adopting melodramatic form for a radical feminist statement, *The Far Shore* both depicts the way the bourgeois family entraps the individual, and critiques the nuclear family as the basic social model of patriarchal culture.

The crises of domestic melodrama are personal and emotional (as distinct from the primarily social and behavioural conflicts of westerns, science-fiction films or horror movies). The possibilities for broad spatial action are therefore more limited in domestic melodrama than in other film categories. The genre must depend upon states of mind expressed (or externalized) in visual terms. British film scholar Thomas Elsaesser has described the process as a sublimation of the dramatic values into the *mise en scène.*[20] Elsaesser concludes that the best family melodramas (including those by

Vincente Minnelli and Douglas Sirk) introduce through the *mise en scène* (or visual trappings and organization) a claustrophobia that visually undermines the family as a structure for a woman's individual fulfilment.[21]

Elsaesser's argument is an important consideration for a discussion of *The Far Shore,* because Wieland makes the "subversive" element submerged in Hollywood family melodrama her dominant mode of expression. The idea of spatial and material entrapment in the family is *The Far Shore*'s primary theme. But while maintaining the characteristic structure of family melodramas, Wieland also introduces a new submerged discourse that addresses the tension between experimental film strategies and imitation of realist cinematic practices.

The Far Shore's chief unifying devices—the visual correlatives articulated through the *mise en scène*—depend upon a host of allusions to personal, filmic and painterly art that exist outside the space of the film. The flattened image on the rectangular screen here becomes an allusion to historic art styles. Interior scenes reproduce the look of Dutch and Italian Old Masters, while the lake wilderness scenes photographically mimic famous Canadian painters' interpretations. Critics have noted similarities between *The Far Shore*'s use of colour harmonies and that of eighteenth-century Venetian artist Giovanni Battista Tiepolo.[22] The movie's lighting and textural effects in certain scenes are reminiscent of Jean-Baptiste Siméon Chardin or the Canadian landscape artists of the Group of Seven. The *mise en scène* employs dramatic expressionistic light to intensify colour, and it imitates a baroque painterly illusionism, functioning simultaneously as a visual correlative for the intense emotional crises of the heroine and a photographic "summary" of European

and Canadian art history. In its attempt to serve both a narrative function and a conscious metaphorical one, the *mise en scène* relies upon such an extended play of painterly homage that it ruptures the smooth operation of cinematic realism. Wieland exploits a common technique from her structural films. As self-consciously composed "forgeries," Wieland's images contradict the notion that they represent photographic material of a natural world.

For example, repetitive close-ups of carpets, paintings and embroideries bridge changes of scene and time within the telling of the story. At the symbolic level, the objects (all works of art) are *leitmotifs* intertwining the heroine's and the hero's identification with artistic activity as the means for spiritual redemption. But these close-ups are so magnified that they emphasize the material qualities of the images, their texture, hue, reflection of light and formal arrangements. The close-ups ultimately undermine the function of the images as objects within an illusionistic story and point instead to their own physical composition.

Borrowing a technique that she used in *Solidarity,* Wieland makes the close-up of a richly patterned carpet Eulalie's (the heroine's) subjective point of view while Eulalie listens to her husband lecturing his employees. The extended duration of the close-up fixes the image as a representation of an art object and as a self-referent, undermining its service to the illusionism of the narrative. The accompanying voice of the husband, Ross, relays information about engineering's role in building the future. It comes from an off-screen space that cannot be identified as an extension of the on-screen space. Sound and image operate as discrete elements, establishing an antagonism between contemplating objects as art and the scientific approach of dominating and mastering nature.

Two other such cutaway close-ups serve similar functions and, like the first example, run counter to the Hollywood convention of introducing a new scene with a wide establishing shot that orients the spectator to an implied three-dimensional space. Wieland instead begins a night scene of the heroine, Eulalie, occupying her time alone with an extreme close-up of an embroidered fish on which a hand sews. The shot again serves Eulalie's subjective point of view and also reinforces the spectator's identification with her as a protagonist-artist. The embroidered fish symbolically refers to the water and the water/life motif that links the painter, Tom, to Eulalie throughout the film; and, finally, the image reinforces the role of art itself as both a structural and a symbolic motif for unity.

The long scene introduced by the embroidery close-up ends when Eulalie's husband begins to rape her. The film cuts from a medium long shot of the grappling couple in their parlour to an extreme close-up of another fish, one that Tom is painting onto a shop window. The motif contrasts Tom and Eulalie as artists to Eulalie's husband. (Ross's sexual activity is a violent attempt at domination in the form of rape, and his professional activity also rapes the land and water in order to build sewers, bridges and dams that will exemplify man's mastery over his environment.) Lacking definition and the suggestion of modelling, the image of the partially formed fish is initially unable to indicate any cinematic space or even a natural object. It momentarily disrupts the smooth flow of the story and links locales and characters only through the image's poetic properties.

An extended scene between Tom and Eulalie in Tom's cabin midway through the film further illustrates how Wieland operates this process along the story's trajectory. The characters take turns

holding a magnifying glass up to their lips and silently mouthing texts to each other. The image is reminiscent of Wieland's extreme close-up of lips as the dominant image in *Pierre Vallières*. A detail within the close-up, the mouth (Wieland's personal motif for women's strength and power) literally becomes magnified cinematographically, producing a visual pun on the cinema's iris effect. The scene's lack of any accompanying sound-track further displaces emphasis onto the visual organization and interrupts the kind of flow on which classic narrative cinema is based.

After the silent mouthing, which occurs in real time, Wieland elides several days and weeks into roughly the same amount of screen time. She then inverts the depiction of elapsed time again as Tom and Eulalie sing an entire folk song together in real time. Although these different depictions of time occur within the same geographic space in the narrative, the sequences convey little new narrative information or insight into character; instead they operate more as pure poetic devices. They thus exemplify a creative mix of experimental and narrative techniques that undermine the film as a conventionally naturalistic story.

Other cinematic devices also convey the dual nature of Wieland's visual expressionism. For example, movement within the frame usually occurs within shallow space and across strictly horizontal or vertical lines. Such limited, rigid movements lack depth cues or any reference to an off-screen geography that would indicate a deeper, more solid sense of fluid space—the ideal of cinematic realism.

In Eulalie's bedroom, where the claustrophobic entrapment of her marriage has reached crisis proportions, the film cinematically achieves its critical climax. A close-up iris shot of Eulalie fades completely to a white disc framed in red. It then slowly dissolves to a

canoe crossing a lake within the white disc and then irises out so that the landscape image fills the entire frame. As a simple narrative transition, the highly unusual shot fluidly weds Eulalie to the wilderness landscape through which Tom now glides in his canoe.

The shot also introduces more abstract levels that make the subject of the transition its transcendence into a cinematic art object. The constriction visually portrays Eulalie's psychological claustrophobia with Ross, and the dilation symbolically foreshadows the psychological release she will feel when she joins Tom in the wilderness. It also suggests a subjective sexual daydream, and the activity of the technique makes female orgasm the power that here controls and unifies the image. The midway red-and-white formal abstraction of the extended dissolve also symbolically links Tom and Eulalie with the colours of the Canadian flag.

The technique pays homage to silent-film director D.W. Griffith's cinematic use of irises as an effective bridge between scenes. *The Far Shore* is punctuated with silent-film techniques that are contemporary with the story's time period. For example, the increasing tempo of cross-cutting between Eulalie and Tom in one canoe and their pursuers, Ross and his friend, in another canoe, cites Griffith's use of parallel action. Griffith's convention for conveying a climactic pursuit may seem a quote easily contained within narrative flow, but the reference itself becomes pronounced when accompanied by a musical cliché for silent-film chases. Removed from current narrative handling of a pursuit, the scene becomes a parody of silent-film chases when the cinematic method itself becomes the subject. The film creates an obvious narrative rupture during its most important dramatic action.

The Far Shore champions the possibility of a genre critique as a political discursive challenge, and the ending eloquently makes the

point. The film does not, in the formula of Hollywood domestic melodrama, effect closure wherein the woman returns to the space within conventional bourgeois boundaries. *The Far Shore* instead concludes with Tom's visible death and an on-screen marker of Eulalie's disappearance. Until this last moment, the possibility for a conventional resolution existed either through Tom as Eulalie's more suitable partner for a contemporary liberal marriage or through Tom's death and Eulalie's subsequent return to her husband. But Eulalie's disappearance beyond the boundaries of the frame ruptures melodramatic closure. Eulalie, beyond the on-screen space established by the film, escapes to the invisible wilderness that Wieland labels "the far shore." In the context, this suggests that Eulalie cannot be reintegrated into any determined closure and can only accede to an as-yet-unactualized territory.

The Far Shore forms its ideological critique by mixing a codified structural film style and the Hollywood generic conventions associated with domestic melodrama. Generic formulas and experimental cinema have traditionally made markedly different sets of demands upon the spectator. *The Far Shore* does not articulate, either within the text (the body of the film) or in the context of marketing and publicity, the importance of simultaneously comprehending both levels of discourse. This resulted in serious problems with "reading" the film. Popular commercial movie audiences were not generally familiar enough with the way Wieland drew upon structural film strategies when the film first appeared, nor were they accustomed to the plethora of visual symbolism that makes the film coherent. Independent cinema followers were not comfortable with Wieland's wholesale adoption of a cinematic discourse so enmeshed in popular codes and so removed from a "pure" experimental

discourse of low budgets, anti-narrative or narrative deconstruction and formal or phenomenological aesthetics. Taking into account the popular audiences that were unprepared for the radical formal strategies, the art crowd that felt the film was a paean to commercialism and the nationalists who thought that *The Far Shore* purveyed an apolitical, sentimental federalism, few viewers were left to champion the film. With all these detractors, *The Far Shore*'s interest as a feminist film got lost.

But the strengths of *The Far Shore* lie in exactly those strategies that most disoriented viewers and that alienated audiences when it was first released, strategies whose radical feminist stance were particularly noted by British feminist theorist-filmmaker Laura Mulvey.[23] In its critique of both Hollywood and experimental cinematic operations, and as an attempt to create a commercially viable feminist cinema, *The Far Shore* prefigures a major direction of independent cinema in the 1980s.

NOTES

Chapter 1 Watershed

1. Quoted by Sara Bowser, *Canadian Architect* 5:10 (Oct. 1960), p. 69.

2. "Kay Armatage Interviews Joyce Wieland," *Take One* 3:2 (Feb. 1972), p. 24.

3. In 1969, Wieland and others formed "Les Activistes Culturels Canadiens," did a burlesque "action" at the Canadian Consulate in New York and sponsored a pro-Trudeau "quilt-in" at her loft. While she has not made much of herself as an "oppositional" artist (except in her anti-American phase), Wieland has a history of activism. She has picketed with several strikes involving women's issues and worked with athletes and farmworkers and with CAR (Canadian Artists Representation). The two *Patriotism* films, the *Hand Tinting* film (constructed from out-takes of a Job Corps film about poor, young black and white women whose vitality and "bad" language have been taken out of society as well as out of the official film) and *Solidarity,* which documents a women's strike solely through the movements of their feet, join the better-known "political films." Wieland also participated in the International Shadow Project to commemorate Hiroshima and Nagasaki and has been active in ecological campaigns. "I am an activist who feels," she said in 1971.

4. P. Adams Sitney, "There Is Only One Joyce," *artscanada* 27:2 (Apr. 1970), p. 44.

5. Quoted in Olivia Ward Taylor, "Artist Joyce Wieland: Blossoming at 50," *Toronto Star,* Feb. 8, 1981.

6. Quoted in Sandra Paikowsky, *Joyce Wieland: A Decade of Painting* (Montreal: Concordia Art Gallery, 1985), p. 3.

7. Quoted in Leone Kirkwood, "Canadian Artist in New York Pioneers in Nameless Art Form," *The Globe and Mail,* Mar. 17, 1965.

8. Quoted in Armatage, "Kay Armatage Interviews Joyce Wieland."

9. See in particular Lauren Rabinovitz's excellent article "Issues of Feminist Aesthetics: Judy Chicago and Joyce Wieland," *Women's Art Journal* (Fall/Winter, 1980-81). Similar ideas were percolating independently through the 1970s in Australia and in England. Rabinovitz's equally important piece "The Development of Feminist Strategies in the Experimental Films of Joyce Wieland," *Film Reader* 5 (1982) and her interview with the artist in *Afterimage* (May 1981), treat many of the issues so intelligently and so well that I have avoided reiterating them here.

10. Jonas Mekas, "Movie Journal," *Village Voice,* Apr. 3, 1969.

11. Quoted in Armatage, "Kay Armatage Interviews Joyce Wieland."

12. Ibid.

13. Sitney, "There Is Only One Joyce."

14. This phrase is used in a different context by Guy Brett in his brilliant new book *Through Our Own Eyes* (London: GMP Publishers, 1986).

15. John Bentley Mays, "Wieland: Strong Overshadows Sweet," *The Globe and Mail,* Apr. 23, 1983.

16. Lewis Hyde, *The Gift: Imagination and the Erotic Life of Property* (New York: Vintage Books, 1979), pp. 143, 192.

17. *True Patriot Love* (Ottawa: National Gallery of Canada, 1971).

18. As did Margaret Trudeau when she allegedly "tore the hand-stitched letters off his quilt and flung them in his face" (as reported by Olivia Ward Taylor, "Artist Joyce Wieland"); certainly reason can be a wet blanket over passion.

19. *True Patriot Love.*

20. As in so much art by women, animals play a major or at least frequent role in Wieland's work. Her "artist's statement" for a 1967 show was the story of a black dog who seemed to be an avatar. Two of her best-known films are *Rat Life and Diet in North America* and *Catfood;* in *The Far Shore* a dog dances and eats at the table; live ducklings were part of the *True Patriot Love* show, as was a sculpture, *The Spirit of Canada Suckles the French and English Beavers;* and "Sweet Beaver: The Perfume of Canadian Liberation" (a play on sex, nature and advertising) was actually bottled and sold. The *True Patriot Love* show, incidentally, was the first at the National Gallery by a living woman artist. Emily Carr's posthumous show was combined with Indian art—killing two minorities with one stone.

21. Kay Kritzwiser, "Wieland: Ardent Art for Unity's Sake," *The Globe and Mail,* Mar. 25, 1967.

22. The idea, which I gather ended up one-sided, was that they would draw each other, just as years before Wieland had used films as a two-way mirror or dialogue with Wendy Michener and Hollis Frampton. Wieland aspires to a certain shamanism, and has often told the story of a great Eskimo woman shaman who "went out in the middle of one winter to have a pee . . . and at that moment a meteor came from space, entered into her body, and she received her helping song from her helping spirit: 'The Great Sea Set Me in Motion, Set Me Adrift, I Move as a Weed in the River, Earth and Great Weather Move Me, and Move my Inward Parts With Joy.' " The counterpart of this story might be the Gaelic tale (included in the book *True Patriot Love*) entitled "The Woman Who Lost Her Gaelic." (The Scottish element in Canada's identity particularly interests Wieland.) The loss or silencing of a language has obvious contemporary relevance.

23. For Lauren Rabinovitz on Wieland's films, see note 9.

24. Christopher Hume, "The Search for 'The Ecstatic'," *Toronto Star,* Apr. 30, 1983. Water as both innocence and sensuality is a recurrent theme in Wieland's recent work as well, taking its place with the other three elements in her similarly "ecstatic" mythology.

25. Sitney, "There Is Only One Joyce."

26. Quoted in Robert H. Stacey, "Joyce Wieland," in *Lives and Works of the Canadian Artists,* Robert H. Stacey, ed., vol. 16 (Toronto: Dundurn Press, 1977-79).

27. Marshall Delaney, "Wielandism: A Personal Style in Full Bloom," *Saturday Night* (May 1976).

28. Carole Corbeil, "Joyce Wieland Finds Room to Bloom," *The Globe and Mail,* Mar. 2, 1981.

29. Quoted in interview with Penelope Glasser, "Problems and Visions: Joyce Wieland Now," *Spirale* 1:3 (Winter 1981/82). Wieland has recently expressed renewed interest in film.

I should like to thank: the artist, for (appropriately) inundating me with the material from which this essay was constructed; the Canadian Film Cooperative, for sending me *The Far Shore;* and Robert Hanforth and Bernard Hogue of the Canadian Consulate, New York, for making it possible for me to view the film.

Chapter 2 Joyce Wieland: A Perspective

Quotations of the artist not otherwise documented are from conversations with the author in spring 1986.

1. *19 Canadian Painters '62*—J.B. Speed Art Museum, Louisville, Kentucky; *Fifteen Canadian Artists,* 1963—circulated under the auspices of the International Council of the Museum of Modern Art, New York; *Nine Canadians,* 1967—Institute of Contemporary Art, Boston; *Canada: art d'aujourd'hui,* 1968—Musée national d'art moderne, Paris; Galleria Nazionale de Arte Moderna, Rome; Palais des beaux-arts, Brussels; Musée cantonal des beaux-arts, Lausanne; *Canada 101,* 1968—Edinburgh International Festival; *Eight Artists from Canada,* 1970—Tel Aviv Museum, Israel; *49th Parallels: New Canadian Art,* 1971—John and Mabel Ringling Museum of Art, Sarasota, and Museum of Contemporary Art, Chicago.

2. The program was headed by Judy Chicago and Miriam Schapiro at the California Institute of the Arts in 1972.

3. Doris McCarthy to the author, May 1986.

4. Wieland worked at packaging design and point-of-sale display. "I had a real apprenticeship." And during this period, she studied at night with Robert Ross at Central Technical School and with a portrait painter, Mrs. Wilson Patrick, whose accomplished use of the oil medium she admired. In Europe Wieland was attracted to the work of the French fifteenth-century painter Simon Marmion and of the German painters Lucas Cranach, Mathias Grünewald and Antonius Köln.

5. Graphic Films was formed as Graphic Associates in late 1949 by former National Film Board animators George Dunning and Jim McKay and their business partner, John Ross. Wieland started working for Graphic on a free-lance basis and still remembers the first project she was given—to animate Niagara Falls. She subsequently joined the staff. McKay left at the beginning of 1955 and soon formed his own company, Film Design. "In 1956 Wieland and others were fired for fooling around too much, leaving Snow (as head of animation) . . . just before the company folded. Dunning moved to England to establish another company, which became famous for producing the Beatles' TV series and *Yellow Submarine.*" John Porter, "Artists Discovering Film, Post-war Toronto," *Vanguard* 13: 5/6 (Summer 1984), p. 26.

6. At noon hour and after work they collaborated in the filming of spoofs and melodramas: *Salada Tea Commercials,* including *Tea in the Garden,* 1955/56—Warren Collins, Graham Coughtry, Michael Snow and Wieland. *A Salt in the Park,* 1959—Warren Collins, Bob Cowan, Michael Snow and Wieland.
 In 1959 Collins helped Wieland buy her first movie camera, a used 16 mm Bolex. That same year they collaborated on a film about dogs. However they could not agree on the editing and the film remains unfinished.

7. Hans Bolliger, *Picasso's Suite Vollard* (Stuttgart: Verlag Gerd Hatje, 1956; English translation, London: Thames and Hudson, 1956). Wieland acquired her own copy in 1959.

8. Attilio Salemme, 1911-1955, is described as: "Boston painter, widely exhibited and collected . . . paintings of geometric . . . carefully thought-out . . . patterns in bright, clean, flat colors show manikin-like figures. . . ." *Art News* 52: 7 (Nov. 1953), p. 57. Illustration in *Bulletin,* 20: 3-4 (Summer 1953), p. 45, Museum of Modern Art, New York.

9. An example of a relevant earlier work of Wieland's is the 1952 wax print, *Woman's Kiss,* formally very close to Picasso's type of combined profile and full-face representation.

10. "I expect my work is influenced a great deal by my husband," Wieland is quoted as saying, by Helen Parmalee in "Meet the Avant-Garde Artists," *The Telegram,* Sept. 24, 1960.

11. Barrie Hale, in the introduction to *Toronto Painting: 1953-1965* (Ottawa: National Gallery of Canada, 1972), p. 26. "During this period two loosely defined but nonetheless distinct groups began to take shape, and it is their growth to maturity that characterizes what might be called the Toronto Look. The first group is comprised of the major artists of Painters Eleven; the second, its numbers growing as the sixties advanced, among them Graham Coughtry, Michael Snow, Joyce Wieland, Dennis Burton, Robert Hedrick, Gordon Raynor, Richard Gorman, Robert Markle and Paul Fournier, are anything from five to a dozen years younger than the youngest of the Eleven . . ."

12. Joyce Wieland, "de Kooning's *February,*" *Evidence* 2 (1961), unpaginated. (*Evidence* was a Toronto periodical published between 1961 and 1967 as a forum for new literature and experimental art.)

13. Sara Bowser, "Joyce Wieland," *Canadian Architect* (Oct. 1960), p. 69.

14. David Burnett, *Toronto Painting of the 1960s* (Toronto: Art Gallery of Ontario, 1983), p. 15.

15. A fascination with Dada and its offshoots was evident in the Toronto scene. The periodical *Evidence* featured Duchamp on its cover and in an interview in its fall 1961 issue; the Isaacs Gallery presented Dada-type shows and mixed-media events culminating in a chess game between Duchamp and John Cage at the Ryerson Polytechnical Institute; University of Toronto professor Michel Sanouillet, who edited Duchamp's writing, "wanted," in Wieland's words, "to have it live again . . . [and] really brought a lot to our scene." In his review of the 1961-62 Isaacs show (in *Canadian Art* 19:2, p. 111), Sanouillet commented, "For instance, Joyce Wieland's *Napoleon's Grave*—a rag dummy in a soapbox coffin surrounded by fresh roses and burning candles daily renewed by the artist—is typical of this new brand of Dadaism. It implies a deep-rooted rebellion"
Moreover, when living in New York, Wieland and Snow visited Duchamp a couple of times. Snow was planning a film; Wieland has footage Snow took of her and Duchamp walking together.

16. William S. Rubin, *Dada and Surrealist Art* (New York: Abrams, 1968), pp. 14, 409.

17. See Lucy R. Lippard, *From the Center* (New York: Dutton, 1976), pp. 49, 73, 81, 143-4.

18. Wieland had tried this approach earlier with Mondrian's work; the resulting paintings, shown at Barry Kernerman's Gallery of Contemporary Art in 1957, no longer exist.
Gustave Moreau, considered by Matisse as the only teacher who counted, gave similar advice: "Don't be afraid to lean on the masters. You'll always rediscover yourself there." Pierre Schneider, *Matisse* (New York: Rizzoli International Publications, 1984), p. 57.

19. On dark background colours of early sixties paintings Wieland used white chalk (sprayed), dry white paint or a combination of both—as in *Redgasm, Wall, War Memories, Notice Board, Cityscape, Laura Secord Saves Upper Canada* and *Hallucination.*

20. This is not surprising in view of the number of assemblages and collages of the period: the *Summer Blues* series, two cloth works and the small wood, paint, tin (round paint-can lids), paper and rag pieces (1959-60) that wittily comment on the urban scene (*Station*) or offer participatory game-like programs (*Machine to Bring Back Famous Literary Personages*).

21. Wieland "liked the look of 4 and really loved 8."

22. Sandra Paikowsky, *Joyce Wieland: A Decade of Painting* (Montreal: Concordia Art Gallery, University of Concordia, 1985), p. 3.

23. The looseness/softness of the canvas is considered an essential part of the work. This could be related to the suppleness and whiteness of a bed sheet.

24. Lauren Rabinovitz, "The Development of Feminist Strategies in the Experimental Films of Joyce Wieland," *Film Reader* 5 (1982), p. 133.

25. Paikowsky, *Joyce Wieland,* p. 3.

26. The legend on the other 1955 collage reads: "She decided to reform Lexi, and found herself in love." Both come out of Wieland's free-lance work at the time, cutting and reassembling layouts of American movie advertisements.

27. "Hatracks" was the nickname for the Hedricks, Bob and his family, who were then leaving for Ibiza.

28. On close examination, a crest and printing can be seen through the paint.

29. Robert Fulford, "Joyce Wieland," *Toronto Daily Star,* Feb. 3, 1962.

30. Wieland has been fascinated with the Napoleonic era for some time. She produced, also in 1961, a prose profile of Napoleon, published in *Evidence,* and, later, a shamanistic box, dedicated to Josephine and containing a small folded hanging.

31. Lauren Rabinovitz, "An Interview with Joyce Wieland," *Afterimage* (May 1981), p. 8.

32. Wieland worked in the loft at 191 Greenwich Street. She had placed nails along the wall and on these she painted her small canvases. "I worked on a lot of things at once."
 Dig the Light has the same size, format and factory background as *Murder in 1921.* They probably were worked on at the same time.

33. Hugo McPherson, "The New Artists," *Canadian Art* 22: 1 (Jan./Feb. 1965), pp. 9, 12.

34. Joyce Wieland and Hollis Frampton, "I Don't Even Know About the Second Stanza" (Unpublished interview, New York, 1971).

35. *Solidarity, Art, Organic Foods* brings together a slogan-enwrapped heart, an enormous female breast pinched by a male hand and the interlocked wedding rings of the jeweller.

36. Oldenburg exhibition, Green Gallery, Sept. 18-Oct. 13, 1962; *New Realists,* Sidney Janis Gallery, Nov. 1-Dec. 1, 1962; *Americans 1963,* Museum of Modern Art, New York, May 22-Aug. 18, 1963.

37. *The Game of Life,* National Gallery of Canada, Ottawa. Burton in *Dennis Burton Retrospective* (Oshawa: Robert McLaughlin Gallery, 1977), p. 18.

38. Occasionally a work such as *Sink* surpasses logic in the number and variety of irregularities.

39. Paikowsky, *Joyce Wieland,* p. 5.

40. Jonathan Holstein, "New York's Vitality Tonic for Canadian Artists," *Canadian Art* 21:5 (Sept./Oct. 1964), p. 278.

41. Wieland, "de Kooning's *February.*"

42. Leone Kirkwood, "Canadian Artist in New York Pioneers in Nameless Art Form," *The Globe and Mail,* Mar. 27, 1965.

43. Wieland and Frampton, "I Don't Even Know About the Second Stanza."

44. Barrie Hale, "The Vanguard of Vision: Notes on Snow and Wieland," *Saturday Night* (June 1974).

45. Harry Malcolmson, "Joyce Wieland," *The Telegram,* Mar. 25, 1967.

46. Like the young lama, each child, to those who love him, has been specially marked or chosen by God.

Michael Montague was four, about to be five, and so the number five nudges its predecessor. In 1963 Wieland had made a special bathrobe for "KID Montague," inscribed with his zodiac sign and, inside, with a list of famous people born under the sign.

47. The penis and the heart first emerged as motifs in her work at about the same time, in 1960. *Don't Mess with Bill* is probably the last appearance of the phallus until the late seventies, while hearts continued to proliferate on the quilts of the seventies.

48. "When I first began doing quilts, it was very important that I work on them. But then I found that there were special qualities with certain stitches; the way my sister did it was exquisite. After three years of doing work together, I really got to understand what was necessary, and she could then tell other people what was needed. So, it was gradually worked out that I did less and less, and she took over. Later I just did sketches, close colour sketches, projecting them on the wall, and drawing the patterns out, leaving the rest to her and the others." Janice Cameron, Frances Ferdinands, Sharon Snitman, Madli Tamme, Annetta Wernick, eds., *Eclectic Eve* (Toronto: Women's Educational Press, 1972), unpaginated.

49. Ibid.

50. The underground film movement was a focus of her life in New York "from the early sixties through 1968—this community of creative people who lived on the edge of nothing. There were no monetary rewards; no Establishment to handle their films. But they created this movement—some of it very visionary. I guess meeting up with the underground was one of the greatest things that ever happened to me." She "hung around with" Hollis Frampton (and they made a film together) and Dave Shackman (who appeared in her film *Patriotism, Part II*). She appeared in Ken Jacobs' *Sky Socialist,* George and Mike Kuchar's *Knocturne* and such films of her husband's as *Wavelength*. Wieland showed her films at the cinématique—"It was scary and wonderful. I'd just be shaking and dripping and freaking out. I had to drag this projector from the subway, stopping every few feet to put it down. . . . The audience had been yelling at the last film and then on came *Water Sark*. People about to leave got halfway up the aisle and then went back and sat down." And there were several films started but unfinished.

51. Dr. Rotstein in conversation with the author, Aug. 1986. In 1967 he was working with a task force on what came to be known as the "Watkins Report"—*Foreign Ownership and the Structure of Canadian Industry,* issued in February 1968. Dr. Rotstein's article "The Commonwealth Still at Stake," in *The Canadian Forum* of February 1971, was accompanied by an excerpt from Wieland's cartoon about buying Canada back, made for the "Empire and Technology" section of the periodical's fiftieth anniversary issue (Apr./May 1970).

52. To sew the quilt, Wieland organized a quilting bee. When Trudeau was asked what he thought "about this quilt all these Canadians are making for you in New York, he said . . . 'reason over passion is the theme of all my writings' . . . I used that as the text in the film because we elicited a response."
 Reason over Passion involves a set of four works—the two quilts, the film and an etching.

53. Inscribed on a card sewn to the back of the work "Title . . . (from a statement about the moon shot by Pierre Trudeau)."

54. Dennis Young, *Recent Vanguard Acquisitions* (Toronto: Art Gallery of Ontario, 1971), p. 19.

55. Also in 1972 Wieland produced the film *Pierre Vallières,* which concentrates on his mouth in close-up. Earlier, in the films *Water Sark* and *Reason over Passion,* she had shown herself mouthing or singing words.

56. Mason Wade, *The French Canadians, 1760-1945* (Toronto: Macmillan of Canada, 1955), p. 42,

quoting from L.P. Kellogg, ed., *Charlevoix' Journal of a Voyage to North America* (Chicago: 1923), pp. 117-18.

57. Joan McGregor, Halifax, embroidery—*O Canada Animation, Wolfe's Last Letter, Montcalm's Last Letter.* Valery McMillin, Dartmouth, knitting—*Flag Arrangement.* Mrs. Louis Philippe Aucoin, Cheticamp, Cape Breton, hooking—*Eskimo Song—The Great Sea.* Joan Stewart, Toronto, quiltmaking, embroidery, general sewing—*109 Views, The Water Quilt* and more.

Wieland had collaborated previously on quilts with her sister, Joan Stewart, and on films with many friends, including Shirley Clarke, Mary Mitchell, Jane Bryant, Betty Ferguson, Wendy Michener Lawrence.

58. "First of all, who took the quilt seriously in the art world? . . . The quilt form reaches people; they can relate to it. That's why I wanted a common basis. It would be nice if we could get the art out there, but not in the way we make corny art for people. I'm interested in working on basic symbols that we know, creatures, trees, and we recognize these instantly. It is what you do with them once you get them into the work. You work on your own myth from the very basic things you have around you." Cameron et al., *Eclectic Eve.*

59. The cake, about a metre high and almost two metres across, "depicts Canada as a huge landscape crowned by icebergs and snowfields. The ice melts into rivers, waterfalls and lakes with evergreen forests lower down. The roughly circular base is decorated with the crests of the provinces, emblems of their floral symbols . . . and sprays of coloured maple leaves. On the summit lies a murdered polar bear, slain by hunters; but the bear has made love to a beautiful woman, *The Spirit of Canada,* and further down the slope we find her giving suckle to her offspring, the French and English beavers." Hugo McPherson, "Wieland: An Epiphany of North," *artscanada* 28: 158/159 (Aug./Sept. 1971), p. 19.

60. The catalogue uses a facsimile of A.E. Porsild's *Illustrated Flora of the Canadian Arctic Archipelago,* Bulletin no. 146, Biological Series no. 50, 1964.

61. Lauren Rabinovitz, "Issues of Feminist Aesthetics: Judy Chicago and Joyce Wieland," *Women's Art Journal* 1:2 (Fall 1980/Winter 1981), pp. 38-41.

62. The trip was for her retrospective exhibition at the Vancouver Art Gallery, Jan. 9-Feb. 4, 1968.

63. *Joyce Wieland: True Patriot Love, Véritable amour patriotique.* Interview with Joyce Wieland— interviewer, Pierre Théberge; interpreter, Michael Snow—Mar. 28, 1971.

64. In this sense the work belongs to a North American tradition, symbolized in Canada by the construction of nationwide railroads, and surfacing in the 1960s in road movies and novels like those of Jack Kerouac.

65. "The Great Sea has set me in motion
 set me adrift and I move as weed in the river
 The arch of sky
 and mightiness of storms
 encompasses me
 and I am left trembling with joy."

To Wieland the Eskimo had special significance—for qualities of his past life, ingenuity, creativity, courage and innocence.

66. Jim Wright, *The Coming Water Famine,* quoted by James Laxer in *The Energy Poker Game* (Toronto/Chicago: new press, 1970), p. 36.

67. Ibid., p. 35.

68. Her interest in returning to Toronto became critical, despite Snow's reluctance, when she found out that, after having been considered part of the Structuralist Film Movement, she was left out of the Anthology Film Archives. "Also I was attacked by a psychopath outside my loft—the two things in one year."

69. By Sarah Elizabeth Bowser:
"Laura crushing flowers, weeds,
Walked further than she knew,
Her slippers carrying the seeds
From which a nation grew.
Gardenless the wild flower grows,
Rock, weeds, split to start.
Laura, as the June sun rose,
Planted a nation's heart."

70. The quilt reads:
Along the line of smoky hills
The crimson forest stands
And all the day the Blue Jay calls
Throughout the autumn lands

Now by the brook the maple leans
With all her glory spread
And all the sumachs on the hills
have turned their green to red

Now by the marshes wrapped in mist
or past some rivers mouth
Throughout the long still autumn day
Wild birds are flying south

71. Pierre Théberge "The Drawings," in Pierre Théberge and Alison Reid, *Joyce Wieland: Drawings for "The Far Shore"* (Ottawa: National Gallery of Canada, 1978), p. 4.

72. Penelope Glasser, "Problems and Visions: Joyce Wieland Now" (unpublished interview, 1982), p. 2.

73. From Lawren Harris, "Revelation of Art in Canada," *Canadian Theosophist* 7:5 (1926), quoted in Peter Mellen, *The Group of Seven* (Toronto: McClelland and Stewart, 1970), p. 181.

74. Pierre Teilhard de Chardin, *Hymn of the Universe* (London: Collins, 1965), pp. 42, 44.

75. It was in a small row house in downtown Toronto, and Wieland had worked there since about 1975. After she and Snow separated, she moved into the house in 1982.

76. Glasser interview.

77. Carole Corbeil, "Joyce Wieland Finds Room to Bloom," *The Globe and Mail,* Mar. 2, 1981.

78. Glasser interview.

79. Anne Wordsworth, "An Interview with Joyce Wieland," *Descant* 8/9 (Spring/Summer 1974), p. 110.

80. The sculpture refers, with human and animal roles reversed, to the Roman legend of Romulus and Remus, the twins who were raised by a wolf and who founded Rome.

Chapter 3 The Films of Joyce Wieland

1. Annette Kuhn, *Women's Pictures: Feminism and Cinema* (Boston: Routledge and Kegan Paul, 1982), p. 185.

2. Pam Cook, "The Point of Self-Expression in Avant-Garde Film," in *Theories of Authorship,* John Caughie, ed. (Boston: Routledge and Kegan Paul, 1981), p. 272.

3. See, "Poetry and the Film: A Symposium with Maya Deren, Arthur Miller, Dylan Thomas, Parker Tyler. Chairman, Willard Maas," *Film Culture Reader,* P. Adams Sitney, ed. (New York: Praeger, 1970), pp. 171-86. The transcript of this 1954 New York symposium amply demonstrates the point.

4. Personal interview with Joyce Wieland, Toronto, Ontario, November 16, 1979.

5. Ibid.

6. With a force unequalled by any other contemporary independent film, Warhol's films had attacked the past decade's romantic films of self-discovery. *Kiss, Sleep,* and *Blow Job*—each constructed of a few takes from a static position extended over long periods of time (*Sleep* was more than six hours long)—seemed to insult the Modernist insistence that art was a pure expression of the filmmaker's subconscious. The films, by showing the activities the titles describe, instead posed as a kind of anti-art.

 Warhol's extended static imagery was so radical that it alienated audiences. Restless viewers shifted their attention to other stimuli around them—the materials, conditions and processes of the image, projection and viewing environment. Warhol made his films so painstakingly self-conscious that they suggested ways in which material processes could become their own content.

7. The term was first coined by P. Adams Sitney in "Structural Film," *Film Culture* 47 (Summer 1969), pp. 1-10; reprinted in *Film Culture Reader,* P. Adams Sitney, ed. (New York: Praeger, 1970), pp. 326-48.

8. For further discussion of structural film in this regard, see: Peter Wollen, "Ontology and Materialism in Film," *Screen* 17:2 (Spring 1976), pp. 7-23; reprinted in Peter Wollen, *Readings and Writings: Semiotic Counter-Strategies* (London: Verso Editions, 1982).

9. Wieland heightened the sense of fragmentation by spacings of irregularly tinted film stock, flashes of other footage and scratches and perforations on the film itself. In this case, she made the perforations with her sewing needles and used cloth dyes in the tinting processes, incorporating into the artisanal process the tools of women's crafts.

10. P. Adams Sitney, *Visionary Film: The American Avant-Garde,* 2nd ed. (New York: Oxford University Press, 1979), p. 369.

11. See: Richard Foreman, "New Cinema Festival at Jewish Museum," *artscanada* 24:7 (Apr. 1967), pp. 9-10; Manny Farber, "Films at Canadian Artists '68," *artscanada* 26:1 (issue 128/129, Feb. 1969), pp. 28-9; "La Raison avant la passion," *artscanada* 26:4 (Aug. 1969), pp. 45-6.

 P. Adams Sitney's "There Is Only One Joyce," in *artscanada* 27:2 (Apr. 1970), pp. 143-5, is still one of the most often reprinted articles on Wieland's experimental films.

12. Manny Farber, "Film," *Artforum* 8: 5 (Jan. 1970), pp. 81-2, and "Film," *Artforum* 8:6 (Feb. 1970), p. 82. A year and a half later, Regina Cornwell's essay, "True Patriot Love: The Films of Joyce Wieland," *Artforum* 10: 1 (Sept. 1971), pp. 36-40, was a full-scale formalist discussion of Wieland's films and paintings.

13. It is not coincidental that Marshall McLuhan, who popularized the idea that electronic communications would make the world a "global village" framing the future, was at this time writing his best-known work in Toronto. See: Marshall McLuhan, *Understanding Media: The Extensions of Man* (New York: McGraw-Hill, 1964).

14. Not only has Wieland formally inverted the message of the phrase that came from a famous speech by Prime Minister Pierre Trudeau, but Wieland and Hollis Frampton (who assisted her with the permutations) arrived at the combinations with the aid of a computer, the ultimate tool for reasoning. They logically, systematically created garbled polysyllables that become phonetically interesting in and of themselves.

15. No single event contributed more to this narrowing of focus than the founding of Anthology Film Archives in New York City in 1970. The formation of Anthology Film as a repository for self-acclaimed "monuments of cinematic art," and for the values inherent in these films, privileged formalist "art for art's sake." The practices by which such films were selected for the archives, the collective ideology of the five men in power and the discursive value of canonization itself rested exclusively on cinema as a formalist activity. Although these were the efforts of a small band trying to preserve their privileged position in discursive practices now controlled by the larger institutions of the arts, the event itself represented the degree to which the dominant discourse could no longer admit the variety that had been one of independent film's hallmarks before institutionalization.

 The exclusion of Wieland's films from the Anthology Film Archives' collection triggered the dissolution of her belief in and dependency on the New York artisanal community. Angered by the Anthology process of canonizing select films and by the ways in which the new discursive practices encouraged her marginalization, Wieland decided to leave New York City.

16. Wieland and Snow even made two films together, *Assault in the Park* (1959) and *Dripping Water* (1969). Wieland and Frampton collaborated on a film together in 1967. Wieland finally completed the film after Frampton's death in 1984 (*A & B in Ontario*).

17. Personal interview with Joyce Wieland, Nov. 16, 1979.

18. Michele Landsberg, "Joyce Wieland: Artist in Movieland," *Chatelaine* 49: 10 (Oct. 1976), p. 110.

19. In the early 1970s, Canadian film production was practically non-existent, although Canada was the single largest foreign market for American films. See: Eleanor Beattie, *Handbook of Canadian Film,* 2nd ed. (Toronto: Peter Martin Associates Limited, 1977), p. 3. Booming box-office revenues in the first half of the 1970s had no effect on Canadian film production. Such a stalemate occurred because two multinational corporations (Famous Players Limited and Odeon Theatres Limited) owned or controlled more than 66 per cent of the commercial cinemas in Canada, while nine distributors acted as agents for American companies and controlled more than 90 per cent of commercial theatrical film rentals (Beattie, p. 15). This effectively reserved the exhibition outlets for American features, virtually guaranteeing that without access to the theatres, few Canadian features would attract investors.

20. Thomas Elsaesser, "Tales of Sound and Fury: Observations on the Family Melodrama," *Monogram* 4 (1974), p. 7.

21. Ibid.

22. Pierre Théberge and Alison Reid, *Joyce Wieland: Drawings for "The Far Shore"* (Ottawa: National Gallery of Canada, 1978).

23. Laura Mulvey, "Feminism, Film, and the Avant-Garde," *Framework* 10 (1979), pp. 3-10.

Bibliography

BOOKS, ARTICLES AND REVIEWS ON ART

Aarons, Anita. *Art for Architecture: The Wall.* Toronto: Art Gallery of Ontario, 1969 (catalogue).

"Air Disaster Whimsical." *Vancouver Star,* 18 June 1964.

Amaya, Mario. *Survey/Sondage 70—Realism(e)s.* Montreal: Musée des beaux-arts de Montréal/Toronto: Art Gallery of Ontario, 1970 (catalogue).

Andrews, Bernadette. "A Look Back in Interest." *The Telegram,* (Toronto), 6 Mar. 1969.

Art Gallery of Ontario. *The Canadian Society of Graphic Art.* Toronto: Art Gallery of Ontario, 1956 (catalogue).

————. *The Canadian Collection.* Toronto: Art Gallery of Ontario/McGraw-Hill Ryerson, 1970.

"Art Post Interviews Joyce Wieland." *Art Post* (Toronto) 2:2 (Sept./Oct. 1984), pp. 18-22.

Balkind, Alvin. *17 Canadian Artists: A Protean View.* Vancouver: Vancouver Art Gallery, 1976 (catalogue).

Benbow, Charles. "New Canadian Art." *St. Petersburg Times* (Florida), 25 Feb. 1971.

"Bill's Hat." *The Globe and Mail* (Toronto), 8 Jul. 1967.

Bismanis, Maija. "Crucial Ten Years of Joyce Wieland." *The Province* (Vancouver), 2 Jan. 1968.

Blanchfield, Cecilia. "My Star Is Shining." *The Gazette* (Montreal), 17 June 1978.

Bowen, Lisa Balfour. "The Joy of Sex: In Pastel Tones." *Toronto Star,* 28 Feb. 1981.

————. "Eye-Opening Tour of Israel Inspires Unusual Collages." *The Globe and Mail* (Toronto), 12 Jan. 1985.

Bowser, Sara. "Joyce Wieland." *Canadian Architect* 5:10 (Oct. 1960), pp. 69-71.

Burall, V. *The Rothmans Collection of Xmas Ornaments.* Toronto: Rothmans of Pall Mall of Canada, 1969 (catalogue).

Burnaby Art Gallery. *Mystic Circle.* Burnaby, B.C.: Burnaby Art Gallery, 1973 (catalogue).

Burnett, David. *Toronto Painting of the 1960s.* Toronto: Art Gallery of Ontario, 1983.

————. *Toronto Painting '84.* Toronto: Art Gallery of Ontario, 1984.

————, and Schiff, Marilyn. *Contemporary Canadian Art.* Toronto: Hurtig Publishers/Art Gallery of Ontario, 1983.

"Canadian Artist Joyce Wieland." *Toronto Daily Star,* 18 Dec. 1968.

Canadian Cultural Centre. *Troisième Biennale de Tapisserie de Montréal.* Paris: Canadian Cultural Centre, 1984 (catalogue).

————. *Sélection des oeuvres de la banque d'oeuvres d'art Conseil des Arts du Canada.* Paris: Canadian Cultural Centre, 1973 (catalogue).

"Caribou Prance in Subway." *Toronto Star,* 6 Jan. 1978.

"Celine Lomez Fêtée par ses camarades!" *Echos-Vedettes* (Montreal), 18-24 June 1978.

Chandler, John Noel. "Notes Towards a New Aesthetic." *artscanada* 29:172/173 (Oct./Nov. 1972) pp. 15-41.

Corbeil, Carole. "Joyce Wieland Finds Room to Bloom." *The Globe and Mail* (Toronto), 2 Mar. 1981.

"Craze for Quilts." *Life* 72:17 (May 1972), pp. 78-9.

Crean, Susan. "Guess Who Wasn't Invited to the Dinner Party." *This Magazine* (Toronto) 16:5 (Nov. 1982), pp. 18-25.

Dain, K. "Patriot Love Preceded Chicago." *The Globe and Mail* (Toronto), 16 June 1982.

Daw, James. "Eaton Centre Puts Art into Advertising." *Toronto Star,* 1 Aug. 1978.

Delaney, Marshall. "Wielandism: A Personal Style in Full Bloom." *Saturday Night* (Toronto: May 1976), pp. 76-7.

Dingman, Elizabeth. "True Patriot Love: Artist Joyce Wieland's Tribute to Canada." *The Telegram* (Toronto), 27 Sept. 1971.

————. "Moment of History When Canada's Capital Was Dead as a Doornail." *The Telegram* (Toronto), 3 Jul. 1971.

Doney, Stef. "Toronto Gets Itself a Brand New Subway." *Toronto Star,* 29 Jan. 1978.

Donnell, D. "Joyce Wieland at the Isaacs Gallery." *Canadian Art* 21:90 (Mar./Apr. 1964), p. 64.

Edinburgh International Festival. *Canada 101.* Edinburgh: Edinburgh International Festival, 1968 (catalogue).

Etrog, Sorel. *Contemporary Outdoor Sculpture at the Guild.* Scarborough, Ont.: The Guild of All Arts, 1982 (catalogue).

Farr, Dorothy, and Luckyj, Natalie. *From Women's Eyes: Women Painters in Canada*. Kingston, Ont.: Agnes Etherington Art Centre, 1975 (catalogue).

Fenton, Terry, and Wilkin, Karen. *Modern Painting in Canada: A Survey of Major Movements in Twentieth Century Canadian Art*. Edmonton: Edmonton Art Gallery, 1978 (catalogue).

Ferguson, Gerald. *Lithographs*. Halifax: Nova Scotia College of Art and Design. Ottawa: National Gallery of Canada, 1971 (catalogue).

"Fine Arts' Finest: The Powers behind Canadian Art." *Canadian Magazine,* 29 Mar. 1975.

Finlayson, Judith. "The Psychology of Power." *Homemaker's Magazine* 17:3 (Toronto), Apr. 1982.

"First in Solo: One-Woman Show for Joyce Wieland." *Toronto Star,* 19 Sept., 1960.

Fleming, Marie. *Canadian Tapestries 1977*. Toronto: Art Gallery of Ontario, 1977 (catalogue).

Fleming, Martha. "Joyce Wieland." *Parachute* 23 (Montreal: Summer 1981), p. 45.

Freedman, Adele. "Portraits from a Daring Artist." *The Globe and Mail* (Toronto), 4 Jan. 1983.

Fulford, Robert. "West Coast Painters Show Vitality." *Toronto Daily Star,* 28 Nov. 1959.

————. "12 Artists Challenge the Country." *The Star Weekly* (Toronto), 4 Nov. 1961.

————. "Joyce Wieland." *Toronto Daily Star,* 3 Feb. 1962.

————. "Now, We Get Psychedelic Quilts." *Toronto Daily Star,* 25 Mar. 1967.

————. "Joyce Wieland: Her Romantic Nationalism and Work." *The Citizen* (Ottawa), 10 Jul. 1971.

————. "Giving Us a Sense of Ourselves." *Toronto Daily Star,* 10 Jul. 1971.

Graham, David. "Shirts as Art? T-riffic!" *Sunday Sun* (Toronto), 29 June 1986.

Guest, Tim, and Celant, Germano. *Books by Artists*. Toronto: Art Metropole, 1981.

Hale, Barrie. "Joyce Wieland: Artist, Canadian, Soft, Tough Woman!" *The Telegram* (Toronto), 11 Mar. 1967.

————, and Reid, Dennis. *Toronto Painting: 1953-1965*. Ottawa: National Gallery of Canada, 1972 (catalogue).

Holstein, Jonathan. "New York's Vitality Tonic for Canadian Artists." *Canadian Art* 21:93 (Sept./Oct. 1964), pp. 270-9.

Hudson, Andrew. "A Critic from Saskatchewan Looks at Toronto Painting." *Canadian Art* 20:88 (Nov./Dec. 1963), pp. 336-9.

Hughes, Robert. "Myths of Sensibility." *Time* (Montreal) 99:12 (20 Mar. 1972), pp. 52-3.

Hume, Christopher. "The Search for 'The Ecstatic'." *Toronto Star,* 30 Apr. 1983.

————. "Venus of Flowers to 'Cheer up Drivers'." *Toronto Star,* 10 Mar. 1984.

————. "Catching Up with the Past Takes Time." *Toronto Star,* 4 Aug. 1984.

————. "Art Exhibit Was Made in Metro." *Toronto Star,* 9 Sept. 1984.

"International Women's Year: Are Canadian Women Equal?" *Canada Today* (Washington: Canadian Embassy Publications) 6 (June 1975), p. 17.

The Jewish Museum. *The Jewish Museum.* New York: The Jewish Museum, 1969 (catalogue).

"Joyce Thinks Canada Is Last Hope for Rats and People." *The Globe and Mail* (Toronto), 8 Mar. 1969.

"Joyce Wieland." *Scene.* Ottawa: The National Arts Centre, 1969 (catalogue).

Kirkwood, Leone. "Canadian Artist in New York Pioneers in Nameless Art Form." *The Globe and Mail* (Toronto), 17 Mar. 1965.

Knelman, Martin. "Don Shebib Throws in the Towel and Joyce Wieland Builds a Parable of Discontent." *Toronto Life* (May 1976), p. 82.

————. "Gina: A Lurid Parable about Quebec Social Injustice . . ." *The Globe and Mail* (Toronto), 8 Feb. 1975.

Kome, Penny. "Joyce Wieland: Artist and Filmmaker." *Chatelaine* (Apr. 1976).

Kritzwiser, Kay. "What's So Special about New York?" *The Globe and Mail* (Toronto), 15 Apr. 1967.

————. "The Spirit of '67: Art with Derring-Do." *The Globe and Mail* (Toronto), 30 Dec. 1967.

————. "Trudeau Lends Quilt to Tel Aviv Exhibit." *The Globe and Mail* (Toronto), 17 Nov. 1970.

————. "A Woman's Work in the National Gallery." *The Globe and Mail* (Toronto), 19 Feb. 1971.

————. "Wieland: Ardent Art for Unity's Sake." *The Globe and Mail* (Toronto), 3 Jul. 1971.

————. "Joyce Wieland." *The Globe and Mail* (Toronto), 4 May 1974.

"L'identité Canadien selon Joyce Wieland." *La Presse* (Montreal), 17 June 1978.

Lippard, Lucy. *Pop Art.* New York: Praeger, 1966.

————. "Notes in Review of Canadian Artists '68: Art Gallery of Ontario." *artscanada* 26:128/129 (Feb. 1969), pp. 25-70.

Lister, Ardele. "Joyce Wieland: An Interview." *Criteria* (Vancouver) 2:1 (Feb. 1976), pp. 15-17.

London Regional Art Gallery. *O Canada*. London, Ont.: London Regional Art Gallery, 1976 (catalogue).

Lord, Barry. *Painting in Canada*. Ottawa: Queen's Printer, 1967.

————. "Canadian Artists in New York Bravely Waving Our Flag." *Toronto Daily Star,* 7 Mar. 1970.

Luc, Pierre. "Celine Lomez n'a pas chômé." *Journal de Montréal,* 5 Aug. 1976.

Madgison, Debbie. "Joyce Wieland's Vision of Canada." *Canadian Forum* (Sept. 1975), pp. 70-1.

————, and Wright, Judy. "Debbie Madgison and Judy Wright Interview Joyce Wieland." *Canadian Forum* (May/June 1974), pp. 61-3, 67.

Malcolmson, Harry. "Joyce Wieland." *The Telegram* (Toronto), 25 Mar. 1967.

————. "True Patriot Love: Joyce Wieland's New Show." *Canadian Forum* (June 1971), pp. 17-22.

Martineau, Barbara, and Rasky, Deena. "Joyce Wieland: She Speaks in Colours." *Broadside* (Toronto) 2:7 (May 1981), p. 13.

Mays, John Bentley. "A Dizzying Variety of Sculptural Styles." *The Globe and Mail* (Toronto), 7 Aug. 1982.

————. "Wieland: Strong Overshadows Sweet." *The Globe and Mail* (Toronto), 23 Apr. 1983.

————. "Comfortable Little Amble Through a Decade." *The Globe and Mail* (Toronto), 5 Jan. 1984.

————. "AGO Show Paints Patchy Portrait of Toronto Scene." *The Globe and Mail* (Toronto), 8 Sept. 1984.

McCook, Sheila. "O Canada." *The Citizen* (Ottawa), 23 June 1971.

McPherson, Hugo. "The New Artists." *Canadian Art* 22:1 (Jan./Feb. 1965), pp. 8-12.

————. "Wieland: An Epiphany of North." *artscanada* 28:158/159 (Aug./Sept. 1971), pp. 17-27.

Mendes, Ross. *Joyce Wieland: Independent Canadian Art Show*. Guelph: University Art Gallery, 1972 (catalogue).

Milrod, Linda. *Pasted Paper: A Look at Canadian Collage 1955-1965*. Kingston, Ont.: Agnes Etherington Art Centre, 1979 (catalogue).

Mira Godard Gallery. *Selected Prints: Aspects of Canadian Printmaking*. Toronto: Mira Godard Gallery, 1978 (catalogue).

Montagnes, Ann. "Myth in Many Media: Joyce Wieland." *Communiqué* (Toronto) 8 (Winter 1975), p. 36.

Moray, Gerta. "New Perceptions: Portraits at the Art Gallery at Harbourfront." *Artmagazine* (Toronto) 15:65 (Fall 1983), pp. 44-5.

Morris, Jerrold A. *On the Enjoyment of Modern Art: An Explanatory Text.* Toronto: McClelland and Stewart, 1965.

————. *The Nude in Canadian Painting.* Toronto: New Press, 1972.

————. *Twentieth Century Canadian Drawings.* Stratford, Ont.: The Gallery/Stratford, 1979 (catalogue).

————. *One Hundred Years of Canadian Drawing.* Toronto: Methuen, 1980.

Murray, Joan. *Women Artists in Canada: A Survey.* Oshawa, Ont.: Robert McLaughlin Gallery, 1978.

————. "A Lusty Salute to the Erotic." *Macleans* (Toronto), 9 Mar. 1981, pp. 70-1.

————. "In Review." *Art Post* (Toronto: May/June 1985), pp. 7-9.

Naiman, Sandra. "Joyce Wieland's Really Living." *The Sun* (Toronto), 1 Mar. 1981.

Nakunecznyi, Janet, and Paddle, Gabriele. "Wieland on Being a 'Canadian' Artist." *Breakthrough* (Toronto) 2:2 (Apr. 1976), p. 4.

National Art Exhibition Committee. *Canadian Artists '68. Artistes Canadiens '68.* Toronto: National Art Exhibition Committee, 1968 (catalogue).

National Gallery of Canada. *Sixth Biennial Exhibition of Canadian Painting.* Ottawa: National Gallery of Canada, 1965 (catalogue).

————. *Wieland and Meredith.* Ottawa: National Gallery of Canada, 1976-8 (catalogue).

Nuovo, Franco. "Lancement au Champagne." *Journal de Montréal,* 15 June 1976.

"One Woman Show for Joyce Wieland." *Toronto Daily Star,* 19 Sept. 1960.

Owens Art Gallery. *The Isaacs Gallery at the Owens Art Gallery.* Halifax: Owens Art Gallery, Mount Saint Vincent University, 1974 (catalogue).

Paikowsky, Sandra. *Joyce Wieland: A Decade of Painting.* Montreal: Concordia Art Gallery, Concordia University, 1985 (catalogue).

Palacio de Cristal parque de Retiro. *Tapices Canadienses Contemporaneos.* Madrid: Palacio de Cristal parque de Retiro, 1983 (catalogue).

Parmalee, Helen. "Meet the Avant-Garde Artists." *The Telegram* (Toronto), 24 Sept. 1960.

Pèclet, Manon. "Les lois du coeur." *Dimanche Matin* (Quebec), June 1978.

Pierce, Gretchen. "Metro Craftsmen Needle Ways into National Gallery Exhibit." *The Mail Star* (Halifax), 22 May 1971.

Pinney, Marguerite. "Joyce Wieland Retrospective, Vancouver Art Gallery." *artscanada* 25:122/123 (June 1968), p. 41.

Purdie, James. "Sense of Wonderment from Women Painters." *The Globe and Mail* (Toronto), 24 Nov. 1975.

"A Quilt for a Subway." *Toronto Star,* 19 Oct. 1977.

Rabinovitz, Lauren. "Issues of Feminist Aesthetics: Judy Chicago and Joyce Wieland." *Women's Art Journal* (San Francisco: Fall/Winter 1981), pp. 38-41.

Reid, Dennis. *A Concise History of Canadian Painting.* Toronto: Oxford University Press, 1973.

————. *Twentieth Century Canadian Painting.* Ottawa: National Gallery of Canada/ Tokyo: The National Museum of Modern Art, 1981 (catalogue).

————, and Burnett, David. *Painting in Canada.* Ottawa: Department of External Affairs, 1985 (catalogue).

Richardson, Douglas S. "Art in Architecture: National Science Library." *artscanada* 31:190/191 (Autumn 1974), pp. 49-67.

Rockman, Arnold. "Reflections on the Erotic in Art." *Canadian Art* 22:98 (Sept./Oct. 1965), pp. 30-7.

Rosenberg, Ann. "Wieland Remarkable at Gallery." *Vancouver Sun,* 19 Jan. 1968.

Rothmans Art Gallery. *Canadian Crossections '70.* Stratford, Ont.: Rothmans Art Gallery, 1970 (catalogue).

Rousseau-Vermette, Mariette. *Canada Mikrokosma.* Kingston, Ont.: Agnes Etherington Art Centre, 1982 (catalogue).

Sanouillet, Michel. "The Sign of Dada." *Canadian Art* 19:2 (Mar./Apr. 1962), p. 111.

Shackleton, Deborah, and Wieland, Joyce. "Artist Wieland Finds Maturity." *Toronto Star,* 27 Apr. 1980.

Silcox, David P. "First-Hand Familiarity with Canadian Art at the Edinburgh Festival." *Connoisseur* 168:678 (Aug. 1968), pp. 273-9.

Simms, Geoffrey. "Av Isaacs." *City and Country Home* (Toronto: Sept. 1984), p. 58.

"A Singular Spirit." *Toronto Daily Star,* 28 Feb. 1959.

Smith, Brydon. "Joyce Wieland," in *Canada: Art d'aujourd'hui.* Ottawa: National Gallery of Canada/Paris: Musée national d'art moderne, 1968 (catalogue).

Sokorp. "Wieland's Back to Drawing at the Isaacs." *The Downtowner* (Toronto), 25 Feb. 1981.

Sones, Derek. "Pictures Show Talent, but Those 'Objects'." *Toronto Daily Star,* 24 Sept. 1960.

Stacey, Robert H. "Joyce Wieland." In *Lives and Works of the Canadian Artists,* Vol. 16. Edited by Robert H. Stacey. Toronto: Dundurn Press, 1977-79.

Steed, Judy. "A Talent for Friendship." *City Woman* (Toronto: Spring 1985).

Stewart, Heather. "Art without a Clash of Ego." *The Telegram* (Toronto), 3 Apr. 1970.

"Subway Art." *Toronto Star,* 31 June 1976.

Such, Peter. "Contemporary Outdoor Sculpture at the Guild." *Artmagazine* (Toronto) 14:60 (Sept./Oct. 1982), pp. 8-13.

"Take the Art Train." *Toronto Star,* 31 Jan. 1976.

"Talk of the Town." *The New Yorker,* 3 Jan. 1970.

"Talk of the Town." *The New Yorker,* 19 May 1973.

Taubin, Amy. "Daughters of Chaos." *The Village Voice,* 30 Nov. 1982.

Théberge, Pierre, and Reid, Alison. *Joyce Wieland: Drawings for "The Far Shore."* Ottawa: National Gallery of Canada, 1978 (catalogue).

————. *Eight Artists from Canada.* Tel Aviv: Tel Aviv Museum, Helena Rubinstein Pavilion, 1970 (catalogue).

Thompson, David. "A Canada Scene: 2." *Studio International* (New York) 176:905 (Nov. 1968), pp. 181-5.

————. *The Canada Council Collection: A Travelling Exhibition of the National Gallery of Canada, Ottawa.* Ottawa: National Gallery of Canada, 1969 (catalogue).

Townsend, William. "Canadian Art Today." *Studio International* (London) 42:6 (1970).

"True Patriot Love: Joyce Wieland at the National Gallery of Canada." *Studio International* (New York) 182:935 (Jul./Aug. 1971), p. 14.

University of Waterloo. *Canadian Art Today.* Waterloo, Ont.: University of Waterloo, 1961, 1963, 1965 (catalogues).

Vermette, Luc. "Les Arts à la Bibliothèque Scientifique National." *Vie des arts* (Montreal) 19:75 (Eté 1974), pp. 82-3.

Walker, Kathleen. "The Artist as Patriot." *The Citizen* (Ottawa), 23 Oct. 1976.

Walz, Jay. "Canadian Gallery Show Strikes Nationalist Note." *New York Times,* 16 Jul. 1971.

Ward, Olivia. "Artist Joyce Wieland Blossoming at 50." *Toronto Star,* 8 Feb. 1981.

Wieland, Joyce. "The Life and Death of the American City (Cartoon)." *Canadian Forum* 48:575 (Dec. 1968), p. 197.

————. *True Patriot Love/Véritable amour patriotique.* Ottawa: National Gallery of Canada, 1971 (catalogue).

"Wieland." *Toronto Daily Star,* 3 Feb. 1962.

Wilkin, Karen. *Changing Visions.* Edmonton: Edmonton Art Gallery, 1976 (catalogue).

Wilson, Peter. "Artist Treats Our Culture as Folklore and Draws Fire." *Toronto Daily Star,* 20 Oct. 1971.

Winnipeg Art Gallery. *The Eleventh Winnipeg Show.* Winnipeg: Winnipeg Art Gallery, 1968 (catalogue).

Withrow, William J. *Contemporary Canadian Painting.* Toronto: McClelland and Stewart, 1972.

"Women in the Arts in Canada." *Canadian Conference of the Arts Communiqué* 8 (May 1975).

Wordsworth, Anne. "An Interview with Joyce Wieland." *Descant* (Toronto) 8/9 (Spring/Summer 1974), pp. 108-10.

Young, Dennis. *49th Parallels: New Canadian Art.* Toronto: Art Gallery of Ontario/Chicago: Museum of Contemporary Art/Sarasota, Fla.: John and Mabel Ringling Museum of Art, 1971 (catalogue).

————. *Recent Vanguard Acquisitions.* Toronto: Art Gallery of Ontario, 1971 (catalogue).

BOOKS, ARTICLES AND REVIEWS ON FILM

Adilman, Sid. "Seven Features Nominated for Top Film Awards." *Toronto Star,* 5 Oct. 1976.

————. "Canadian News and History Attracting Moviemakers." *Toronto Star,* 6 June 1974.

————. "First Lensing of Far Shore." *Toronto Star,* 19 Nov. 1974.

Anthony, George. "Wieland's Far Shore Has Appeal with Stunning Sense of Detail." *Toronto Star,* 26 Sept. 1976; also appeared in *The Sun* (Toronto), 28 Sept. 1976.

Armatage, Kay. "Kay Armatage Interviews Joyce Wieland." *Take One* (Montreal) 3:2 (Feb. 1972), pp. 23-5.

————; Handling, Piers, and Pevere, Geoffrey. *Perspective Canada.* Toronto: Festival of Festivals, 1986 (catalogue).

Auchterlonie, Bill. "Joyce Wieland: Filmmaker—The Far Shore In Progress." *Artmagazine* (Toronto) 7:24 (Dec. 1975), pp. 6-11.

Bannon, Anthony. "Focus on Frampton Clearer with Time." *Buffalo News,* 10 Oct. 1984.

Beattie, Eleanor. *The Handbook of Canadian Film.* Toronto: Peter Martin Associates, 1973.

Beker, Marilyn. "Expanded Cinema Rocks Gallery." *The Globe and Mail* (Toronto), Nov. 1967.

Black, David. "Cats Purr in New York Film Festival." *The Boston Phoenix,* 8 May 1973.

Blue, Janice. "On Film: A Woman's Vision Breakthrough." *Houston Post,* Oct. 1978.

Bradley, Jessica, and Nemiroff, Diana. *Songs of Experience: Canadian Experimental Film Programme.* Ottawa: National Gallery of Canada, 1986 (catalogue).

Camper, Fred. "Avant-garding the Feature Reader." *Chicago Free Weekly,* 3 Mar. 1978.

Canadian Filmmakers Distribution Centre. *Films By Women.* Toronto: Canadian Filmmakers Distribution Centre, 1973 (catalogue).

―――――. *Catalogue 1984. (Catalogue Supplement 1985).* Toronto: Canadian Filmmakers Distribution Centre, 1984/85 (catalogue).

Cole, Arthur. "Canadian Playwright Opens off Broadway." *The Telegram* (Toronto), 3 Aug. 1966.

Cornwell, Regina. "Activists of the Avant-Garde." *Film Library Quarterly* 5:1 (Winter 1971), p. 29.

―――――. "True Patriot Love: The Films of Joyce Wieland." *Artforum* 10:1 (New York: Sept. 1971), pp. 36-40.

Curtis, David. *Experimental Cinema.* London: Studio Vista, 1971.

Daigneault, Claude. "Le Film 'The Far Shore'." *Le Soleil* (Quebec), 7 Aug. 1976.

Edinburgh International Film Festival. *The Twenty-ninth Edinburgh International Film Festival.* Edinburgh: International Film Festival, 1975 (catalogue).

―――――. *The Thirtieth Edinburgh International Film Festival.* Edinburgh: International Film Festival, 1976 (catalogue).

Eiblmayr, Silvia; Export, Valie; and Prischl-Maier, Monika. *Kunst Mit Eigen-Sinn.* Wien, Austria: Löcker Verlag, 1985.

Elliott, David. "Adventurous Offerings at Facets, Film Center." *Chicago Daily News,* 28 Feb. 1978.

Everett-Green, Robert. "Frames Beyond the Fringe." *The Globe and Mail* (Toronto), 13 May 1985.

―――――. "Celluloid Experiments." *The Globe and Mail* (Toronto), 8 Sept. 1984.

"The Far Shore." *Canadian Forum* (May 1976).

"The Far Shore." *Variety,* 18 Aug. 1976.

Farber, Manny. "Films at Canadian Artists '68." *artscanada* 26:128/129 (Feb. 1969), pp. 28-9.

―――――. "La raison avant passion." *artscanada* 26:4 (Aug. 1969), pp. 45-6.

―――――. "Film." *Artforum* 8:5 (Jan. 1970), pp. 81-2.

―――――. *Negative Space, Manny Farber on the Movies.* New York: Praeger, 1971.

Festival de Cannes. *Quinzaine des Réalisateurs.* Cannes: Festival de Cannes, 1970 (catalogue).

Fetherling, Doug. "Joyce Wieland in Movieland." *Canadian Weekly* (Toronto), 24 Jan. 1976, pp. 10-12.

————. "Wieland's Vision." *Canadian Forum* 56:661 (May 1976), pp. 10-12.

Film Center of the Art Institute of Chicago. *Films By Women.* Chicago: Film Center of the Art Institute of Chicago, 1974 (catalogue).

"Film Maker Casts Dwight Eisenhower Eating Fish." *The Globe and Mail* (Toronto), 2 Dec. 1967.

Foreman, Richard. "New Cinema Festival at Jewish Museum." *artscanada* 24:7 (Apr. 1967), pp. 9-10.

Freedman, Adele. "Joyce Wieland's Re-emergence: The Arctic Light at the End of 'Far Shore'." *Toronto Life* (June 1980), pp. 184-5.

Funnel. *Catalogue 1984.* Toronto: Funnel, Experimental Film Theatre, 1984 (catalogue).

Gale, Peggy. "The National Filmmakers Series." *artmagazine* (Toronto) 6:19 (Fall 1974), p. 27.

Gerber, Eric. "Stumbling Blocks: Hard to Film 'Far Shore'." *Houston Post,* 22 Sept. 1978.

Gidal, Peter, ed. *Structural Film Anthology.* London: British Film Institute, 1976.

Glasser, Penelope. "Joyce Wieland Now." *Spirale* (Toronto) 1:3 (Winter 1981/82), p. 69.

Gow, Gordon. "16 mm." *Films and Filming New York* (Feb. 1973), pp. 75-6.

Hale, Barry. "La Raison Avant Passion." *Toronto Daily Star,* 15 Jul. 1969.

————. "A Pure New Film of a Pure Land." *Toronto Daily Star,* 19 Jul. 1969.

————. "The Vanguard of Vision: Notes on Snow and Wieland." *Saturday Night* (Toronto: June 1974), pp. 20-3.

Harcourt, Peter. "Joyce Wieland's The Far Shore." *Take One* 5:2 (May 1976), p. 63.

Hartt, Laurinda. "Finally a Film with a Woman's Perception." *Canadian Campus* (Feb. 1977), p. 29.

Hayward Gallery. *Film as Film: Formal Experiments in Film, 1910-1975.* London: Arts Council of Great Britain/Hayward Gallery, 1979 (catalogue).

Héreux, Denis. "Du 'Cinéma à la va comme je te pousse'." *La Presse* (Montreal), 15 Feb. 1975.

Hong Kong Arts Centre. *Canadian Film Week.* Hong Kong: Hong Kong Arts Centre, 1981 (catalogue).

Hume, Christopher. "Ideas Reeled Out at Experimental Film Fest." *Toronto Star,* 11 Jan. 1985.

Istvan, Antal. "Kollektiv meditacio a hatvanas evekrol—Torontoi beszelgetes Joyce Woielanddel." *Film Kultura* (Budapest) 11:7 (Jul. 1985), pp. 61-5.

James, Geoffrey. "Whimsy over Passion." *Time* 98:2 (12 Jul. 1971), pp. 11-12.

Jergins, Roland. "All Things Canadian." *Showbill* (Toronto: Feb./Mar. 1978).

"Katzenfilm-Festival". *Der Ausschnitt Berlin,* 1970.

Kay, Karyn, and Perry, Gerald, eds. *Women and the Cinema: A Critical Anthology.* New York: Dutton, 1977.

Kerr, Richard. *Practices in Isolation: Canadian Avant-Garde Cinema.* Kitchener, Ont.: Kitchener-Waterloo Art Gallery, 1986 (catalogue).

Kritzwiser, Kay. "Four Sets of Art Films to Be Distributed." *The Globe and Mail* (Toronto), 3 May 1974.

Landsberg, Michele. "Joyce Wieland: Artist in Movieland." *Chatelaine* (Toronto) 49:10 (Oct. 1976), pp. 57-9, 110-11.

Langlois, Christine. "Joyce Wieland Likes Her Movie." *The Guardian* (Brampton, Ont.), 7 Oct. 1976.

Lanken, Dane. "Wieland Film Leads List of Test Debuts." *The Gazette* (Montreal), 31 Jul. 1976.

————. "Wieland Explains Well the Life and Death of Tom Thomson." *The Gazette* (Montreal), 7 Aug. 1976.

Laurae, Jean. "Celine Lomez triomphe au cinéma et étudie à Hollywood." *Dimanche Matin* (Quebec), 18 June 1978.

LeGrice, Malcolm. *Abstract Film and Beyond.* London: Studio Vista, 1977.

MacDonald, Lorne. "Canadian Myth in Cinema." *The Varsity* (Toronto) 97:6 (24 Sept. 1976).

Maltais, Murray. "The Far Shore: Joyce Wieland a voulu réaliser un film esthétique et sensuel." *Le Droit* (Ottawa), 7 Aug. 1976.

Martin, Robert. "Canada's Mini-Epic Film Costing 6 Years, $450,000." *The Globe and Mail* (Toronto), 7 Aug. 1976.

————. "Canadiana on Film: A Busted Cowboy and a Vaguely Familiar Painter." *The Globe and Mail* (Toronto), 25 Sept. 1976.

Martineau, Barbara. "The Far Shore." *Cinema Canada* 27 (Apr. 1976), pp. 20-5.

McLarty, Lianne. "The Experimental Films of Joyce Wieland." *Ciné-tracts* (Montreal) 5:17 (Summer/Fall 1982), pp. 51-63.

Mekas, Jonas. "Movie Journal." *The Village Voice,* 27 June 1968.

————. "Movie Journal." *The Village Voice,* 20 Nov. 1969.

————. "Movie Journal." *The Village Voice,* 3 Apr. 1969.

————. *The Rise of a New American Cinema, 1959-1971.* New York: Macmillan, 1972, p. 326.

————. "Movie Journal." *The Village Voice,* 26 Apr. 1973.

————. "Movie Journal." *The Village Voice,* 13 Jul. 1973.

Mendes, Ross. "Light: 24 Frames Per Second." *Canadian Forum* (Sept. 1969), pp. 135-6.

Michelson, Annette, ed. *New Forms in Film.* Montreux, Switzerland: 1974 (catalogue).

————, and Kertess, Klaus. *Options and Alternatives: Some Directions in Recent Art.* New Haven, Conn.: Yale University Art Gallery, 1973.

Miller, Donald. "Art Films of Wieland Stir Mind." *Pittsburgh Post-Gazette,* 9 Mar. 1972.

Moses, Michele. "A Glimpse of The Far Shore." *Cinema Canada* 23 (Nov. 1975), pp. 41-4.

Musée de Cinéma. *Prix L'Age D'Or.* Brussels: Musée de Cinéma, Palais des beaux-arts, 1977 (catalogue).

National Film Theatre. *Women in Canadian Cinema.* Edmonton: National Film Theatre, 1978 (catalogue).

National Film Theatre, London. *The Twentieth London Film Festival.* London: National Film Theatre, 1976 (catalogue).

Noguez, Dominique. *Elogue du cinéma expérimental.* Paris: Musée national d'art moderne, 1979 (catalogue).

"Ook Canada Heeft Zijn Underground Filmers." *Nieuwe Rotterdamse Courant-Vrijdag* (Okt. 1969).

Pacific Ciné Centre. *National Film Week '86.* Vancouver: Pacific Ciné Centre, 1986 (catalogue).

Pacific Film Archive. *The Films of Michael Snow and Joyce Wieland.* Berkeley, Calif.: Pacific Film Archive, 1972 (catalogue).

Patterson, Maggie. "Canadian Films Say: 'Rats' to U.S." *The Pittsburgh Press,* 9 Mar. 1972.

Peary, Gerald. "Berlin Looks Kindly on Canadian Content." *The Globe and Mail* (Toronto), 2 Mar. 1985.

"The Politics of Film in Canada." *Film Library Quarterly* 2:1 (Feb. 1976).

Porter, John. "Artists Discovering Film: Post-War Toronto." *Vanguard* 13:516 (1984), pp. 24-6.

————. "Consolidating Film Activity: Toronto in the 60s." *Vanguard* 13:9 (Nov. 1984), pp. 26-9.

Pringle, Douglas. "La Raison Avant Passion." *artscanada* 26:4 (Aug. 1969), pp. 45-6.

Purdie, James. "The Best Tom Thomson Faker in the Whole World." *The Globe and Mail* (Toronto), 12 Jul. 1975.

Rabinovitz, Lauren. "An Interview with Joyce Wieland." *Afterimage* (New York) 8:10 (May 1981), pp. 8-12.

————. "The Development of Feminist Strategies in the Experimental Films of Joyce Wieland." *Film Reader* 5. Evanston, Ill.: Northwestern University, 1982, pp. 132-9.

Rasky, Frank. "Passionate Painter and Filmmaker Directs a Classical Romance." *Toronto Star,* 18 Sept. 1976.

Reid, Marilyn. "New Canadian Film Premieres." *Evening Times Globe* (St. John, N.B.), 10 Aug. 1976.

Relph, Irene. "A Tour with Joyce Wieland." *Visions: Art News.* Toronto: TVOntario, Fall 1984 (catalogue).

Rubin, Joan Alleman. "Staking Out a New World of Film." *Mademoiselle* 62:5 (Mar. 1966), p. 170.

Russel, Katie. "Festival Hits Home." *Now* (Toronto), 28 Aug.-3 Sept. 1986.

Sarris, Andrew. "Films in Focus." *Village Voice,* 18 Mar. 1971.

Scigliano, Eric. "Lush Beauties of the North Woods." *The Santa Fe Reporter,* 5 Oct. 1978.

Singer, Joel. "Talking with Joyce Wieland." *Cinemaviews* (San Francisco: Nov. 1978).

Siskind, Jacob. "Joyce Wieland's Reason over Passion at Loyola Experimental Film Festival." *The Gazette* (Montreal), 4 Jul. 1969.

Sitney, P. Adams. "Structural Film." *Film Culture* (New York) 47 (Summer 1969), pp. 1-10.

————. "There Is Only One Joyce." *artscanada* 142/143 (Apr. 1970), pp. 43-5.

————, ed. *Film Culture Reader.* New York: Praeger, 1970.

————. *Visionary Film: The American Avant-Garde.* New York: Oxford University Press, 1974.

————, ed. *The Avant-Garde Film: A Reader of Theory and Criticism.* New York: New York University Press, 1978.

Stack, Peter. "A Canadian Tale of Passion at the Red Victorian." *San Francisco Chronicle,* 13 Nov. 1980.

Steed, Judy. "Women and Film and Debutantes." *This Magazine* (Toronto) 7:2 (Aug. 1973).

Sutton, Joan. "Tom Thomson to Live Again—on Film." *The Sun* (Toronto), 31 Jul. 1974.

Tadros, Jean Pierre. "A tour d'une definition de l'underground." *Le Devoir* (Montreal), 18 Apr. 1970.

Tausig, Susanne. "The Far Shore Combines Film and Art." *London Free Press* (London, Ont.), 28 Oct. 1978.

Taylor, Noel. "True Patriot Love for Fledgling Filmmaker." *The Citizen* (Ottawa), 13 Aug. 1976.

Testa, Bart. "Experimental Film: Its Past, Its Future." *The Globe and Mail* (Toronto), 31 Aug. 1984.

Townsend, Charlotte. "Converging on 'La Région Centrale'." *artscanada* 28:152/153 (Feb./Mar. 1971), p. 46.

Tuer, Dot. *Cache du Cinéma: Discovering Toronto Filmmakers*. Toronto: Funnel, Experimental Film Theatre, 1985 (catalogue).

Tulane University. *The New Orleans International Women's Film Festival*. New Orleans, La.: Tulane University, 1975 (catalogue).

Veten, Carol. "Far Shore: A Bittersweet Love Story." *San Diego Union,* 19 Sept. 1978.

Wheeler, Dennis, ed. *Form and Structure in Recent Film*. Vancouver: Vancouver Art Gallery, 1972 (catalogue).

Wieland, Joyce. "True Patriot's Love." *Film Culture* (New York) 52 (Spring 1971).

Worthington, Helen. "Artist Sees Tom Thomson as Romantic Hero." *Toronto Star,* 12 Jun. 1974.

Chronologies

EXHIBITIONS

ONE-WOMAN SHOWS

1960	Here and Now Gallery, Toronto, Ontario
	Isaacs Gallery, Toronto, Ontario
1962	Isaacs Gallery, Toronto, Ontario
1963	Isaacs Gallery, Toronto, Ontario
1966	20/20 Gallery, London, Ontario
1967	Isaacs Gallery, Toronto, Ontario
1968	*Cineprobe,* Museum of Modern Art, New York, New York
	Joyce Wieland Retrospective, 1957 to 1967, Vancouver Art Gallery, Vancouver, British Columbia
1969	*Cineprobe,* Museum of Modern Art, New York, New York
	Joyce Wieland Retrospective, Glendon College Art Gallery, York University, Toronto
1971	*True Patriot Love/Véritable amour patriotique,* National Gallery of Canada, Ottawa, Ontario
1972	Isaacs Gallery, Toronto, Ontario
	Joyce Wieland: Independent Canadian Art Show, University of Guelph Art Gallery, Guelph, Ontario
1974	Isaacs Gallery, Toronto, Ontario
1978	*Joyce Wieland: Drawings from "The Far Shore,"* National Gallery of Canada, Ottawa, Ontario (travelling exhibition)
1979-80	Pauline McGibbon Cultural Centre, Toronto, Ontario
1981	Isaacs Gallery, Toronto, Ontario

1982	*Joyce Wieland: New Paintings,* Forest City Gallery, London, Ontario (travelling exhibition)
	Yajima/Galerie, Montreal, Quebec
1983	Isaacs Gallery, Toronto, Ontario
1985	*Joyce Wieland: A Decade of Painting,* Concordia University, Montreal, Quebec

TWO-PERSON SHOWS

1959	*Drawings of Michael Snow and Joyce Wieland,* Westdale Gallery, Hamilton, Ontario
	Gordon Rayner and Joyce Wieland, Greenwich Gallery, Toronto, Ontario
1962	*Drawings by Michael Snow and Joyce Wieland,* Hart House Gallery, University of Toronto (travelling exhibition)
1967-68	*Wieland and Meredith,* National Gallery of Canada, Ottawa, Ontario (travelling exhibition)
1980	*Joyce Wieland and Judy Chicago,* Powerhouse Gallery, Montreal, Quebec

MAJOR GROUP SHOWS

1957	Gallery of Contemporary Art, Toronto, Ontario
1957-59	Society of Co-operative Artists, Toronto, Ontario
1959	*76th Annual Spring Exhibition,* Montreal Museum of Fine Arts, Montreal, Quebec
1960	Winnipeg Art Gallery, Winnipeg, Manitoba
1961	*Canadian Art Today,* University of Waterloo Gallery, Waterloo, Ontario
	12th Annual Winter Exhibition, Art Gallery of Hamilton, Hamilton, Ontario
1961-62	*Dada: Dennis Burton, Arthur Coughtry, Greg Curnoe, Richard Gorman, Gordon Rayner, Michael Snow, Joyce Wieland,* Isaacs Gallery, Toronto, Ontario

1962	Albright-Knox Art Gallery, Buffalo, New York
	National Gallery of Canada, Ottawa, Ontario
	19 Canadian Painters '62, J.B. Speed Art Museum, Louisville, Kentucky
1963	*Canadian Art Today,* University of Waterloo Gallery, Waterloo, Ontario
1964	Philadelphia Museum of Art, Philadelphia, Pennsylvania
1965	*Canadian Art Today,* University of Waterloo Gallery, Waterloo, Ontario
	Confederation Centre Art Gallery and Museum, Charlottetown, Prince Edward Island
	Graphics, University of Western Ontario, London, Ontario
	Interim Works by Four Artists: Richard Gorman, Robert Markle, Michael Snow, Joyce Wieland, Isaacs Gallery, Toronto, Ontario
	Polychrome Construction: Dennis Burton, Donald Judd, Gordon Rayner, Michael Snow, David Weinrib, Joyce Wieland, Isaacs Gallery, Toronto, Ontario
	Sixth Biennial of Canadian Painting 1965, National Gallery of Canada, Ottawa, Ontario
1966	Norman McKenzie Gallery, Regina, Saskatchewan
	The Satirical in Art, Art Gallery of York University, Toronto, Ontario
1967	Centennial exhibition, Hudsons Galleries, Detroit, Michigan
	Painting in Canada, Canadian Government Pavilion, Expo 67, Montreal, Quebec
1968	*Canada: Art d'aujourd'hui,* Musée national d'art moderne, Paris, France (travelled to Rome, Lausanne, Brussels)
	Canada 101, Edinburgh International Festival, Edinburgh, Scotland
1969	*Art for Architecture: The Wall,* Art Gallery of Ontario, Toronto, Ontario (travelling exhibition)
1970	*Eight Artists from Canada,* Tel Aviv Museum, Israel
	Rothman's Art Gallery, Stratford, Ontario
	Survey/Sondage 70—Realism(e)s, Montreal Museum of Fine Arts and Art Gallery of Ontario, Toronto
1971	*49th Parallels: New Canadian Art,* Art Gallery of Ontario, Toronto; Museum of Contemporary Art, Chicago; John and Mabel Ringling Museum of Art, Sarasota, Florida

1972	*Comic Art Traditions,* National Gallery of Canada, Ottawa, Ontario
1974	Inaugural exhibition, National Museum of Man, Ottawa, Ontario
1975-77	*Landscape Canada: Roots and Promise, Image and Symbol,* Art Gallery of Ontario, Toronto, Ontario (travelling exhibition)
1976	*First Dalhousie Drawing Exhibition,* Dalhousie University Art Gallery, Halifax, Nova Scotia
1976	*O Canada,* London Regional Art Gallery, London, Ontario
1977	*Canadian Tapestries '77,* Art Gallery of Ontario, Toronto, Ontario (travelling exhibition)
1978	*Modern Canadian Painting in Canada: A Survey of Major Movements in Twentieth-Century Art,* Edmonton Art Gallery, Edmonton, Alberta
1981	*Twentieth-Century Canadian Painting,* National Museum of Modern Art, Tokyo, Japan
1982	*Contemporary Outdoor Sculpture at the Guild,* Guild of All Arts, Toronto, Ontario
1983	*New Perceptions: Portraits,* Harbourfront Community Gallery, Toronto, Ontario
	Toronto Painting of the 1960s, Art Gallery of Ontario, Toronto, Ontario
	Toronto Women Artists/Three Decades, Gallery Quan, Toronto, Ontario
1983-85	*Canada Mikrokosma: An Exhibition of Contemporary Canadian Tapestries,* Agnes Etherington Art Centre, Kingston, Ontario (travelling exhibition to: Crystal Palace, Madrid, Spain; Textile Museum, Krefeld, Germany; Nord Gyllands Kunstmuseum, Copenhagen, Denmark; and major centres in Canada)
1984	*Edge and Image,* Concordia University Art Gallery, Montreal, Quebec
	Hearts, Hart House Gallery, University of Toronto, Ontario
	Reflections: Contemporary art since 1964 at the National Gallery of Canada, National Gallery of Canada, Ottawa, Ontario
	Toronto Painting '84, Art Gallery of Ontario, Toronto, Ontario (travelling exhibition)
	Troisième Biennale de Tapisserie de Montréal, Canadian Cultural Centre, Paris, France

FILMOGRAPHY

FILMS

1958	*Tea in the Garden,* 16 mm, 4 min., b&w, Collins and Wieland
1959	*A Salt in the Park,* 16 mm, 20 min., b&w, Snow and Wieland
1963	*Larry's Recent Behaviour,* 8 mm, 18 min., colour
1964	*Patriotism, Part I,* 16 mm, 15 min., colour
	Patriotism, Part II, 16 mm, 5 min., colour, silent
1964-65	*Water Sark,* 16 mm, 14 min., colour
1964-86	*Peggy's Blue Skylight,* 8 mm, 17 min., b&w, printed on colour stock
1967-68	*Hand Tinting,* 16 mm, 5½ min., colour, silent, 24 fps.
	1933, 16 mm, 4 min., colour
	Sailboat, 16 mm, 3½ min., b&w, printed on colour stock
1967-69	*Reason over Passion,* 16 mm, 90 min., colour
1968	*Rat Life and Diet in North America,* 16 mm, 14 min., colour
	Catfood, 16 mm, 13 min., colour
1969	*Dripping Water,* 16 mm., 10 min., colour, co-director Michael Snow
1972	*Pierre Vallières,* 16 mm, 45 min., colour
1973	*Solidarity,* 16 mm, 11 min., colour
1976	*The Far Shore,* 35 mm, 106 min., colour
1984	*A & B in Ontario,* 16 mm, 17 min., b&w, with Hollis Frampton
1985	*Peggy's Blue Skylight,* 16 mm, 11 min., b&w
	Birds at Sunrise, 16 mm, 10 min., colour

MAJOR SHOWINGS OF FILMS

1963	First Program of Underground Films, Isaacs Gallery, Toronto, Ontario
1967	Boston Museum of Contemporary Art, Boston, ''Canadian Film Survey''
	Jewish Museum, New York, N.Y., ''The Painter as Filmmaker''
1968	Museum of Modern Art, New York, N.Y., ''Five Films by Joyce Wieland''
	Quinzaine, Directors' Fortnight, Cannes Film Festival

1968-69	Museum of Modern Art, New York, "Cineprobe"
	World Experimental Film Festival, Knokke-le-Zoute, Belgium
1968-72	Edinburgh International Film Festival, Scotland
1969-70	Canadian Mini Festival (European tour of a selection of Canadian films)
1970	Film Festival, Oberhausen, Germany
1972	New York Cultural Center, "Festival of Women's Films"
	Pacific Film Archive, Berkeley, California, "Joyce Wieland Retrospective"
	Sonsbeek Film Festival, Holland
	Vancouver Museum, Vancouver, B.C., "Structural Films"
1973	Avant-Garde Festival, "Canadian, American and European Films"
	National Film Theatre, London, England, "International Festival of New Cinema"
	2nd International Cat Film Festival, New York/Paris/Berlin
	Whitney Museum of American Art, New York, N.Y. "Retrospective Films of Joyce Wieland"
1974	Montreux Film Festival, Switzerland, "New Forms in Film"
1976	Cannes Film Festival
1977	London Film Festival, London, England
	New Delhi International Film Festival
1978	Chicago Art Institute, Chicago, Illinois
	Museum of Fine Arts, Houston, Texas
1981	Hong Kong Arts Centre, Hong Kong, "Canadian Film"
1982	Museum of Art, Carnegie Institute, Pittsburgh, "The Films of Joyce Wieland"
1983	*O Kanada,* Akademie der Künste, Berlin, West Germany, "Experimental Films by Artists"
1984	Gallery of Modern Art, Edinburgh, Scotland, "Creation: Modern Art and Nature"
	Hungarian Film Festival, National Gallery of Hungary, "Selected Films of Joyce Wieland"
	Western Front, Vancouver, British Columbia, "Canadian Avant-garde/ Experimental Films"

1985	Art Institute of Chicago, Illinois, "Visiting Filmmakers Series"
	Berlin Film Festival, Berlin, West Germany
	Cinémama, Montreal, Quebec, "Her Language, Her Voice"
	International Festival of Art and Films by Women, Museum Moderner Kunst, Vienna, Austria, "Kunst Mit Eigen-Sinn"
	London Film Festival, London, England
	Pacific Film Archive, Berkeley, California, "The Far Shore"
	Randolph Street Gallery, Experimental Film Coalition, Chicago, Illinois
	San Francisco Art Institute, San Francisco, California, "Cinematheque"
	San Francisco Art Institute, San Francisco, California, "Retrospective"
1986	Ann Arbor Film Festival, Ann Arbor, Michigan
	Art Gallery of Ontario, Toronto, Ontario, "Experimental Film, Spring 1986"
	Art Gallery of Ontario, Toronto, Ontario, "Experimental Film, Fall 1986"
	Ciné-Club de Saint-Charles, Université de Paris, Sorbonne, Paris, France
	Collective for Living Cinema, New York, N.Y.
	Festival of Festivals, Toronto, Ontario
	London Regional Art Gallery, London, Ontario, "Vision: Focus on Narrative in Film"
	National Arts Centre, Ottawa, Ontario, "Israel: A Canadian Perspective"
	Oberhausen Film Festival, Oberhausen, West Germany
	Pacific Ciné Centre, Vancouver, British Columbia, "National Film Week '86"
	TVOntario, Toronto, Ontario, "New Directions—Film" (aired on September 3)
	University of Toronto, Ontario, "Innis Fall Film '86 Programme"

AWARDS, COMMISSIONS AND GRANTS

1966	Canada Council Grant
1967	*Bill's Hat,* Expanded Cinema, Cinecity, Toronto
	Bill's Hat, Commission, Film and Mixed Media, Art Gallery of Ontario, Toronto, Ontario

1968	Canada Council Grant
	Vancouver Film Festival, Award of Merit, Vancouver, British Columbia
	Vancouver Film Festival, Honourable Mention, Vancouver, British Columbia
1969	*Rat Life and Diet in North America,* Third Independent Filmmakers Festival Award, New York (two prizes)
1971	Philadelphia International Festival of Short Films, Award for Exceptional Merit, Philadelphia, Pennsylvania
1972	Canada Council, Victor Martyn Lynch-Staunton Award
1973	Member of the Royal Academy of Arts
1975	National Science Library, Commission, Ottawa, Ontario
1977	Bata Shoes, Commission, Eaton Centre, Toronto, Ontario
	The Far Shore, Canadian Film Awards (three awards)
	The Far Shore, London International Film Festival
	TTC, Commission, Spadina Subway Line, Toronto, Ontario
1981	Laidlaw Foundation, Commission, Toronto, Ontario
1983	Officer of the Order of Canada
1984	Canada Council Grant
1985	Ontario Arts Council Grant
1986	*A & B in Ontario,* Ann Arbor Film Festival, Ann Arbor, Michigan (second prize)

Photo Credits